ASPIRE

150
PROJECTS TO
STRENGTHEN YOUR
PHOTOGRAPHY
SKILLS

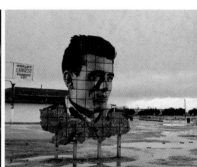

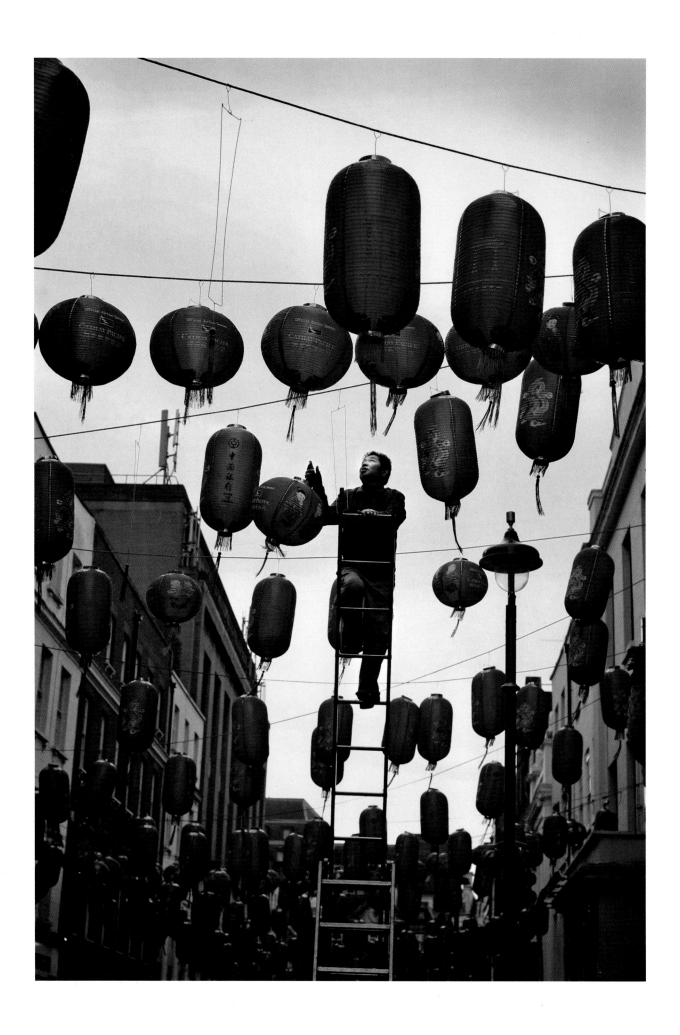

ASPIRE

150 PROJECTS TO STRENGTHEN YOUR PHOTOGRAPHY SKILLS

John Easterby

GARFIELD COUNTY LIBRARIES
Parachute Branch Library
244 Grand Valley Way
Parachute, CO 81635
(970) 285-9870 – Fax (970) 285-7477
www.gcpld.org

BARRON'S

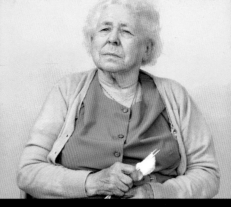

A QUARTO BOOK

First edition for North America
published in 2010 by Barron's
Educational Series, Inc.

All inquires should be addressed to:
Barron's Educational Series, Inc.
250 Wireless Boulevard
Hauppauge, NY 11788
www.barronseduc.com

ISBN-13: 978-0-7641-4470-7
ISBN-10: 0-7641-4470-7

Library of Congress Control Number:
2009934380

QUAR.WOP

Conceived, designed, and
 produced by
Quarto Publishing plc
The Old Brewery
6 Blundell Street
London N7 9BH

Senior editor: Ruth Patrick
Art editor: Louise Clements
Art director: Caroline Guest
Illustrator: Kuo Kang Chen
Picture researcher: Sarah Bell
Design assistant: Saffron Stocker
Proofreader: Pat Farrington
Indexer: Ann Barrett

Creative director: Moira Clinch
Publisher: Paul Carslake

Color separation by Pica Digital
 Pte Ltd, Singapore
Printed by Star Standard
 Industries (PTE) Limited,
 Singapore

9 8 7 6 5 4 3 2 1

Contents

Foreword

For many, the start of an interest in photography is marked by a particular moment—an epiphany—after which nothing is ever quite the same. So it was for me when, as a late teenager, I came across the work of the legendary French photographer and co-founder of the incomparable Magnum Photos, Henri Cartier-Bresson.

Seizing the photographic moment

Henri Cartier-Bresson's famous photograph, Behind the Gare Saint-Lazare, taken in 1932.

In 1979 I had just left school and really had very little idea what I wanted to do with my life. My parents were keen for me to pursue some kind of higher education and the rather gray and depressing prospect of a degree in business studies seemed the most likely of outcomes. Were it not for the unexpected opportunity to go and live and work for a year in Paris, on my own, I would not be sitting here today reflecting on a career of nearly thirty years in some of the most exciting and interesting areas of the industries that have photography and photographers at their very core.

My interest in photography at the time was very schizophrenic. I had a decent camera, did my own processing occasionally, and enjoyed making prints in my friend's darkroom under the stairs. But it would be fair to say that for me at the time, photography was just a hobby—one of many. By chance, my best friend at school had been the nephew of Don McCullin, Britain's greatest ever photojournalist, and his dark and disturbing work had greatly impressed me. In contrast to McCullin's brilliant work on war and human suffering, the walls of my bedroom at home were adorned with the standard album art, glossy posters, and misty pictures of semi-naked girls in French landscapes by the photographer of the moment, David Hamilton.

In Paris, I grew up. Working in hotels and bars, often on night shifts, I found myself walking for hour upon hour around the great city, either in my spare time or when returning home from work, exploring every different *quartier*, witnessing the city come to life in the mornings, wandering through the markets, meeting and talking to people from all walks of life, and loving every moment. Perhaps it was my age or maybe it was just the extraordinary romantic quality of the place, but there was something about living in Paris as a young man that made me want to record the experience—create something lasting that would serve as a reminder in years to come.

The photographic epiphany

Above all, my favorite pastime in Paris was going to bookstores and galleries that specialized in photography and on one such occasion, in the bookstore at Pompidou Centre, I came across a large, heavy book on the work of Henri Cartier-Bresson. This was my "moment," the point where

photography stopped being a hobby and became a method of documenting my experiences and ultimately became my career.

Bresson's work was and remains extraordinary and magical to me. It has everything. The pictures were taken all over the world and revealed a humanity, humor, and compositional beauty that took my breath away. Perhaps the thing that impressed me most was that nearly all of the pictures appeared to be amazing observations from essentially ordinary daily life. Through Bresson's eyes, everything became exceptional, relevant, and unique.

To me, the picture of the man crossing a bit of wasteland behind Paris' Gare Saint-Lazare in 1932 is possibly the greatest picture ever taken. The most mundane of actions—some guy taking a short cut across a waterlogged railway yard—is elevated to something altogether different by the vision, skill, and timing of the photographer. There is a calm tension in the photograph, as if life itself took a gentle intake of breath and held it for a fraction of a second, and during this briefest of pauses, everything was in balance, all was quiet, and the world was beautiful. The picture has the same impact on me today as it did in 1980.

As if being the author of such a picture were not enough, Cartier-Bresson chose also to write about the photographic process and in doing so, created many of the most articulate and compelling pieces of prose on photography, (see *L'Imaginaire d'après Nature* on page 8).

It's truly extraordinary how photography has evolved within a relatively short time. This evolution has been less about technical advancement—in truth, very little has really changed in terms of the basic quality of the image from the very earliest days of Daguerre—but massively significant in terms of the role that the photographic image plays in our daily lives.

It is hard to imagine a fashion industry without photography and fascinating to wonder how advertising would work without its dependence on aspirational visual imagery to sell us the latest products. The tourism industry is driven by our desire to spend time in places that we have seen in photographs, and the way we recall history is often defined by iconic pictures from momentous occasions.

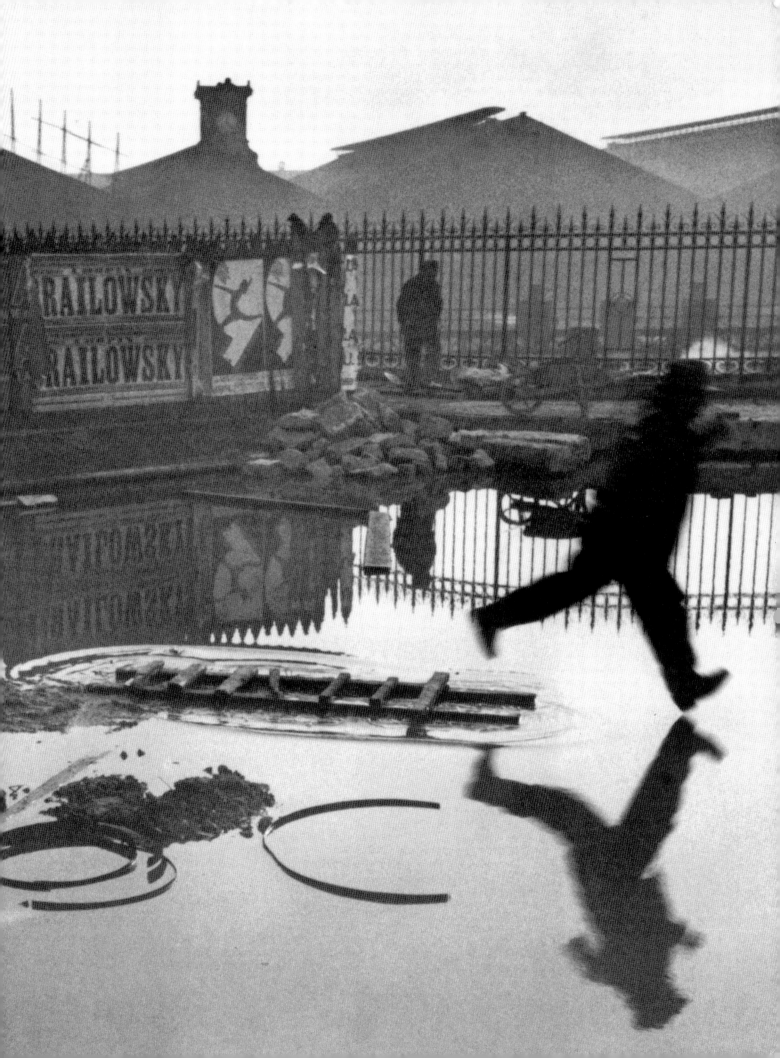

Reach for the sky (left)
Timing and awareness is all important to the street photographer. Keep your eyes open for impromptu moments where something routine, such as the maintenance of a billboard, can result in an amusing picture.

Off the beaten track (right)
It is still possible to roam the world and find subjects and places that many have never seen before. Treat these encounters with sensitivity and understanding and always consider the consequences of your work.

Action shots (center and far right)
Try your hand at all kinds of photography before specializing. Capturing a moment in sport requires skill and awareness of where the peak of the action lies (center right). See if you can turn a simple street portrait into something with a choreographed element in the background (far right).

Power in stillness (bottom right)
In contrast to freezing the action, a great deal can be said by emptiness and simplicity, as with this simple picture of a closed shop.

I implore you to study the work of others and to look into the past as well as at the work of the current masters. Try to ignore the advice of those who would have you believe one genre of photography is superior to another. The fashion work of photographers such as Richard Avedon, Helmut Newton, and David Bailey is as relevant as a historical, social record today as it was effective, in its day, in selling clothes and celebrating the work of great designers.

A career in photography

For those of you who are interested in becoming a photographer, this book is intended to give you a range of exercises that will improve your practice, enhance your understanding of what it really means to be a photographer, and help you to decide on the right kind of course for your particular interests and how to get onto it. I don't expect this book to be your "moment" but I would be indescribably proud if it contributed toward your being able to say "I am a photographer." We are in an era of great change and uncertainty in photography. Many of the established outlets for the photographic image are in terminal decline and the alternatives, which will inevitably exist in the virtual world, remain underdeveloped and poorly funded. Despite this, I think photography has never been at a more exciting crossroads. The new generation of photographers—you—will be the people who make sense of the new technology and use it to bring the unique power of the still image to ever broader audiences.

John Easterby

L'Imaginaire d'après Nature

Photography has not changed since its origin except in its technical aspects, which for me are not a major concern.

Photography appears to be an easy activity; in fact it is a varied and ambiguous process in which the only common denominator among its practitioners is their instrument. What emerges from this recording machine does not escape the economic constraints of a world of waste, of tensions that become increasingly intense, and of insane ecological consequences.

"Manufactured" or staged photography does not concern me. And if I make a judgment, it can only be on a psychological or sociological level. There are those who take photographs arranged beforehand and those who go out and discover the image and seize it. For me the camera is a sketchbook, an instrument of intuition and spontaneity, the master of the instant which, in visual terms, questions and decides simultaneously. In order to "give meaning" to the world one has to feel oneself involved in what one frames through the viewfinder. This attitude requires concentration, a discipline of mind, sensitivity, and a sense of geometry. It is by great economy of means that one arrives at simplicity of expression. One must always take photographs with the greatest respect for the subject and for oneself. To take photographs is to hold one's breath when all faculties converge in the face of fleeting reality. It is at that moment that mastering an image becomes a great physical and intellectual joy.

To take photographs means to recognize—simultaneously and within a fraction of a second—both the fact itself and the rigorous organization of visually perceived forms that give it meaning. It's putting one's head, one's eye, and one's heart on the same axis.

As far as I am concerned, taking photographs is a means of understanding which cannot be separated from other means of visual expression. It is a way of shouting, of freeing oneself, not of proving or asserting one's originality. It is a way of life.

Henri Cartier-Bresson

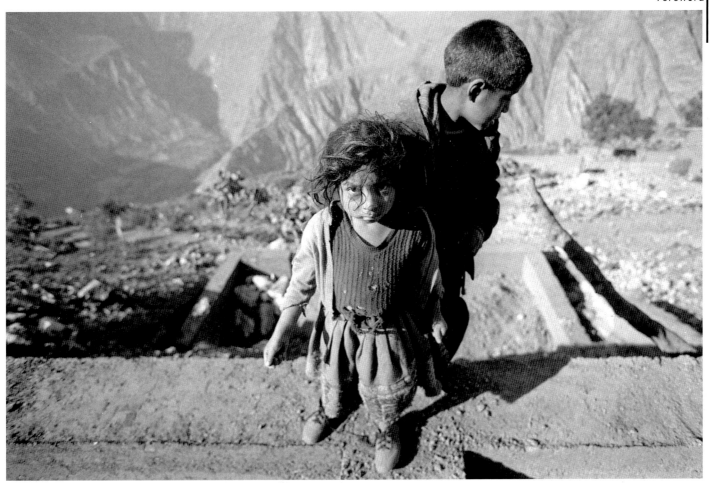

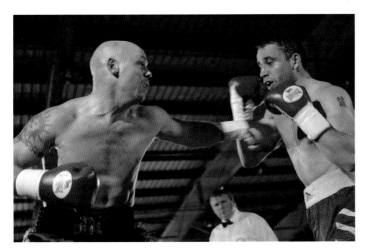

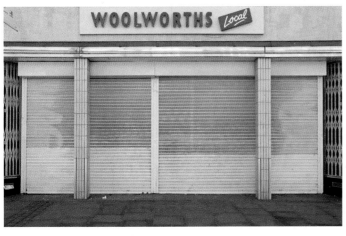

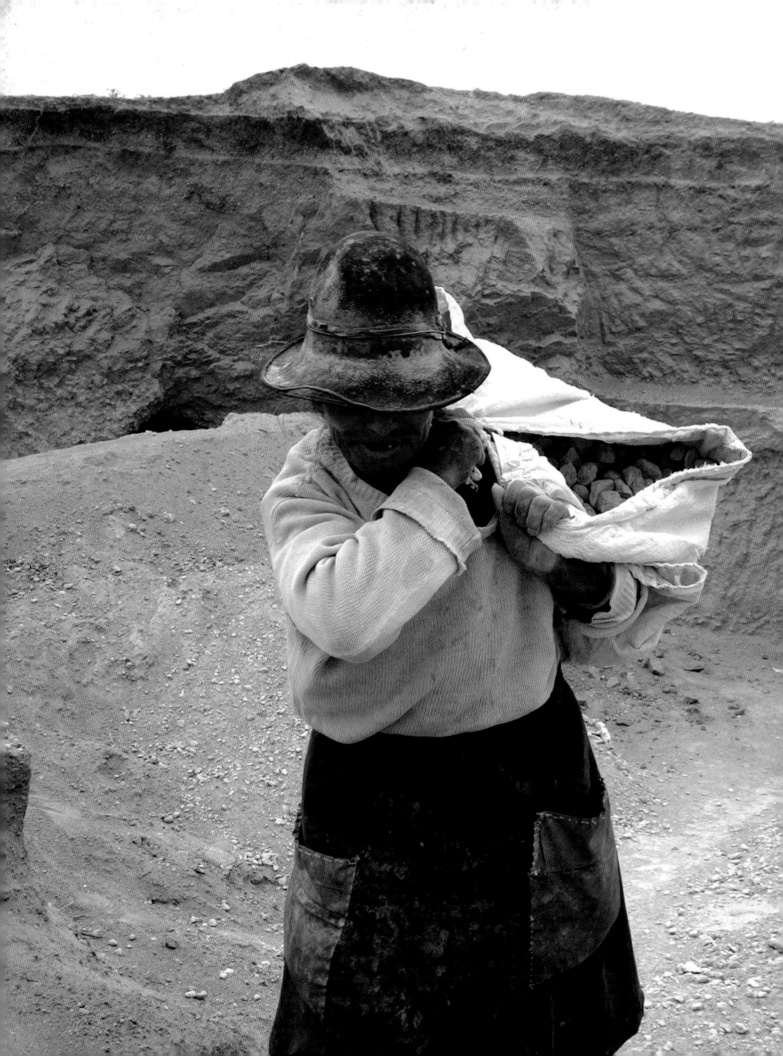

Getting started

Not since its origin in the late 1830s has photography exerted such a grip on our collective consciousness. Today our fascination has changed from the wonder of a new visual form, to one of excitement at being active participants in the photographic process.

This book is aimed at aspiring photographers from all genres, who feel they have something unique to communicate and believe the camera to be the best way to achieve their goal. This chapter introduces photography and examines some of the background issues relevant today.

Travel photography
Take your camera on your travels to capture interesting and unusual moments.

Introducing photography

The very first steps on the road to becoming a photographer have little to do with owning the latest expensive equipment, having a knack for taking pictures that people like, or even whether or not you are interested in photography.

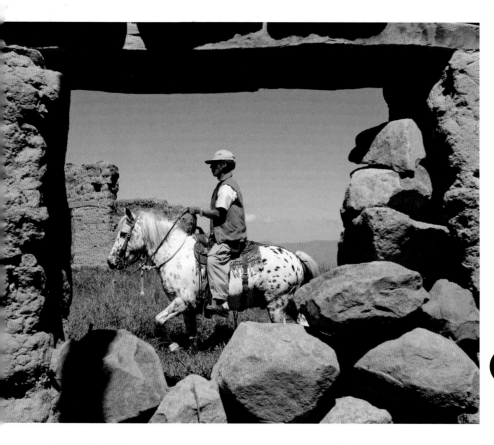

To become a photographer is to decide that your chosen method for interpreting life and revealing your findings to others is the camera. This tool, much like the word processor for a writer, is a device with which you express your unique point of view on life, the human condition, and the world around you. As with all artistic and cultural expression, mastery of your tools eventually takes a distant second place to the content and style of what you wish to say to your audience.

Becoming a photographer (left)
Think of your camera's viewfinder as a window on your world. Photograph your subjects the way you see them and how you want others to see them.

1 **Project:** Practice framing your scene

Make a rectangle by joining your thumbs and forefingers and practice looking through this with an eye at situations that you think might make a good photograph. Try framing things vertically and horizontally.

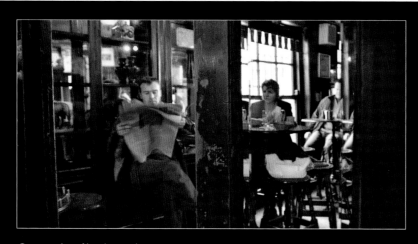

Opportunity knocks

Carry your camera with you at all times as you never know when a photographic opportunity will present itself. Learn to keep your eyes open and look for situations that could make a good shot: even seemingly mundane scenes like people sitting in a bar can make an interesting photo.

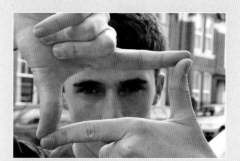

Visualizing the shot
Framing potential photos with your fingers will help to isolate the scene or subject from its surroundings. This will help you to see if the shot will work or not before taking a picture.

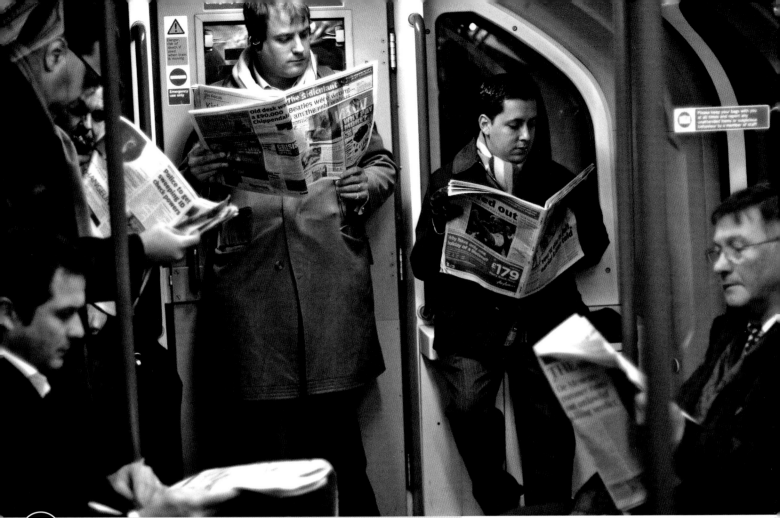

2 Project: Use your mind as a cognitive camera

Imagine that you have a camera inside your head and that your eyes are the shutter. With this in mind, go out and start to look for situations that you think would make good photographs, deciding carefully when to "click" your eyes. This very easy process really helps to develop the skill of seeing pictures without having to deal with technical practicalities or with people's reluctance to be photographed.

Photography is a journey
Try to spot interesting photographic scenes, such as this shot of the horizon through a plane window, whenever you're out and about.

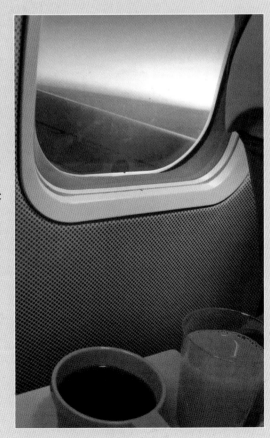

Your photographer's eye (above)
As you begin to learn to see like a photographer, you'll notice arresting photos everywhere. Even when you're commuting on the train or subway there will be countless chances to capture great photos.

3 Project: Do your homework

Spend time in a good bookstore or library and look through the work of some of the great photographers from different photographic traditions. Awareness of the work of others is of huge importance to your own personal development and you should make this a regular part of your life. It's important to not only look at their photographs but also to consider carefully what each photographer has to say about their work and the photographic process. Choose favorite photographs from each book and try to assess why you like them, what the strength of each picture might be, and how the photographer achieved the end result.

Photography in the 21st century

Photography is an intrinsic part of our daily lives. From our first waking moment we are bombarded with photographs of all kinds in every conceivable context. Our consumer decisions are, they would have us believe, informed by "aspirational" advertising images, and the products we buy employ photography in their packaging to reinforce our confidence that we have spent our money wisely.

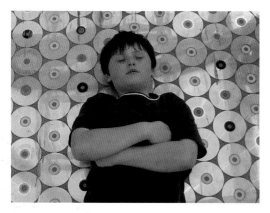

Work on your family snapshots (above)
Try to think of how to make a good photo out of tourist activities, such as visiting an art gallery.

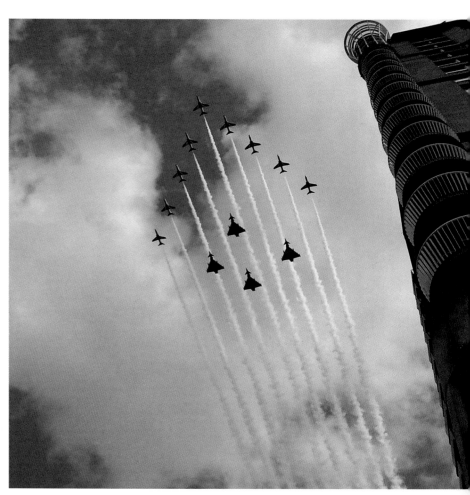

Photography plays a major part in keeping us informed of world events, telling us where we should go for our vacations or which poor soul has gone "missing." So ubiquitous is the still image that it has been estimated that on average we are bombarded with over 40,000 photographs every single day. Spend just 10 minutes on the Internet and you'll probably see hundreds of photographs and remember none of them.

Within the space of a little over a century, the photograph has evolved from being a thing of wonder, whose processes were viewed as a kind of alchemy, to something that is so commonplace we sometimes barely take notice.

In this photo-laden environment the public are not only consumers of photographs but producers too. Whereas in the past it was not uncommon for a single film from the family camera to contain photographs from two different summer vacations ("I didn't see the point in processing it yet, there were still 10 shots left... "), the situation today is one where the vast majority of people carry a cell phone and with it, the possibility to shoot, edit, and distribute photographs on the move at will.

The serious contemporary photographer operates in a world full of images and full of photographers, where everyone is potentially a photographer with an exclusive image.

4 **Project:** Shoot on a cell phone

Go out and try to take professional-looking photographs using a cell phone. Establish a clear theme before you go out to shoot. For example, you might decide to just concentrate on photographing scenes of people eating through restaurant and fast-food chain windows. At the end of the day, download the pictures onto your computer and edit the work into the strongest set of 12 pictures.

On the move
Most modern cell phones have decent digital cameras. So even if you haven't got your camera in hand, you can use your cell to capture interesting moments.

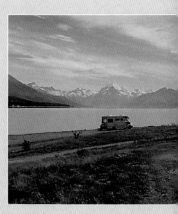

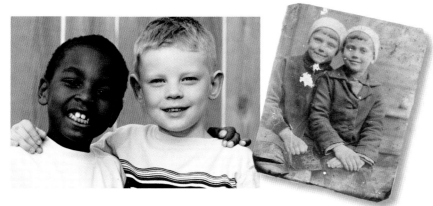

Modern methods (left)
Camera and print technology is constantly advancing. In the early 20th century, there were only expensive film cameras and black-and-white prints. Nowadays modern digital SLRs and color prints have never been more affordable.

Capture the moment (above left and above)
Make the most of your camera phone—modern phones can now create file sizes that are larger than the first professional digital systems. The immediacy and speed with which you can run off some pictures with a camera phone—and send them to friends or clients—make them very interesting and enjoyable tools. Practice catching moments, like the fly-by (above left), and experimenting with the surreal, sequences, and close-ups (above).

5 **Project:** Build a scrapbook

Start to build a scrapbook of photographs, drawings, and paintings that you find interesting and which elicit your emotional response. Copy these from the Internet, cut them out from magazines, and even include your own photographs when you feel you have taken one that is good enough for your book of inspiration.

6 Project: Compile a series of leisure images

Shoot a series of pictures in a public environment such as a beach or park, where people relax and have fun. Try to shoot a broad representation of the place, showing the landscape, activities, people, and some more abstract details.

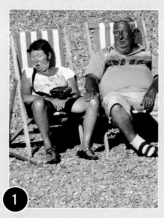

1

People
Try to capture a scene, taking candid portraits of one or two people.

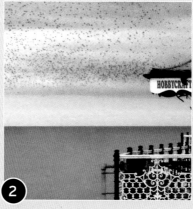

2

Places
Experiment and look for interesting and unique angles to transform the ordinary into something extraordinary.

3

Abstract
Finish off with a creative session. Look for color, shapes, and texture, and fill the frame for added impact.

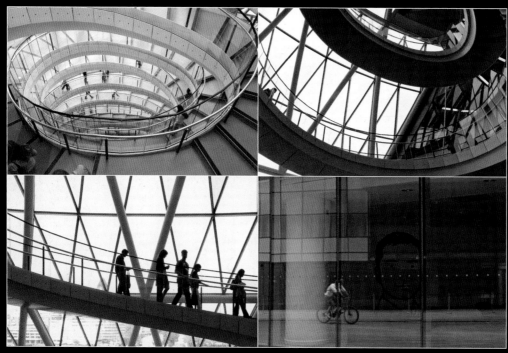

Learning to recognize a shot

Go out with your camera for half a day and implement a shooting system whereby you must take a picture every 20 minutes, no matter where you are or what you are doing. You may be able to set your phone or watch to beep at 20-minute intervals. When the alarm goes off you must take a photograph within 30 seconds. This exercise is designed to improve your ability to "see" a picture within any given situation as quickly as possible.

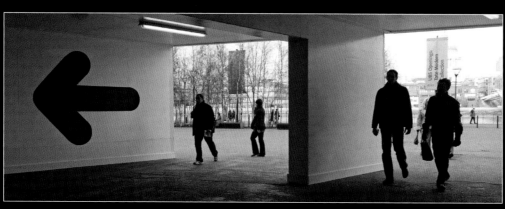

Twenty-minute rule (left)
By taking photos at regular intervals for half a day you'll quickly learn to assess any scene and identify something, somewhere, or someone that's worth photographing.

Image meltdown, or learning to discern?

Some people have suggested that in a daily environment so saturated with photography, we will start to show signs of image fatigue, and that photography will lose some of its power. Perhaps a better, more constructive way of looking at the situation is to acknowledge that the majority of people are now familiar with the language of photography and therefore, as in literature, those of you who can master the language will be able to express yourselves powerfully and make effective connections with mass audiences.

The language of photography (left)
To become a good photographer you need to become fluent in the language. Think of your photography as a way of communicating with people by using images instead of words.

7 **Project:** Start an on-line photo account

Set up an account on Flickr, Facebook, or one of the other on-line networks and start the process of uploading your best images to your site. If you intend to use these sites as a means of showing your work to others, start by choosing only the best material, clearly labeling each set by date, place, and subject, and editing carefully. Irrespective of which kind of platform you show your work, you should make sure that what you present is something that you are happy for others to see.

8 **Project:** Give your on-line account a professional edge

Now that you have uploaded some of your work on-line, you have created a personal profile through the display of your photography. In maintaining your site, opt for quality at all times and adopt a professional presentation and tone. Avoid posting personal information and images—especially if you want to be judged only on the quality of your work.

Your on-line portfolio
Think carefully about the photos you choose to display on-line. Only show a consistent standard of photos to give your portfolio a professional feel.

Jses of photography

Your own reasons for being drawn toward a career in photography, as well as the things you want to show through your pictures, are personal and unique. The key is that you have something to say to a broader audience and that the primary way you choose to communicate this vision is through photography.

Practice makes perfect (above)
If you're interested in a career in photography, learn to keep your camera on you at all times so you can practice taking photos in a wide variety of situations. This will give you confidence as you'll be prepared and familiar with the best exposure for any given scene or subject.

9 Project: Don't let the camera rule you

The camera offers nothing more than an exposure guide based on a formula that tries to control the behavior of the shutter and the aperture in order to ensure that the same average amount of light hits the film/sensor each time you take a picture. The majority of camera sales are made to amateurs who are happy for the camera to look good and "do" everything for them. The professional photographer or serious practitioner will be aware of the limitations of the Auto setting and only use it sparingly. Practice shooting on Manual and experiment with overexposure and underexposure in order to become more confident in what your eyes tell you, rather than what the camera tells you. Remember, if you set a camera on Auto and take a picture at night, the camera will compensate to such an extent that the resultant frame will appear to be day (see below).

Take control
Learn to shoot in Manual mode on your D-SLR. In Manual, you—not your camera—control the aperture and shutter speed to capture the scene as you see it.

10 Project: Practice guessing the light meter reading

Always take exposure readings wherever you are, even if not taking pictures. This will develop your ability to predict exposures in advance, and will help you to work out the correct exposure. After a while, you should be able to try and guess exposure readings by eye without a meter, since light in similar situations—for example, sunny day, overcast day, candle light—remains fairly constant. You can play this as a game with your friends and colleagues. Practice adjusting your focus and settings on a regular basis so that you are ready to take a picture at any time.

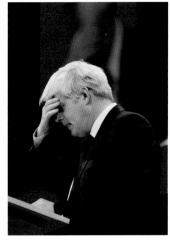

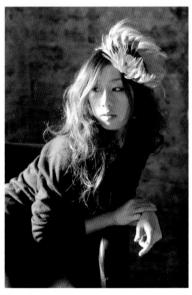

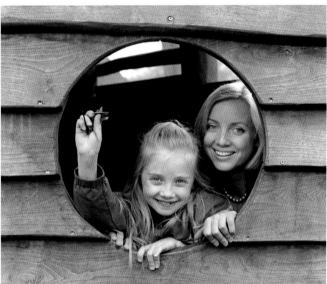

Artistic license (far left) There are many different genres of photography to choose from—including artistic imagery—so focus on the type that inspires you.

Political images (left) You might like to consider news and political photography—politicians can make fascinating yet challenging subjects.

Fashion (far left) You'll need a sharp eye to capture the beauty of the creations being modeled.

Family portraiture (left) It can be rewarding to capture families on camera in a creative way.

Social photography (below) If you want to use your photography to show people the tougher, more hard-hitting sides of life, consider the field of news or social photography.

You may have a desire to create images that reflect the issues of our time: educating, informing, and highlighting suffering and injustice. You may want to blow people away with pictures of the natural world in all its beauty. The statement you want to make could be political, social, cultural, or artistic—or it could be that you just happen to see the world in an amusing way and want to make others laugh through your brilliantly observed slices of everyday life. Whatever your choice, remember that there is nothing inherently superior, or for that matter second rate, within any of the photographic genres you might pursue (see Chapter 2 for more on genres).

It is important to understand and master your tools. While photography is not about what camera you own, how many lenses you have, or how much money you have spent on equipment, there is nothing more disappointing than missing a photograph because you made a technical mistake. Modern digital cameras come with a telephone directory-sized manual and so much technical flexibility that one could easily become confused. Learn about your camera, get comfortable with it, and be confident that it will do what you ask of it.

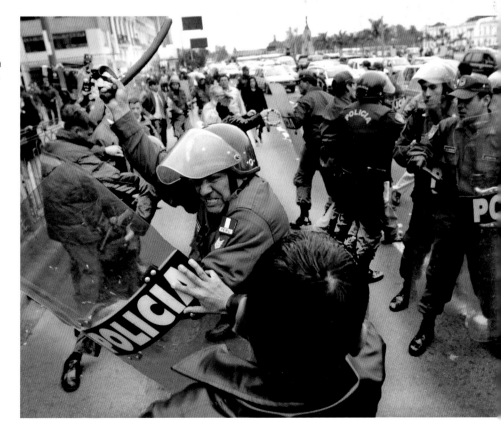

Learning to see photographically

We have to learn how the camera "sees" because it does not reproduce a scene in the same way as the human eye. The camera records only a part of the larger scene, reducing it to two dimensions, frames it, and stops the moment in time.

1 **Project:** Practice daytime long exposure

There are occasions when you will want to emphasize the sense of movement in your subject by using blur as a deliberate creative device. This technique can be relevant in most genres, such as sports and fashion photography, photojournalism, and, in particular, landscape photography, where the power and drama of the natural world can often be enhanced by allowing the movement of elements like waves, trees in a storm, or the flow of a stream.

Choose a subject where there is a moving element in an otherwise stationary environment. A tripod is essential so that your camera is absolutely steady. You then need to set your camera to a fairly long shutter speed (the slower the shutter speed the greater the blur) and adjust the aperture accordingly to ensure a correct exposure. On bright days it sometimes helps to reduce the ISO so that you can get the slower speeds required.

When we look at a scene we selectively see only the important elements and ignore the rest. A camera, on the other hand, sees all the details. Elements that we don't notice can suddenly become dominant when seen in print.

The best way to learn the elements that make an image interesting in two dimensions and within a frame is to look at a lot of pictures—not just photographs, but also paintings and movies. Every artist and movie director has to deal with the organization of space within the frame, and it is interesting and useful to see how they have solved this problem in various ways across the media.

The more images you look at carefully the more you will have in your "memory bank" that will help you make your own pictures better. By looking at images in this way we can find many similar techniques of composition, which can also be thought of as the orchestration of the space in the frame.

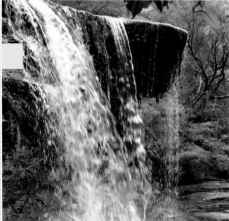

Freezing the moment (left)

Using a fixed focal length of 50mm will train your photographic eye and make you interact more closely with your subjects. This shot, however, is more a simple record of the scene and doesn't really display the power and movement of the waterfall.

Capturing the movement (right)

This time, by photographing the same scene from the same spot with the same lens and 50mm focal length, but with a slower shutter speed, you can transform a static shot into one that captures the motion and beauty.

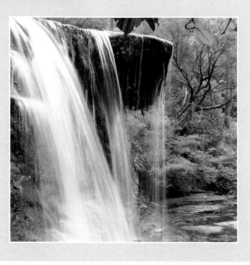

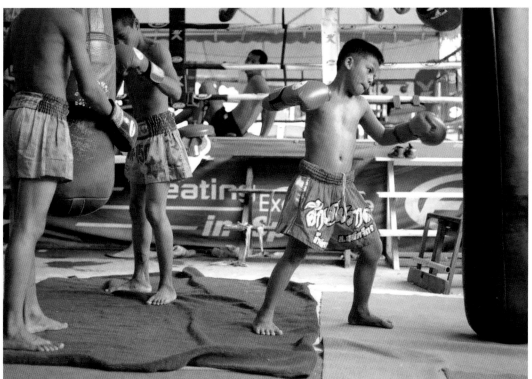

Photographic influences (above and right)

The best way to learn which elements and compositions work well within a photographic frame is to browse other photographers' work. Try and look at different types and styles of photos and make mental notes of what works and doesn't work so you can apply the successful methods to your shots. Also go to galleries to see how painters—both classical and modern—constructed their paintings.

12 **Project:** Practice framing your scene

Practice looking at situations through a small frame, moving the frame forward and backward to establish the best framing of the subject in view. This will help you start to understand the best lens choice for your photography.

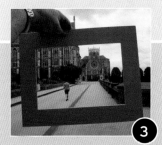

3

2

Horizontal (landscape) frame
1. By using a frame you can see how part of the scene will work as a photo on its own—without its surroundings distracting or leading your eye elsewhere.

Vertical (portrait) frame
2. Also try the frame in the vertical position when considering a shot of taller subjects or scenes. Again the frame will isolate your subject from its environment.

Tilt the frame
3. A photo frame can also help you to choose the best lens for the scene, such as a telephoto for this shot. Try tilting the frame for a more creative result.

Ethics in photography

It is no coincidence that the growth in public participation as active photographers has been paralleled by a growing sense of suspicion of professional photographers in public. It is essential to understand and respect the shift in public opinion on the right to privacy and adapt your working methods accordingly.

Candid camera (right)
Taking candid portraits can be great fun, but remember which privacy laws apply to the country you're in, and always carry model release forms just in case you need your subjects' consent.

13 Project: Practice negotiating permission

Practice negotiating permission to shoot in private places. Looking behind closed doors is at the very heart of the documentary process, and establishing your own successful, ethically sound methodology is vital. Learn to explain honestly and with transparency what your intentions are and what you plan to do with the photographs.

Honesty helps (above)
Be polite, friendly, and honest with people when asking to photograph them.

Observational photography (left)
You need a keen, observational eye for good documentary photos. Learn to watch people and read situations so you can be in the right place at the right time.

This change in public attitude has resulted in a shift in the dynamic between the photographer and his subject. Furthermore, the death of Princess Diana in 1997, after a high-speed car chase by paparazzi through the Parisian night, led to a change in privacy laws in France, making it illegal to photograph anyone in the street without permission. Although, as yet, this change in French legislation has not been adopted in quite the same way by other countries, it has definitely marked a global industry rethink on the ethical practices of photographers. Whether supported by the law or not, permission is now often a prerequisite to photographing in public places and learning how to deal with this matter and with the public at large is fundamental to your practice as a photographer.

Research privacy laws

It is important that you understand the laws governing privacy in any country you work in and that you adapt your practice accordingly. In the United States, for example, photographing strangers and publishing then in magazines or newspapers, or exhibiting them as fine art is covered under the first amendment, and this has been tested many times in the courts. However, the majority of American magazines now expect their photographers to obtain signed model releases for all identifiable people featured in the images, and this is now established practice for photographers.

14 Project: Involve your subjects

Make time to go back and visit people who have allowed you into their lives. Show them your work and make a habit of giving people you have worked with prints to keep.

Trust me (right)
Gaining people's trust before you take their photo will help them to relax and forget you're there—at this point you'll be able to get great, natural-looking shots.

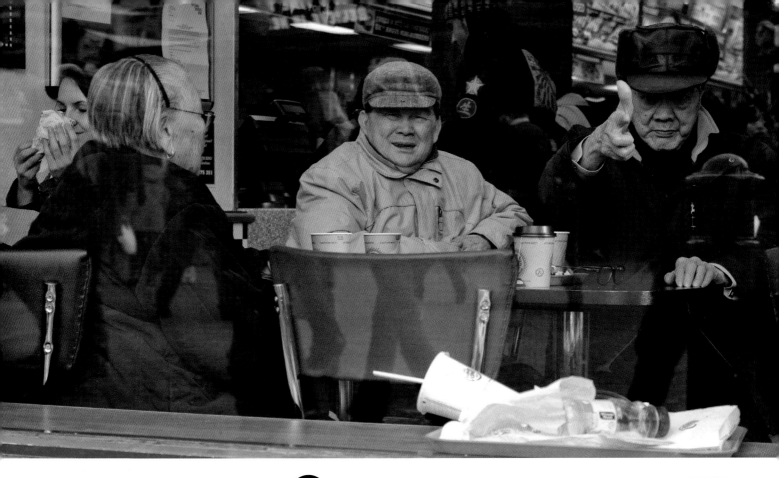

In parallel with these important changes in photographic practice we should do everything in our collective power to resist any changes to a democratic, free press, as seen recently in the United Kingdom when a law forbidding the photography of any member of the police was introduced.

Gaining access

Getting access to private situations can seem difficult, but it is extraordinary how willing many people are to let a stranger into their lives to document the most intimate situations. You have to be patient, and open about your intentions and the uses to which your pictures will be put. Sometimes you may have to use one contact to get inside a situation by being introduced personally. It is much easier to call and say "x gave me your number and suggested you might be able to help," than it is to call up cold.

Some photographers take things slowly, often not taking any pictures at all until their subjects become used to them. Others prefer to be up-front and start shooting immediately. You need to find your own strategy, but always be honest with your subject.

15 Project: Study a model release form

Model releases are informed consent forms. There are numerous forms available on-line from professional organizations and representative bodies, that will help you deal with the issue of obtaining signed consent for your pictures to be used commercially. The classic model release form is a contract that requires a signature from all parties appearing in your photograph and sets out the possible uses to which the photograph will be put. Model release forms are standard practice in many countries— France and the United States in particular.

Getting consent (right)
When taking photos of people, remember to get their permission and consent first. You'll need to get them to sign a standard model release form.

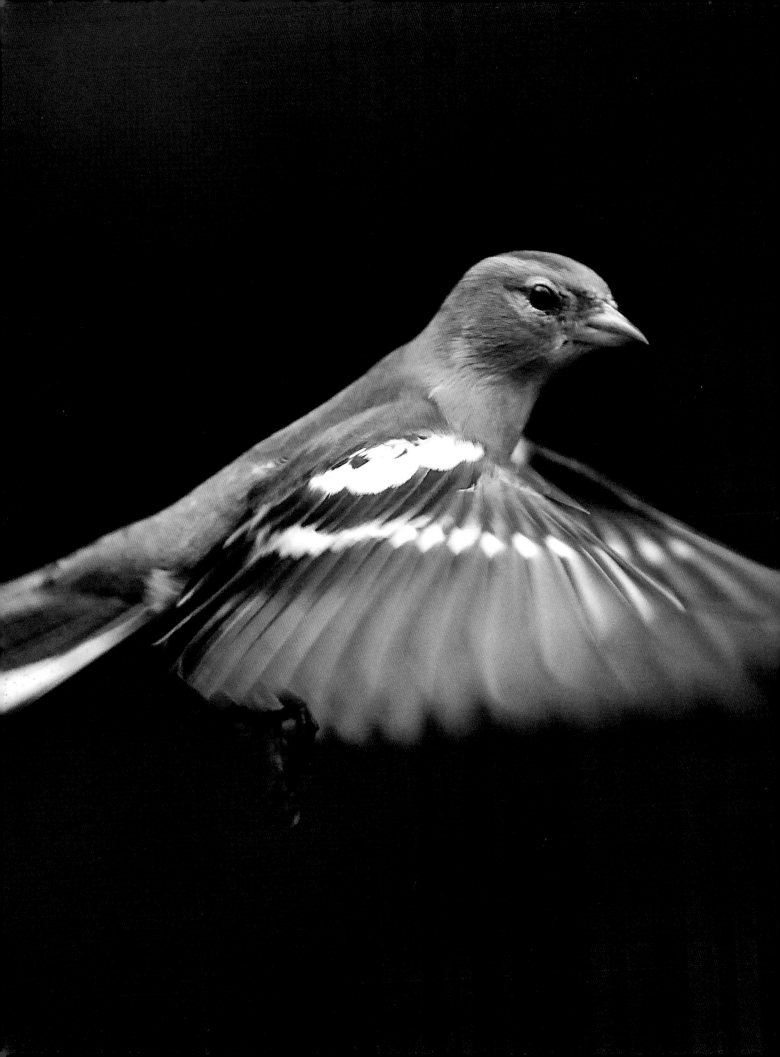

Genres

There is a tendency within the broader world of photography to label each specific discipline by "genre," with the most established categories being advertising, fashion, editorial, fine art, and wildlife.

Within these genres—all of which are covered either specifically or in more general terms in a range of college courses—there are many shared essential skills that are common to most kinds of photography.

Although many of the greatest photographers have resisted the efforts of others to categorize them as members of a single genre, it is important that you decide which direction you would like to move in and in which areas of the industry you would like to make your living.

Wildlife photography
Photographing wildlife is an exciting and dynamic area, and one where timing is vital
(see page 34).

Street photography

The street has been a focal point for photographers from the very beginnings of the medium. It is the stage for much of everyday life, for business, for entertainment, to get from one place to another, for relationships, for life, death, and every aspect of human activity.

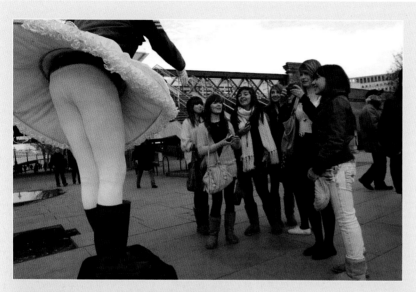

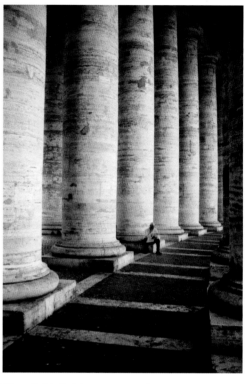

Quality street (above)
Follow the crowds in tourist spots or town centers and look for fun photo opportunities, perhaps from a unique angle.

Capturing intimacy (left)
Watch groups or pairs of people to see how they're interacting before quickly taking a snapshot.

The right light (above)
Don't just snap away and go home. Patiently waiting for the right light—which has created brighter stonework and longer shadows in this shot—can instantly transform lifeless scenes into photogenic masterpieces.

Street life (right)
Hit your local streets and wander about with your camera in hand ready to capture natural shots. As this example shows, you don't need everyone to look into your lens for a good shot.

16 **Project:** Practice capturing human interactions

Spend a day on the streets trying to capture human interactions and body language. Look hard at how people relate to one another and their surroundings. Pay special attention to people's eyes and hands, as they can say a lot about someone's attitude to those around them. Look out for juxtapositions and contrasts, and if you can, take some funny, humorous images too.

Patience is the main virtue with street photography. You need to spend a lot of time waiting for the right combination of light, moment, and timing to get really good images. Like a film director, you need to find a location that presents you with a good backdrop to shoot against. This "stage" is now a place to wait, look, observe, and anticipate when the "actors" will bring the scene to life. Other times, it can be just walking around, pounding the streets, waiting for the opportunity when a photograph comes out of nowhere, to make a decisive moment.

Blending in with the crowd
Modify your body language and appearance to enable you to work unnoticed. Don't wear bright clothing, use one small camera with a fixed lens, not a huge SLR with a motor drive

and a big zoom. Keep the camera out of sight until the moment you want to make your exposure.

Sometimes you can make it look like you are photographing one scene, then quickly turn to get the picture you actually want. Some photographers do the opposite too, and dress like tourists so they don't look like professionals. Try working in crowded areas, especially ones in tourist areas, since you won't stand out as much as when you are wandering the back streets.

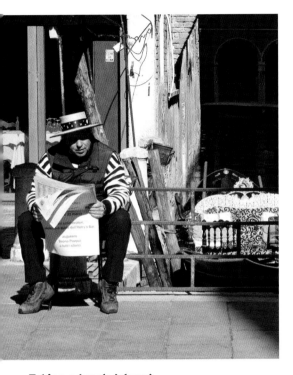

Taking a break (above)
Street photography is all about capturing people going about their daily lives, but try to do so in an innovative and inspiring way.

17 Project: Try the paradoxical approach

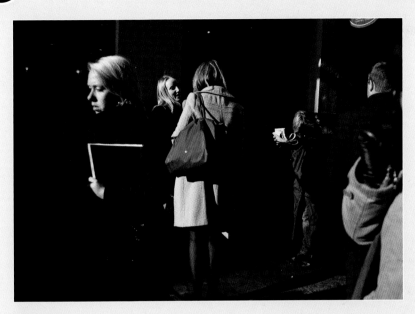

Interaction
How you interact with your subjects on the street—whether conspicuously or inconspicuously—will have a big impact on your results.

As if shooting on the street isn't hard enough on its own, you will encounter many people who simply don't want a camera pointed at them. Trying to dissolve into the background sometimes just won't work and a different approach is called for. Instead of trying to make yourself invisible, put your camera on a big tripod, wear a visibility vest, and set yourself up in a busy area of the street—maybe by an exit to a subway or a crossing point. By creating a physical presence that people come across as they go about their day, you are changing the dynamic from one where you are furtively looking for photographic moments to one where you are already visible on the street. The way people will react to you will be quite different.

18 Project: The art of remaining unobserved

Try shooting a series of pictures holding your camera at waist level without looking through the viewfinder. With practice, it can become easy to know roughly what the camera will see.

1

Shoot from the hip
Learn to set up your camera so you shoot successfully from waist height without using the rear LCD or viewfinder. After a while you'll learn where to aim to get the shot.

2

Blend into the crowd
Become another tourist with a camera or merge into the crowd so you go unnoticed. Turn off your camera's beep so it's less obvious you're taking photos.

3

Shoot from afar
If you're photographing big scenes with the wide-angle end of your zoom lens, you're more likely to remain undetected.

Studio photography

The studio is a place where little is left to chance and you are in absolute control of your environment. As with its movie industry namesake, the photographer's studio is a space in which all manner of different "realities" can be created, controlled, and altered.

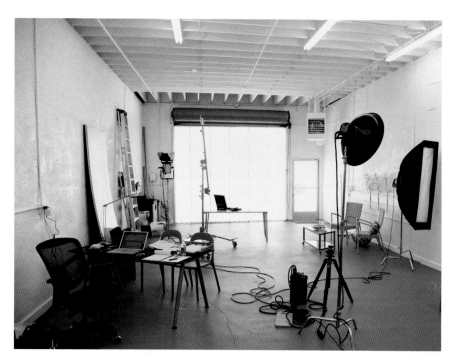

At one end of the spectrum, studios are environments where incredibly complex advertising shoots take place; at the other, the high street studio is as old a concept as photography itself.

There is traditionally an implied formality to the photographic process in the studio but in truth they can be wonderfully creative places in which to produce commercial work, portraiture, fashion, still life, and, perhaps the most enduring and important of all kinds of photography, the family portrait.

Some studios have large glass areas where daylight can be allowed into the shooting area and controlled or balanced with artificial light. Others, known as "blackout studios," have no natural light coming into the room at all and depend entirely on studio lighting and flash systems.

The key areas in which you have control are the choice of backdrop or stage-set, the lighting of the background, and the lighting of the subject.

19 Project: Build a makeshift studio

Build a makeshift studio in a room at home. Choose a room with as few windows as possible and do your best to black out these with black garbage bags or dark blankets. Hang and secure a makeshift white backdrop at the back of the room with as few creases in it as possible. Make sure it runs from ceiling to floor and that the piece of material is long enough for it to run flat on the floor for a couple of yards in front. (This will be where your model stands.) Light the background as evenly as possible with lights at either edge of the material. Experiment extensively until you are able to create a full-length portrait of someone against a pure white background. Remember your white balance settings on your camera (see page 61) and adjust them accordingly to see what impact the changes have on rendering your backdrop pure white.

Home studio
You don't need a huge studio to get pro-level photos. Invest in a set of decent lights and turn that spare room into a home studio. The studio shown also features a power pack that runs the lights.

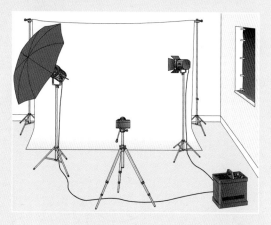

Artistic arena (left)
A studio is the place where you're totally in control of your photography. And although studios can appear a bit sterile with their cleanliness and white walls, they can also be places of great creativity to capture stunning photographs of every subject matter.

20 Project: Read up on the basic studio set up

Buy a book on basic studio lighting technique and read up on your subject, taking note of the minimum requirements for a beginner. Read carefully about the different kinds of lighting unit, the difference between tungsten light and flash, and on ways you can create a makeshift diffuser lighting rig (equivalent to a "soft-box").

Studio backgrounds and lighting

White backdrops (below and right)

Using a clean white backdrop will make your subjects, such as this Cockney pearly king, stand out clearly. White backgrounds can also work well in editorial designs as the background will flow seamlessly into the page and its words.

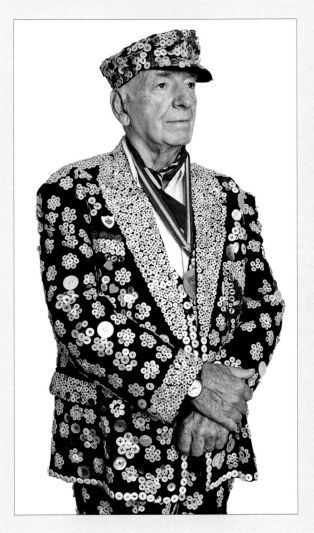

White backdrop suspended on a bar and two stands ·····

Flash heads x 2, directed at the backdrop in order to flood it with white light

Flash with softbox for lighting the subject ·····

Reflector board to bounce soft light back onto subject ·····

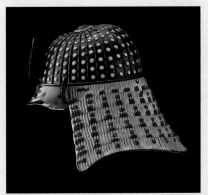

Black backdrops (right and below right)

For best results, when photographing smaller objects such as this Japanese helmet, use black velvet for your backdrop because of its ability to absorb stray flash or tungsten light.

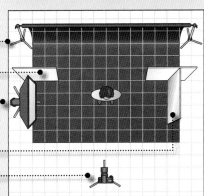

Black velvet backdrop suspended by bar and two stands ·····

Two light blocking boards ·····

Flash unit with softbox for lighting the subject ·····

Reflector board ·····

Camera on tripod ·····

21 Project: Create a portable studio

Create a simple outdoor portable "daylight" studio, using a white background to shoot against and reflector boards to bounce light toward your subject.

Mobile studio

You don't need—or want—to be lugging about big studio lights for outdoor shoots. Keep it simple by using a lightweight white backdrop and a couple of reflectors to bounce the available light onto your subjects.

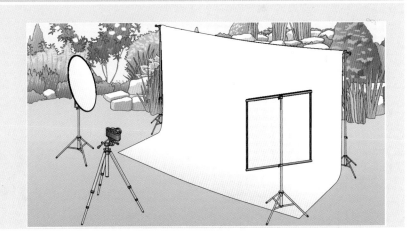

Fashion photography

The fashion industry is by definition a world that is in a constant state of change. Whatever you may feel about an industry that tells you each year that the clothes it convinced you to buy just 12 months ago are in fact now out of date and should be replaced by the latest trendy ware, the role that photography plays in the business is absolute and vital.

At their best, fashion photographers create images that make such a strong connection with their audience that they contribute to the changing trends that underpin society. Great fashion photographers like Richard Avedon, David Bailey, and Helmut Newton have demonstrated an ability to tune into the ambience and morals, and intellectual, cultural, ethical, and political climate of an era as effectively as the best photojournalist or artist. This ability to tune into the zeitgeist is what makes fashion photography so interesting and why the best way to understand fashion photography is to look at it as an historical record of our times. Without the work of fashion photographers, we would find it difficult to look back at, for example, the Swinging Sixties with any sense of visual dimension.

Fashion photography as a career

For photographers with an interest in fashion, the route forward is clearer than in other genres. To start with, the fashion industry is made up of numerous micro-industries that support and supply it. At the heart of everything is the fashion shoot, without which the new ranges wouldn't be seen and wouldn't be bought. Clothes need to be photographed, photographers need an assistant, shoots need

Visual records (below)
As well as showing off new clothing ranges and attractive models in a creative and captivating way, fashion photography is fundamental to recording the changes in fashion throughout the decades.

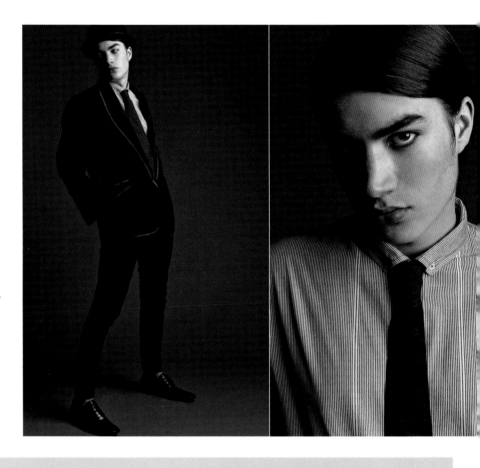

22 **Project:** Shoot on location

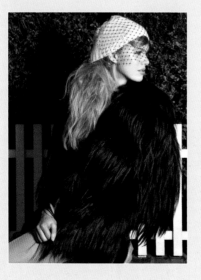

Find an interesting location and arrange a simple fashion shoot with borrowed clothes, friends, and helpers to deal with all the classic areas, including hair styling and make-up.

Take full-length photos (far left)
For full-length fashion shots of models, pick interesting and colorful locations that match the clothes and fashion you're photographing. Experiment with natural sunlight and using reflectors to bounce light back on to your models.

Try tighter compositions (left)
For tighter shots that fill the frame, you only need to see a suggestion of a background or location. Experiment with using your on-camera flash or a budget set of studio lights to capture crisp images that clearly display the clothes and accessories.

models, and models need make-up, hair styling, and accessories. In each of these sectors, there are thousands of people trying to climb the ladder toward their goal and for this reason, the seemingly cut-throat business is surprisingly generous in helping the aspiring.

Model agencies, and agencies that represent make-up artists and stylists, all have young people on their books who need the experience of working on shoots and who, far more importantly, need photographs that show what they do. As a young photographer starting out, you must try to learn as much as you can by assisting other photographers while building a portfolio of your own work. Without commissions, your own work will require you to find models, make-up, and clothes. Providing you are able to return the favor with good photographs, it is quite possible to get all the help you require, free of charge.

Extend your portfolio (right)
Art colleges usually have a fashion department. Offer to shoot a fellow student's end of term collection.

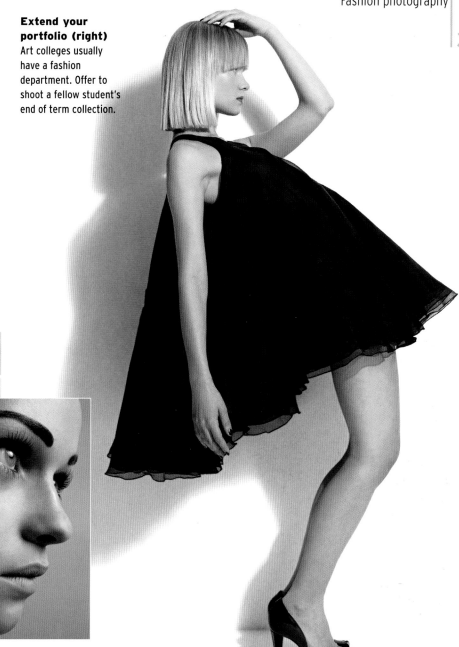

23 Project: Set up a professional shoot

Contact a model agency and a make-up artist agency to see if they have any people who would like to work with you on a shoot for some free pictures for their portfolios. Contact some young designers to borrow some clothes for a shoot.

Work for free
Many aspiring models will be glad to be photographed to bolster their portfolio—and yours too.

24 Project: Create fashion magazine mock-ups

Using the layout of any well-known fashion magazine, produce a mock-up of the magazine using your own photographs and see where the strengths and weaknesses lie. Show this to others to get an honest feedback.

Fashion magazines
Learn from fashion magazines and their editorial photoshoots. Try and take fashion photos that will work together collectively and which will work well on pages with headlines and text running around them.

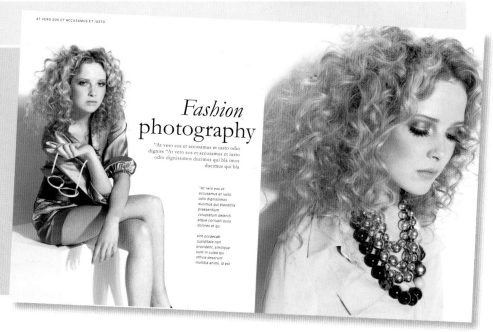

Fashion
photography

Still life nd product

For centuries, artists have depicted still life scenes in paintings and, later, in photography. Photographing still life subjects is one of the best ways to improve your photographic skills. The main advantages are that you are free to take your time, you have control over the arrangement of your subject(s), and once arranged, they stay still!

Still life photography is the depiction of inanimate subject matter, most typically a small grouping of objects that are either human-made or natural. In art, still life photographers search for meaning, symbol, and metaphor in their compositions. In commerce, they try to present objects in as alluring and attractive a manner as possible to facilitate sales.

Every day we are bombarded with still life images of appetizing foods, shiny housewares, and other appealing products in magazine ads, brochures, and catalogs. Professionals spend a great deal of time setting up these shots and you can learn a lot just by studying the photos you find most appealing and unique. Notice how photographers use repeating shapes and lines to create patterns and use complementary colors. Study the lighting that they use. One of the best things you can do before you shoot still lifes is to collect images that inspire you.

Keep it simple

Simplicity is very important when composing still lifes. You don't need to collect a wide range of complicated objects to create an interesting picture. Instead, choose a few objects with a common thread. The arrangement of a still life should begin with the positioning of a single dominant subject. Then add other objects one at a time, and examine the arrangement through your camera's viewfinder. Experiment with your camera angle until the scene shows the elements in the most pleasing balance. Photograph the original grouping, and then rearrange or remove objects to see if it improves the composition. Good composition, framing, and lighting are all

Still-life home studio (above)
Setting up your own home studio for photographing still life is simple. Use a light tent to create a soft, even light and then put your camera on a tripod and use the light to capture faithful representations of objects on a white background with shadow-less results.

(25) Project: Mimic the masters of the genre

Still life photography is not just about imitating past masters of painting or selling products—it is as valid and vibrant a form of self expression as any other form of photography. Look carefully at the work of Edward Weston in the 1930s—in particular his astonishing study of a pepper—for confirmation of the genre's potential for artistry. Take photographs of your own in a similar style, showing a fruit or vegetable, or a cross-section of either, in black and white.

Down to the details
On a 35mm SLR with a 50mm standard lens, use the highest f-stop (f22 or f32). Because of the aperture, you may need a long exposure, so have a tripod ready.

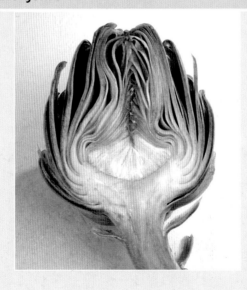

Jewelry photography (below)
Precious metals, in particular, are often judged by their color, so make sure you check the final photo against the actual subject.

Food, glorious food (left)
Food can make a great subject to photograph.
Use natural light with a reflector, plus a tripod for
shake-free shots. And once you're finished you can
eat your still-life subjects. Bonus!

26 **Project:**
Traditional still life

Using a great painting by an old master
as a reference source, arrange a table
of fruit and food taking great care with
every element of the process. Carefully
choose the table covering, the backdrop,
the arrangement of the produce, and the
lighting. Experiment with different lighting,
use window lighting as part of a multiple
light source shoot. Use
reflector boards. Try to
create the feeling of a
Biblical-style table of food.

Careful composition
Before you arrange your
table of produce, set up your
camera on a tripod and aim it
at the key area. As you arrange
your still life, regularly look
through the viewfinder to see if
it is working photographically.

very important to translate your still life into a
great photo.

Still life photography is a demanding art, one
in which the photographers are expected to be
able to form their work with a refined sense of
lighting, coupled with compositional skills. The
still life photographer makes pictures rather than
takes them. Knowing where to look for props and
surfaces also is a required skill.

Accuracy and product photography

Accuracy takes on a whole new meaning for the
still life photographer. Color, shape, brilliance,
and quality of workmanship might all be
elements contained in the original object that
must be reflected in almost scientific detail.
Consider, for example, the responsibility that a
photographer has when shooting objets d'art for
the catalog of a major auction house. In such a
case, faithful representation is essential to the
process of an honest auction. In advertising,
too, the need for accuracy is important. The
skills needed to photograph jewelry demand
understanding of light and color temperature,
in order to obtain an accurate representation
of a luxury item that your photography will
encourage someone to take a closer look at
and possibly buy.

27 **Project:** Create a low-budget still life

A cheaper way to recreate big-budget photo shoots is to use toy
figures. Set up a realistic scenario with toy figures and buildings
and take a series of shots that explore the ambiguity of scale. Try
to make the situation look as real as possible.

Larger than life
Get down to the toys' level and treat the shot as if they were actual
people, applying the same composition and shallow depth-of-field
techniques as you would in real-life situations.

Wildlife photography

Wildlife photography is a specialist field populated by photographers of dedication and inventiveness. To create work of excellence, you must demonstrate exceptional understanding of your subject, its behavior patterns, and the time of day when there is likely to be photogenic activity.

You must also choose where to position yourself so as not to be visible by your subject while being close enough to capture something amazing. It is not unheard of for photographers to spend months hidden in the undergrowth of their chosen wilderness location, as they wait for the appearance of a rare animal or insect.

Animals on the move

Decide what styles of photograph you want to take beforehand, in order to determine your technique and settings. Artistic blurred-motion pictures require one approach; pin-sharp action shots, another. In a high-action situation with non-human subjects, it's easy to regret not being fully prepared.

You'll need plenty of light or a fast, light-gathering lens to allow the camera's autofocus system to cope with the speed of your subject and the rapidly shifting focal plane. All of the top of the line SLRs have a continuous auto-focus mode, which you should make sure you have enabled.

Make sure you know how many shots your camera can take at a time before it buffers. Although it's good to start tracking the subject early, don't fire off all your available shots and then have to watch it run by as your camera buffers at the perfect moment.

Don't be tempted to open your aperture right up. Fast-moving subjects, such as horses, can move in and out of the focus plane easily, and

closing down the aperture value to between 6 and 8 will give you room for error as the subject moves closer or further away or as the camera battles to keep up with the shifting pace.

Finally, make sure your shutter speed is sufficient to freeze the motion, and carry spare flash cards for when you run out of memory.

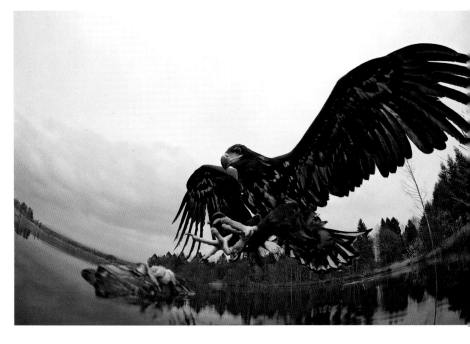

Eagle eyes (above)
Birds of prey can make for excellent and thrilling subjects to photograph (shot here with a fish-eye lens), especially when in flight or attack. Arrange a visit to an eagle or owl sanctuary as you'll stand a far better chance of getting close enough to fill your frame.

28 **Project:** Photograph domestic wildlife

By definition, wildlife exists almost everywhere, and while we would all like a trip to the Serengeti to shoot African animals, there is no better place to start developing your understanding and portfolio of wildlife photography than in your own backyard. With careful planning and studying of behavior patterns combined with a willingness to lift a few rocks and get your hands dirty, it is possible to shoot beautiful photographs of anything from bees gathering pollen, spiders weaving their webs, and birds feeding, to cats stalking their prey.

Domestic bliss
This shot was taken with a telephoto lens, which was precomposed with a clean, dark background to make the bird really stand out.

29 **Project:** Photograph wildlife at your nearest zoo or safari park

If it's big game you want, the best place to go is a wildlife reserve or zoo. Many modern zoos have taken steps to recreate the natural habitat of their residents and therefore make excellent settings for realistic photography of exotic animals. Light, vantage point, timing, and "moment" are as important as ever but you will have the added complication of trying to hide any signs of the man-made structures that are part of the zoo environment.

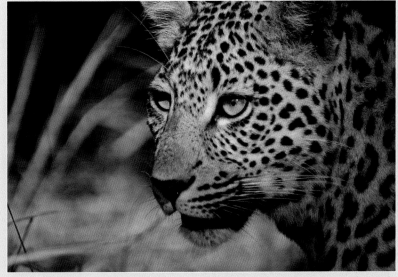

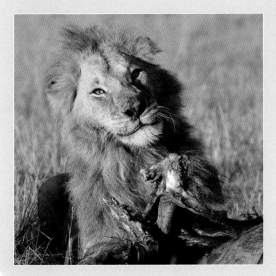

King of the Savannah (left)
Professional wildlife photographers may go on safari to Africa to capture exotic animals in their natural habitats, but you can get excellent shots of red-blooded, meat-eating wildlife at your local zoo or safari park.

Head hunter (above)
Use a long telephoto zoom lens and concentrate on capturing head shots that show the beauty and power of big cats as their captivating eyes focus on their prey—whether that's a gazelle in the wild or fresh steak in the safari park.

Rules of engagement

- Above all, consider both your own safety and that of the wildlife you are photographing. Keep a safe distance from your subjects and respect their natural spatial needs. If the animal interrupts its behavior, while resting or feeding, for example, then you are too close and should pull back.
- Never force a situation. As with all photography, patience is usually rewarded.
- Never crowd, pursue, trap, or make deliberate noises to distract, startle, or harass wildlife.
- Never feed or leave food (bait) for wildlife.
- Never encroach on nests or dens as certain species will abandon their young if their habitat has been tampered with.
- Never interfere with animals engaged in breeding, nesting, or caring for young.
- Learn to recognize wildlife alarm signals, and never forget that these animals are not tame, no matter how docile or cuddly they appear.
- Acquaint yourself with and respect the behaviors and ecosystems of the wildlife you may encounter. By doing so, you will enrich your experience tremendously.

30 **Project:** Small is beautiful!

Spend a couple of hours watching an army of ants going to and from a distant source of food and it becomes clear that the natural world is as fascinating under a macro lens as it is though a big telephoto. There are mini-ecosystems in gardens, hedges, and even pot plants—try to capture a moment (see page 98) in the life of an insect.

Mastering macro
Use a 100mm or 180mm macro lens to get up close and personal with plant and insect life. The lens will magnify your subjects as well as creating a very shallow depth of field to blur anything behind your subjects—both of which will help to increase your chances of successful shots.

36 Landscape photography

With such a rich fine-art landscape painting tradition preceding the birth of photography, it is perhaps fortuitous that the initial era of photographic landscape work could only take place in black and white.

A combination of the unique status that photography enjoyed as an objective, evidential art form and the urge for early photographers to travel the world in search of images of natural wonders that few ordinary people would ever see, resulted in a strong and lasting presence of the landscape genre within the history of photography.

Fine art and landscape photography

Many of the established fine-art traditions have been applied to their photographic counterpart and the genre remains in good health both within the photographic fine-art world of galleries and print collecting as well as in the commercial sector where great landscape photography often presents the backdrop to advertising campaigns. Take a look at advertising campaigns for top end 4 x 4 cars, for example, or the use of landscape photography to imply the joy of riding your motorbike down one of the classic never-ending American desert highways.

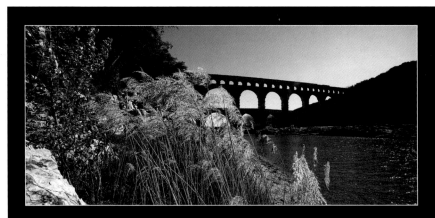

Foreground detail

Landscape pictures that incorporate a strategically positioned element of foreground detail make for more interesting and dynamic compositions. Although the foreground is important, it should only serve to create a composition with greater depth and not detract from the main focal point.

Controlling the viewer

By composing your landscape photos so there are elements of foreground detail, it leads the viewer onto the main focal point.

31 Project: Practice field photography

Get your walking boots on and prepare for a hike. You are not going to find great unseen natural beauty from the roadside! If possible, take a small tent with you and some basic survival provisions so that you can go some distance, take your time, and, once you have found the spot that you feel really works, wait for the light to be at its very best.

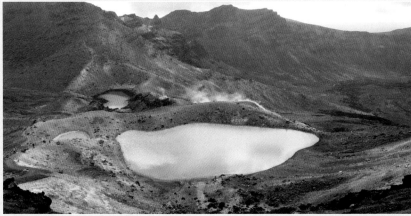

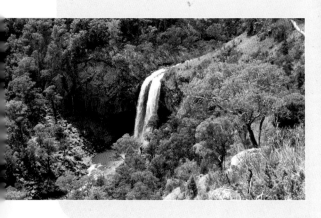

Chasing waterfalls (left)

Look for spots of natural beauty, and don't be afraid to use a telephoto zoom lens to focus on key areas of interest rather than trying to squeeze an entire landscape in with your wide-angle lens.

Move any mountain (above)

Be prepared to hike up high to get the best mountain landscape shots. Mountain ranges are ideal locations for brilliant, expansive landscape images, as this shot of the Tongariro Crossing in New Zealand shows.

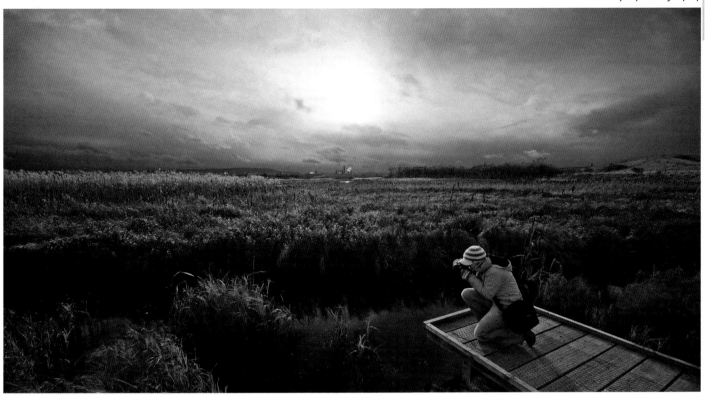

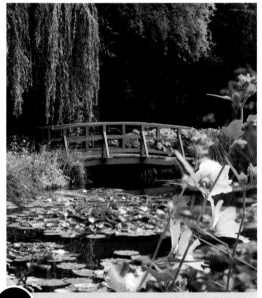

32 **Project:** Visit well-known scenes depicted in art

Try exploring some of the locations popularized by the great landscape painters of the past. Many of the scenes we know well from artists such as Constable, Turner, Monet, Cole, or Van Gogh can be visited today.

Monet's garden
Monet's Japan-inspired garden in Giverny, France, where his famous Waterlilies series was painted.

Color and light (above)
Look out for landscapes with rich colors, such as grassy reeds in lakes or swamps, and try and be on site to photograph the scenes either at sunrise or sunset so the light is warmer and softer, and the shadows are longer. The wooden platform adds a greater sense of depth to this powerful landscape.

33 **Project:** Photograph landscapes in black and white

Look at the work of the great American black-and-white landscape photographers who formed the f64 group. People like Ansel Adams, Edward Weston, and Imogen Cunningham established a style and attention to technical detail that has informed all subsequent generations of landscape practitioner. Try to emulate their style in a photograph of your own. Try using a red filter to darken the blue sky (see page 71).

Big landscapes (below)
Photograph your landscapes in color to capture a broader range of tones, then convert them to black and white in Photoshop afterward.

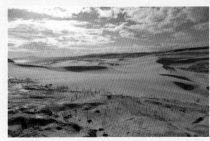

Mono masterpieces (above)
Try and imitate legendary American black-and-white landscape photographers like Ansel Adams by capturing scenes with a mixture of highlights and shadows for a high-contrast mono image.

News and events

The spectrum of subjects contained within the broad definition of "news" is almost endless. News photographers need to be quick-witted, adaptable, and physically quite strong, so that they can carry enough equipment to deal with changing situations as they unfold. Photographers who deal in news pride themselves in knowing exactly what is happening around the world at any given time.

Newsworthy stories (below) Stay on the ball with what's going on by reading web sites and newspapers for events in your area. Events can be sporting, theatrical, political, or involve celebrity visits.

News photographers monitor every conceivable news service, keep their eye on political tensions that have the potential to escalate, and try to be ready to be the first journalists on the spot when a story breaks. The notion of a "scoop" is as valid today as it was when Evelyn Waugh's novel of the same name was published in 1938.

The scramble for the scoop

There is often huge competition with other photographers to get the best picture from the same event and great emphasis given to the speed with which you can get a picture from the "front line" to the picture desk. If you are working as a freelance, you have to be able to decide on the most newsworthy story to pursue, judging it both on its relevance, its photographic potential, and exclusivity value. Being in the right place at the right time is sometimes a matter of chance but—and this is substantiated by the regularity with which certain photographers keep on winning awards for their work—there is a great deal you can do to improve your chances.

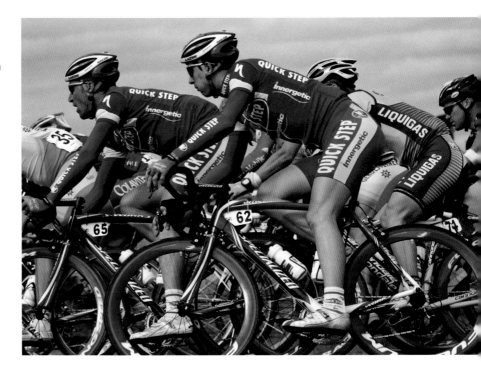

34 Project: Shoot a protest or demonstration

Try to cover a protest or demonstration from the perspective of the protesters, then from the perspective of the police. Look for a single picture that sums up the whole story as well as a sequence of pictures that work as a set.

Police (left) and protesters (right)
Get as close as possible to demonstrations to try and capture—as shown here—the emotion and energy of the protesters juxtaposed with the calm authority of the police.

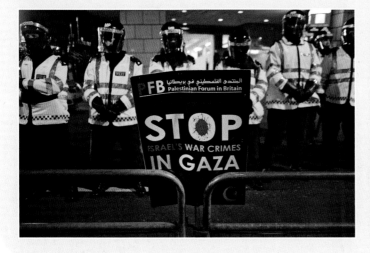

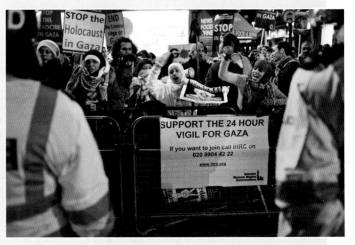

Good sport (right)
You don't need to be a professional sports photographer with a press pass to the Olympics to get great shots. Check out your local sports center—you'll be able to get closer for shots with more intimacy and impact too.

Remember, great photography has the capacity to render the mundane exciting. In learning about how to operate in the news arena, it is not necessary to travel the world in search of danger and hardship. Done well, local, national, and international news events all have the potential to provide you with opportunities to create fantastic photographs.

Ethics in news: honesty, show the situation from both sides, and no manipulation of events or, later, of your images in Photoshop.

35 Project: Look out for events and festivals

Unusual rural crafts and arts festivals, and rare religious events or processions make good subjects. If a festival is coming up, shoot someone preparing a costume. The day before the local soccer season starts, take a picture of the players on the training field. If the 150th anniversary of some important event in national history is coming up, make a picture that can be run on the anniversary.

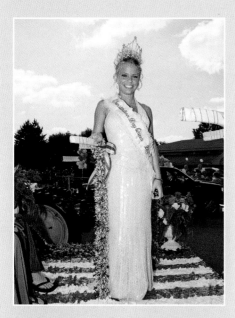

Carnival queen
Learn to focus on and photograph the salient points of an event. Make it your mission to try and get one photo that sums up the whole day.

36 Project: Photograph a local sporting event

Research a local sporting event and find a good vantage point to capture the moment of victory—crossing the line or landing the winning blow—a pure photographic delight that captures the essence of the sport and the ceremony. Remember that defeat can be as emotive as victory and it is always worth looking at the emotions and pain of coming second or even last. Don't forget about the spectators.

Portrait photography

Every photographer needs to master some basic techniques to create a portrait that will hold the attention of the viewer. A few simple tricks can transform the usual straight-on "mug shot" into something more profound, that offers an insight into the character of the subject.

 Project: Try different lighting setups

Explore the way in which different lighting setups can change the mood and story of a photograph. The 45/45 is a classic lighting model in portraiture: the light source is at a 45-degree angle to the subject and 45 degrees above them. Try adding a second light source on the opposite side to fill in the shadows (2), then add a light pointing at the backdrop (3), with an optional reflector to reflect light onto the subject's face.

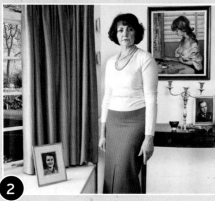

1. Subject at 45-degree angle from the window.

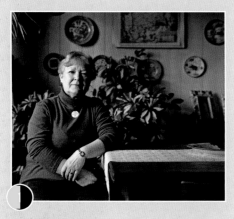

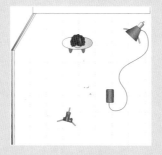

2. Window light with softbox flash unit balancing the light so that the room looks evenly lit.

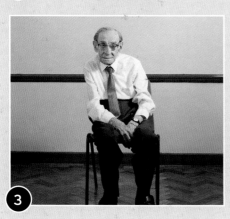

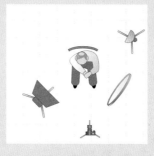

3. One light for the backdrop or, in the case of this illustration, the wall, and one for the subject.

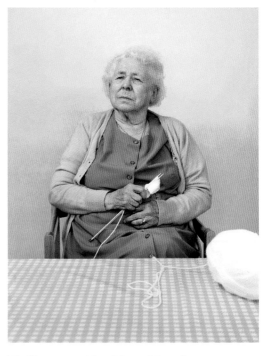

Finding a good backdrop (above)
When shooting on location, look for existing features that make for a good backdrop, as in this picture, which is part of a portrait series in a center for pensioners.

One of the biggest challenges in portraiture is dealing with the directorial responsibility you have as the photographer. This role is counterintuitive to most photography, where, in general, we look, wait, monitor the situation, then strike. In portraiture you are often dealing with a subject who is not comfortable with the situation and may not be used to being photographed or, for that matter, being told what to do. Portraiture is as much about management as it is about photography. If you cannot get your subject to do what you want, you will end up with a photograph that is more about chance than design.

The work of the great portrait photographers is often instantly recognizable as their own, and establishing your style, or range of styles, is helpful to you on a number of levels. First, it is important to know roughly what you are going to do when you walk through the door for the first time to meet your subject. Confidence is important and a good rapport essential, if you are going to be able to convince your subject to perform for you. Second, establishing a routine helps in the development of your style and, ultimately, your identity with the people who will commission you.

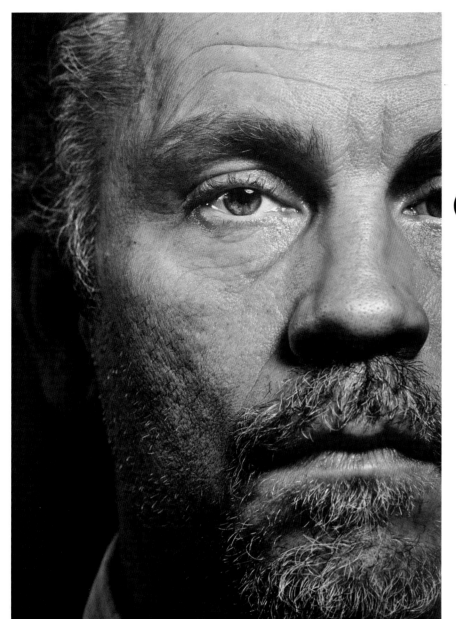

All about face (left)

For many portrait photographers and artists, the most exciting, revealing, and rewarding area to concentrate on is the human face. Lighting, lens choice, and an ability to sensitively manage your subject in such a way as to be able to make a close-up study of their face, is the secret to creating photographs as powerful and haunting as Alastair Thain's portrait of John Malckovich.

38 Project: Reflecting light

Experiment with reflector boards—you will be amazed how much you can do by reflecting light from the main source back or "up" to your subject.

Natural light
This portrait was taken without the use of reflector boards. Note the shadow on the left side of the subject's face.

Reflector boards
Reflector boards were used in this version. Note the subject's even skin tone and the difference in mood.

39 Project: Using natural light in portraiture

When shooting portraits in natural light, avoid having the subject looking directly at the light source, as they often squint and close their eyes, which is very unflattering. It's better to have the light over their shoulder or to the side. Shooting away from the light source often allows the colors to become more saturated, so try to make use of elements within your environment to create a strong background (see left).

Using natural light

Remember, all artificial light sources are effectively trying to imitate nature. Before you think about introducing artificial lighting to a portrait situation, explore the possibilities of natural light.

There are numerous collapsible reflector systems available that can be carried in a camera bag for quick and easy use when required. These offer a range of different reflecting surfaces ranging from white, which gives a good natural feel; gold, which is great for warm healthy skin tones; and silver, which emphasizes highlights.

Making the ordinary extraordinary

A straight-on shot with the subject's shoulders parallel to the camera often makes a flat, dull image. Conversely, it can be very powerful if used well, as its direct style can be very confrontational and powerful.

Generally, however, it is better to get the sitter to turn one shoulder so that they are at an angle to the camera. Try this both ways. Getting the subject to sit down often makes them more comfortable; folding their arms or putting one hand up to their chin or mouth can help too. If you place yourself slightly above the subject, it will tend to make double chins and fat faces look less overweight and can be more flattering. Going lower than the subject is to be avoided unless you want them to look threatening and sinister, as it tends to make them look too dominating.

Look for interesting light to make your picture. Window light can be incredibly successful in portraiture, and should undoubtedly be the starting point for your experimentation and learning. Window light tends to "fall off" quite rapidly, allowing the photographer to have a gradation of light on the face and a background that falls away into darkness.

Make use of your environment and keep your eyes open for location opportunities that will help you to get a photograph with a difference. There is nothing worse that trying to take an interesting picture of, say, a company executive,

Body positions (right)

Don't simply photograph somebody on a chair sitting facing you. It'll create a much more involving portrait if you ask your subject to sit sideways then look over one shoulder, perhaps with one hand on their head or chin. Getting them to perch on the arm of the chair will create more interesting body shapes too.

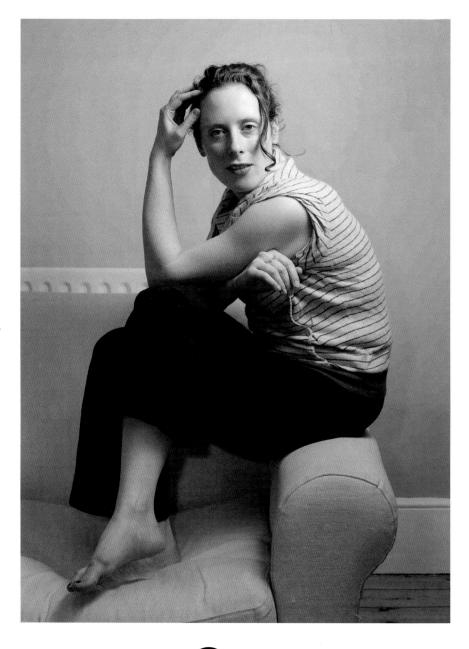

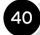 **40** **Project:** Create an interesting self-portrait

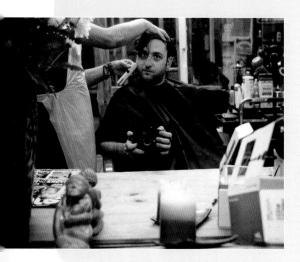

Trying to shoot a picture of yourself is extremely testing and one of the classic first tasks that photography students are asked to do at college, and for good reason. Good luck!

Man in the mirror

Be creative in your approach—taking a picture of your reflection in the mirror is a good technique to try. The trick is to position your camera so the shot's not obviously a self-portrait.

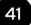 **41** **Project:** Set up a portable studio

Set up a portable studio, with a backdrop, camera mounted on a tripod, and a long cable release, in a familiar place—maybe your school—where a lot of people are passing by. Invite people to take a picture of themselves with your help. They are in control of pushing the button and you are there to help them get the kind of picture they want by changing the lighting, exposure, focus, and the choice of lens.

sitting in her office behind a desk. (We don't need another "CEO on the phone" picture, do we?) Try to arrive early at the location where you will be working, and take a look around to see if there are any interestingly colored walls, graphic corners, or balcony areas that might offer a more dynamic setting to shoot in.

Don't say cheese!

The human smile is a beautiful thing but to the portrait photographer, a person's temptation to smile when a camera is directed at them can prove troublesome. It is generally very important to try and get some versions of your chosen situation where the subject is not expressing a facial emotion. Often the easiest way to achieve this, particularly with children, is to first have the "fun" pictures then to ask for them to try to express no emotion at all for the final part of the shoot.

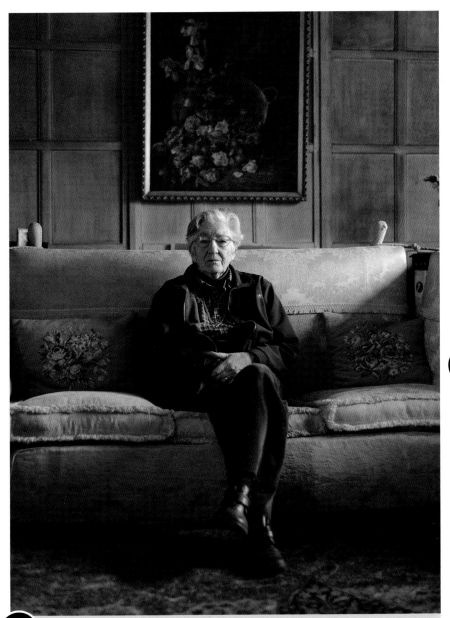

43 Project: Shoot an informal series of portraits

Take a person you know out for the day to one of their favorite places—somewhere where they feel comfortable and happy. Bring a couple of additional pieces of clothing so that they can make minor changes to the way that they look, and try to shoot an informal series of portraits of your friend during the day that will form a small portfolio of images.

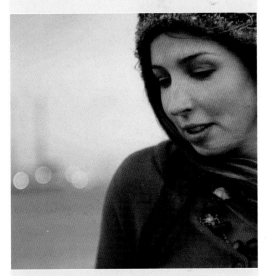

Colorful clothing
Brightly colored clothing or hats can give your portraits a boost by helping to lift your subjects out of their surroundings, as well as providing a contrast to their skin tones.

42 Project: Photograph a family member

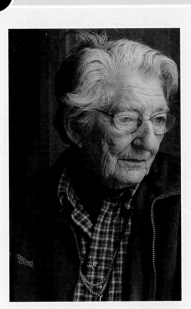

Photograph a family member, concentrating on a full-length shot and a head shot. Make sure you explain to them exactly what you want and then direct them firmly but with humor. It is important that they understand what you want them to do and that they are able to visualize your idea too. Your self-assignment is to get two strong pictures from both situations that do not show the person smiling.

No smiling please
Although you may instinctively want to take photos of your family members smiling, your portraits will appear more intriguing if your subjects are looking thoughtful instead.

The photo essay

The photo essay sits as the cornerstone to photojournalism and has a direct link to the print media and magazines in particular. Once you start to think in terms of larger features, stories, and projects, you have to begin grouping pictures together and considering their interrelationship and narrative structure. This is essentially what photojournalism is all about.

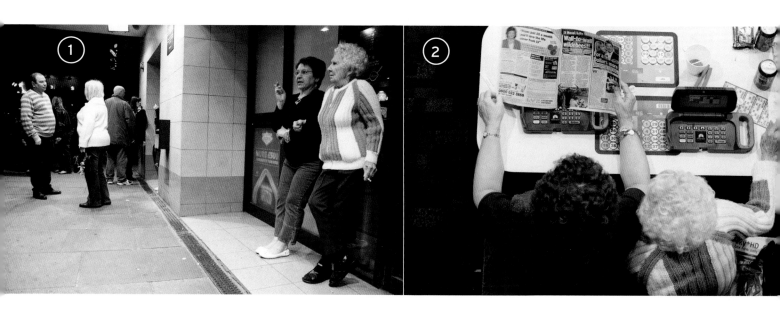

For a large part of a century, particularly after the invention of the 35mm camera in the 1920s, magazines across the world discovered new audiences, hungry for news of world events. Current affairs were delivered to them almost as a kind of evidence, through the photo essay. With a world at war with itself, such publications as *Life* magazine in the United States and *Picture Post* in the United Kingdom started to publish extended bodies of work by the new photojournalists.

Constructing a photo essay

When put together as a "story" your individual pictures become greater than the sum of their parts. Although you should continue to work on creating strong individual images, it is important that these pictures complement each other and collectively create a sense of narrative in the final product.

Your pictures have to tell the story in visual terms, which means that you have to understand what the story is, what the important constituent elements of this story are, what makes it interesting to a third party, and also what you are trying to say.

Set the scene

If you are working on a story about the crew of a fishing trawler, for example, you want to capture the sense of build-up to a long journey, first showing the boat in the harbor to give the

45 Project: Shoot a photo essay

Set yourself a mini-assignment on a subject that you feel will allow you to tell a story. Don't worry too much about finding something newsworthy at this stage, just concentrate on a situation that is photogenic and has a enough different elements to build a story. You might want to photograph the activities of something very simple like the local dog's home, concentrating on the staff, the arrival of new dogs, the medical side of things, the emotional highs and lows, a happy family collecting a new pet, feeding time, and closure at the end of the day.

Storyteller

When shooting a photo essay, avoid photos with your subjects posing or looking to the camera, since they will just look like bog-standard snaps. Instead aim to make yourself "invisible" and shoot your subjects in their natural roles.

Project: Research photo essays

Spend time in a library looking through back issues of magazines that traditionally run photo essays, such as the *New York Times*, *Time*, *LIFE*, *Sunday Times Magazine*, *Paris Match*, *Picture Post*, and *National Geographic*. Study the use of photography, the caption information, and the narrative structure. If a picture from the story was used on the front cover of the magazine, assess what its strengths are to have won the battle for the prime space in any magazine. Make notes on your research and apply the principles to your next project.

Gimme five! (below)

1. Start off with wide-angle shots setting the scene.
2. Look for interesting angles of view; try getting up high or low down.
3. Don't be afraid to zoom in for tighter shots of key moments that help tell the story.
4. Take photos that capture your subjects immersed in their activities.
5. Don't forget to get a "winning shot" if you're photographing a competitive event.

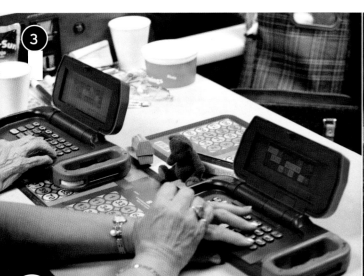

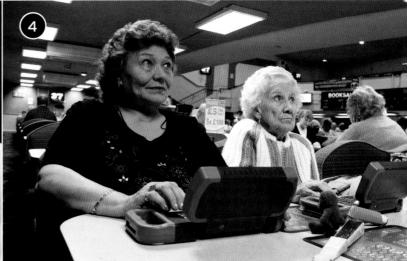

Project: Edit your photo essay

After making a basic edit of all the good material, select a series of five pictures that tell the complete story. The complexities of editing are covered on pages 112–115 but for now, make the five picture selection and assess as critically as possible whether you have succeeded in telling the story. Without any text or explanation, show the work to others to get their feedback on the photographs and on what they believe the story to be.

Evaluating your own work can be the hardest of tasks. You were "there," your experience was multisensory and real, and your job as a photographer is to create something that conveys some of the emotions you experienced to an audience that has not been able to engage with the subject in the same way as you. You should not necessarily allow your editing process to be led by your emotional recollections. Take a dispassionate, unemotional perspective when editing, asking yourself if the photograph works or not for someone unfamiliar with the story.

Unemotional editing

When editing your photo essay shots, try to remain unemotional and detached and only choose five photos that will tell the story, rather than choosing photos you feel are technically brilliant but don't add to the story.

story a sense of place, then the preparatory work, bringing the supplies aboard, checking the rigging, as well as human moments when crew members meet again after time spent ashore with their families.

Introduce the subjects

You would also need to identify the members of the team, from the captain to the first-time sailor. In lending depth to the characters, you might take a look at their living quarters, showing the family snapshots pinned to the woodwork of the bunk and other mementoes from home, giving the viewer some insight into the emotional wrench that each trip represents for sailor and family alike. With the stage now set for the voyage, you should take a look at the process of coexistence, the camaraderie, the meals together, and the boredom of waiting to get to the fishing area.

Show the action

The peak of the story will be the fishing itself— man against nature—as all hands are on deck bringing in the catch, processing the fish, and

hopefully, filling the hold with enough good fish to make some money on their return. This is a time of extreme physical strain, fraying of nerves, and high tension, as the catch could make the difference between a successful trip or a failure.

The resolution

With the catch on board, the emotional climate changes from tension to euphoria and the anticipation of getting home, seeing the family, and hitting the bars. You might take some pictures of a crew member asleep after his ordeal, then the first sight of land before another period of activity as the fish is unloaded, money changes hands, and returning fishermen are greeted by friends and loved ones, ending with the captain, bag over his shoulder, walking down the harbor into the sunset! Beginning, middle, and end, the narrative form at its simplest.

47 Project: Write a synopsis of your next photo essay

Photo Essay Pitch
Kushti—The Art of Indo-Pakistani Wrestling

Magazine: *National Geographic*
Time frame: Two days to shoot on location in Lahore, Pakistan

The aim of this photo essay is to examine the relationships that exist between a group of Pakistani wrestlers. The photos will capture the close-knit kinship that exists between them—this closeness will be contrasted with action shots from actual fights. The photographs will also highlight the environment in which the men live and fight. The wrestlers also provide perfect subject matter for a study of the human form.

- A group shot of the wrestlers will demonstrate the brotherly relationship between the men.
- A selection of photographs from fights will bring a sense of action and danger to the work.
- Shots of the men eating and washing will visually help to explore the environment in which they work, while emphasizing their physiques.
- The cover shot will be an iconic photograph of two wrestlers washing and relaxing post fight.

Location budget:	
Cost	Details
£500	Flight to Lahore
£10	Taxi travel in Lahore
£20	Accommodation

Repeat the process in Project 45, researching a story that you feel is worthwhile and photogenic. This time, write a short synopsis about your idea taking up no more than one page. In the magazine world, the story synopsis is often the starting point for a photographer looking to get financial support to shoot his idea. It should set out what the story is, why it is worthwhile—perhaps specifically to an individual magazine's readership—how you plan to shoot it, how much it would cost, and how long it would take. Since the story synopsis doubles as a sales device, there is no point whatsoever in promising what cannot be delivered.

Pitch perfect

When writing your synopsis, treat it as a sales device for pitching your planned photo essay to a targeted publication. Be sure to provide hard facts and evidence as to why your photo story is perfect for your chosen magazine's readership.

48 Project: Shoot your new photo essay

Shoot your new story, thinking carefully about magazine layout. Approach the story with a specific magazine in mind, both in terms of the subject matter and in the way it uses photography. Try to shoot a picture that is suitable for a front cover (see right), remembering the most obvious basic requirement for a cover, that the frame is vertical and, importantly, allows the magazine logo and typography to coexist with the photograph. Be ruthless with your editing, selecting only the best image from groups on the same situation, until you have the best edit you can make over 12 pictures. Write captions for each picture.

The resulting set of 12 captioned pictures with a story outline is a good approximation of the "packages" that criss-cross the world from agents/agencies and photographers to the editorial marketplace many thousands of times each day.

Design sensibility (below)

When shooting a story for a specific magazine, you'll need to think like the art editor. Provide a good mixture of images that fit the magazine's editorial tone and photographic style. Take a series of varied shots, with wide and tight, vertical and horizontal compositions, and make sure the edited shots you supply will work well collectively on the page, as in the dummy layout below.

Cover star (right)

Don't forget to take shots that will work well on the magazine's cover. Ignore traditional compositional techniques as you'll need to leave space at the top of your frame for the magazine logo and around your subject(s) for headlines and text. Provide several vertical shots of the same scene with different poses and facial expressions, such as shots with subjects looking to camera and others with no eye contact, to give the art editor a choice.

AT VERO EOS ET ACCUSAMUS ET IUSTO

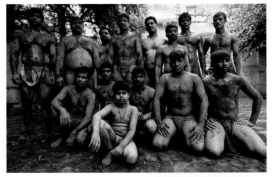

"At vero eos et accusamus et iusto odio dignissimos ducimus qui blanditiis praesentium voluptatum deleniti atque corrupti quos dolores et quas molestias excepturi sint occaecati cupiditate non provident, similique

sunt in culpa qui officia deserunt mollitia animi, id est laborum et dolorum fuga. Et harum quidem rerum facilis est et expedita distinctio. Nam libero tempore, cum soluta nobis est eligendi

"At vero eos et accusamus et iusto odio dignissimos ducimus qui blanditiis praesentium voluptatum deleniti atque corrupti quos dolores et quas molestias excepturi sint occaecati cupiditate non provident, similique sunt in culpa qui officia deserunt mollitia animi, id est laborum et dolorum fuga. Et harum quidem rerum facilis est et expedita distinctio. Nam libero tempore, cum soluta nobis est eligendi optio cumque nihil impedit quo minus id quod maxime placeat facere possimus, omnis voluptas assumenda est, omnis dolor repellendus. Temporibus autem quibusdam et aut officiis debitis aut rerum necessitatibus saepe eveniet ut et voluptates repudiandae sint et molestiae non recusandae. Itaque earum rerum hic tenetur a sapiente delectus, ut aut reiciendis voluptatibus maiores alias consequatur aut perferendis doloribus asperiores repellat."

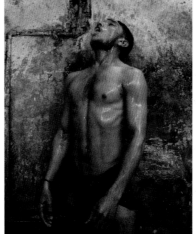

"At vero eos et accusamus et iusto odio dignissimos ducimus qui blanditiis praesentium voluptatum deleniti atque corrupti quos dolores et quas molestias excepturi sint occaecati cupiditate non provident, delectus, ut aut reiciendis voluptatibus maiores alias consequatur aut perferendis doloribus asperiores

officia deserunt mollitia animi, id est laborum et dolorum fuga. Et harum quidem rerum facilis est et expedita distinctio. Nam libero tempore, cum soluta nobis est eligendi optio cumque nihil impedit quo minus id quod maxime placeat facere possimus, omnis voluptas assumenda est, omnis dolor repellendus. Temporibus autem quibusdam et aut officiis debitis aut rerum necessitatibus saepe eveniet ut et voluptates repudiandae sint et molestiae non recusandae. Itaque earum rerum hic tenetur a sapiente

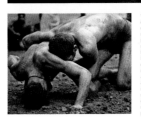

"At vero eos et accusamus et iusto odio dignissimos ducimus qui blanditiis praesentium voluptatum deleniti atque corrupti quos dolores et quas molestias excepturi sint occaecati cupiditate non provident, similique sunt in culpa qui officia deserunt mollitia animi, id est laborum et dolorum fuga. Et harum quidem rerum facilis est et expedita distinctio. Nam libero tempore, cum soluta nobis est eligendi optio cumque nihil impedit quo minus id quod maxime placeat facere possimus, omnis voluptas assumenda est, omnis dolor repellendus. Temporibus autem quibusdam et aut officiis debitis aut rerum necessitatibus saepe eveniet ut et voluptates repudiandae sint et molestiae non recusandae. Itaque earum rerum hic tenetur a sapiente delectus, ut aut reiciendis voluptatibus maiores alias consequatur aut perferendis doloribus asperiores repellat."

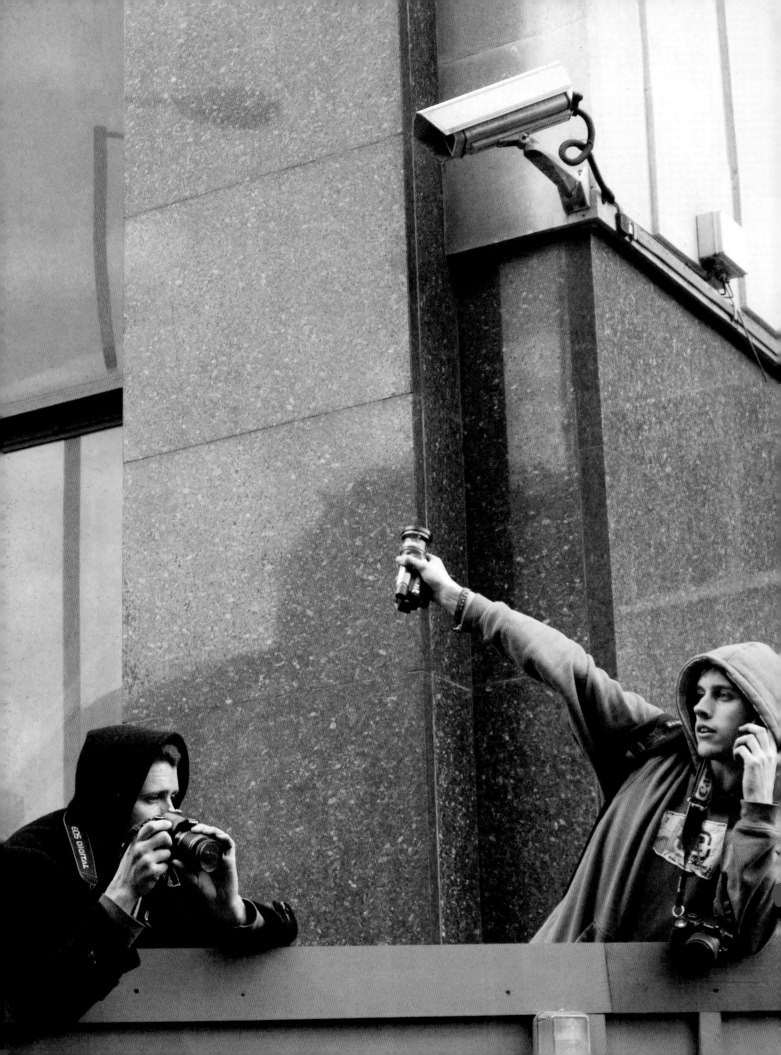

Equipment, methods, and techniques

As anyone who has spent time in one of the leading professional photography shops will confirm, you can spend a huge amount of money on camera equipment.

It is worth remembering that photography is also one of the most popular hobbies on the planet and the industry that has evolved to supply the massive demand is as interested, if not more so, in selling to the kit-obsessed amateur as it is in supplying you with the equipment you need to carry out your practice.

Professionals tend to establish a system that they are comfortable with, which does the job well and that does not break down. Above all, when starting to build your own system, make sure you buy the best lenses you can afford. Notwithstanding the genuine technical developments in digital cameras—which are difficult to ignore because they generally offer steps forward in critical areas such as digital file size, quality of sensor, and such advances as HD video—the bulk of the kit anyone requires should have a good life span.

Them filming you photographing me filming them...
We live in a society where the camera is ever present!
Picture taken from a protest against excessive CCTV.

Cameras and other kit

The kind of photography you are interested in will inevitably inform many of your decisions in terms of the cameras, lenses, and other pieces of kit that represent the core of your equipment.

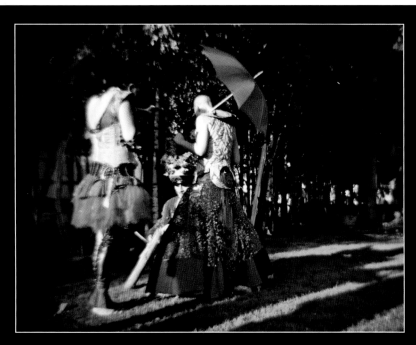

Lomography: classic plastic

"Lomography" has become the generic term for photography that uses cheap, plastic cameras. As well as the Lomo cameras, Diana, Seagull, and Holga make their own similar versions. Back in the 1960s the Diana was adored by amateur and professional alike for its unique, dreamy, "low-fi" aesthetic. Today, they have become favorites among art students, amateurs and professional photographers who want a different feel and like the quality of medium format.

Low-fi style (above)
Many professionals still like to make use of the very different but often beautiful feel these cameras achieve. Warning: don't leave them on the rear shelf of your car on a sunny day, they melt.

Cheap as chips (right)
Great fun to experiment with, the range of plastic cameras is extensive.

49 **Project:** Write a list of basic equipment

Establish a realistic and prioritized shopping list of equipment that you don't already own that would make up your own preferred basic set up. Read the descriptions of equipment in this section and prioritize according to your individual needs so that you would be in a position to shoot your own work.

It takes many years to build up the range of equipment of a seasoned professional, so don't worry if you can't afford it right away. Also, it is possible to rent nearly any kind of lens, camera, lighting system, or equipment from a number of rental companies in most international cities. It could be a better idea to establish an account with one of these organizations than to try to buy everything yourself.

Cameras

The spectrum of cameras ranges from high-end "point-and-shoot" cameras, which are made by all of the major manufacturers, right up to large-format cameras (see page 55), mainly used in advertising studio work, portraiture, and landscape photography.

The point-and-shoot systems are essentially aimed at the amateur market and generally do not operate quite as quickly, often have restrictive lens options, and sometimes do not generate files of adequate size for reproduction. At the top end of this market, there are a couple of cameras with interchangeable lenses and semi-professional specification. These are portable, unobtrusive, and highly flexible units that can be ideal for working in situations where you may not want to draw attention to yourself and prefer people to assume you are an amateur.

SLR (single-lens reflex) cameras

The choice of SLR systems is more complex than in any other sector of the market. The main professional market is dominated by two manufacturers—Canon and Nikon—who each offer exceptional camera bodies that are supported by extremely good lenses. With so little difference in quality between these manufacturers, decisions on which model to buy might be made on practical issues, such as the weight of the camera, service costs, price of the lenses, size, and design. The best systems have microprocessors and sensors with the capability of creating very large digital files and, significantly, these systems also deliver images that accurately reflect what you saw through the viewfinder.

There are still many film cameras on the market, mainly in the areas of medium format and large format. The same basic guidelines apply—choose a camera you are comfortable handling and make sure you buy the best lenses you can afford. It's better to buy one good camera body than two inferior ones.

Cleaning your sensor
Lock your mirror "up" and very gently dust off your sensor using a specially designed fine-haired brush.

Taking note of all manufacturer warnings, clean your lenses, check your camera sensor for dust (and remove gently with compressed air if required), and check all the points where there are screws. If any screws are missing, immediately obtain replacements from the manufacturer. A missing screw can result in light leakage in a camera and lead to ruined frames. Avoid directly polishing the glass of your lenses where possible, but if necessary, always use the softest possible optical cloth.

Basic setup

Cameras:

- 2 x 35mm SLR bodies with 100% sensors.

- 35mm fixed focal length lens (ideally f1.4).

- 50mm fixed focal length lens (ideally f1.4).

- 28mm fixed focal length lens (ideally f1.8).

- 2 x converter.

- 70-200 zoom lens (f2.8).

- UV filters for all lenses (for protection).

Other kit

Your budget will inevitably determine the degree to which you are able to realize your ideal equipment list. You should aim to build a basic kit that complements the kind of work you do and enables you to undertake all but the most specialist kind of commission.

Find an area of your home where your kit can safely be stored, out of the reach of children. Your storage area should not be damp or get hot. You should invest in basic maintenance tools like lens cloths, compressed air canisters for dusting those tricky areas, and individual bags for your lenses. Your kit represents the tools of your trade and should be kept fully operational, serviced at the appropriate intervals, and looked after at all times.

Flash

It's a good idea to have a decent flash unit either made by your camera manufacturer or one of the many companies specializing in flash guns for all camera systems. Make sure any flash you buy is fully compatible with your camera system and gives you all the benefits. It's worth considering investing in a diffuser attachment for your flash gun to soften the harshness of the

Don't let the lens do the walking! (above)
Zoom lenses are useful but it's still important to think of the best focal length and position yourself well to get the strongest shot.

Fixed focal length (above)
You will eventually start to favor a certain focal length in your work. When you can afford it, buy your chosen fixed lens, making sure that you opt for the fastest, highest quality "main" lens you can afford.

Choose the right bag (right)
Before buying a bag, make sure you can get all your basic main items in the bag and that it is comfortable. Look for bags that allow you to customize the compartment size to snugly fit your camera and lenses.

51 **Project:** Look into equipment rental

Investigate the process of opening an account with a photographic equipment rental company. Many offer good deals for students and assistants.

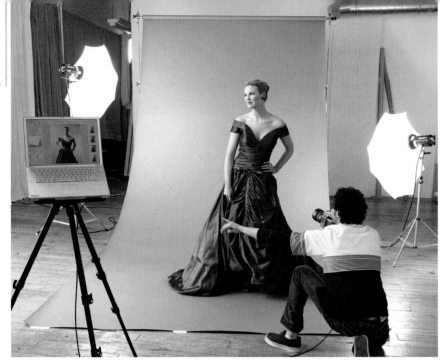

Digital link-up (above)
You can link your digital camera to a laptop so that work can start on the files immediately and, if present at the shoot, the client can see the pictures as they are taken.

Memory cards (below)
Go for the best quality, highest speed, and largest storage capacity you can afford, in that order.

direct flash. A cable that allows you to detach the flash unit from the camera is also very worthwhile (see page 67).

Compact flash memory card
The compact flash memory card is the standard removable device that stores your pictures in your camera. These are available in a range of sizes and speeds, enabling you to store up to 1,000 images on one card. Always insert and remove the cards carefully in order to avoid any internal damage to the coupling prongs inside the camera's card slot. If these get bent or damaged, you will get an imperfect connection between camera and storage device, resulting in corrupted data and a heavy repair bill.

External hard drive
Within a very short amount of time, the active photographer will amass vast quantities of digital files. Ultimately, you will start to run out of space on your computer's hard drive and compromise other computer activities that are part of your daily life. Memory is cheap, so you

should archive all but the most recent work onto an external hard drive. The truly conscientious photographer will create a master duplicate drive that replicates all the data on the external hard drive and is updated maybe once each month, before being stored in a different location to the home filing system.

Camera bag
You may need a number of bags in the future, but initially aim for a bag that can hold all of your basic equipment and protect it from the weather and the knocks and bangs of travel. There is a wide range of bags available and, as with most photographic equipment, you get what you pay for.

Tripod
When working in low-light conditions, the tripod enables you to take pictures without the camera shake that would be inevitable if shooting "hand held." When choosing a tripod, try to strike a sensible balance between weight and rigidity. Some of the lightweight tripods are too flimsy for reliable use, whereas the very robust versions are far too heavy for carrying around for long. Take your time in choosing the best unit for your most common practice and pay particular attention to the quality of the tripod head—the multidirectional part that your camera clips onto, which allows movement in all directions. If you are shooting in a style that requires regular slow pans, for example, in sport or wildlife photography, you may want to consider the "oil-damped" head, which offers the smoothest horizontal and vertical movement. Tripods are also useful in portraiture, allowing you to remove yourself from the viewfinder, once the focus has been set up, and release the shutter with a cable release as you talk to your subject.

Monopod
Although far less effective than a tripod, the single-legged monopod offers far greater stability than could be achieved with hand-held shooting, and is considerably less restrictive because of the smaller ground area it requires. It

52 Project:
Make a backup of your pictures

Make sure to back up all your photographs on an external hard drive. Use your chosen workflow software to make this job easier and more manageable (see pages 112–115).

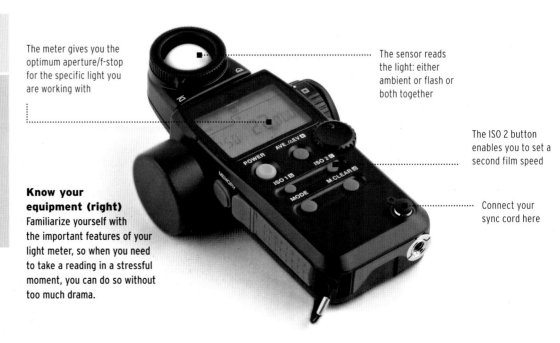

The meter gives you the optimum aperture/f-stop for the specific light you are working with

The sensor reads the light: either ambient or flash or both together

The ISO 2 button enables you to set a second film speed

Connect your sync cord here

Know your equipment (right)
Familiarize yourself with the important features of your light meter, so when you need to take a reading in a stressful moment, you can do so without too much drama.

won't be useful for seriously long exposures, but will allow you to shoot at shutter speeds approaching one second if you use an additional support (such as a lamppost) to steady yourself.

Cable release

This device triggers the camera without introducing any of the physical pressure that pressing the button manually would involve. It is advisable to use a cable release when using a tripod and useful to have one when you want to take photos without looking through the viewfinder.

Light meter

Although all 35mm cameras have built-in light meters of increasing sophistication, they do not have the flexibility of a hand-held meter. Furthermore, the new generation of light meters combine ambient metering capabilities with flash meters, enabling you to deal with the most complex of multiple light source scenarios.

Reflectors

When the white sheet in your bag is not enough, you may need to use reflectors to bounce the light back into your field of vision. There are a number of collapsible systems with different surfaces available from all good professional equipment suppliers. They snap shut into a small portable back that can be carried along with the rest of your kit in the ever-heavier camera bag!

Portable studio lighting kit

For photographers who regularly need to use more complex lighting than can be achieved with a camera-mounted system, there are many different portable systems available that might typically include two flash heads, stands, and collapsible softboxes. For portrait photography, this kind of kit would enable you to handle most situations.

Duct tape

It is always useful to have a roll of duct tape in your bag. It helps secure unwanted elements from the frame, covers up potentially dangerous trailing cables, and is useful for establishing markers on the floor for studio situations, if you want people to return to the same spot after a break.

Swiss Army knife

No shoot is complete without it being necessary to cut something, tighten a screw, or open a bottle of wine at the end!

Bean bags

You can make a small bean bag out of a resealable freezer bag and some uncooked rice or lentils. These are handy as weights, for example, to hold down a piece of fluttering fabric from your backdrop and, more importantly, as something you can use as a makeshift tripod. For the latter use, you could place the bean bag on, say, a gatepost, and then settle the camera into the volume of the bag so that it is steady enough for you to be able to attach a cable release, let go of it, and shoot a long exposure.

53 Project: Practice using your cable release

Mount your camera to a tripod and connect your cable release. Using this setup, try to take some photographs that illustrate movement using blur in some areas of the picture but ensuring to keep at least one element of your shot absolutely pin sharp.

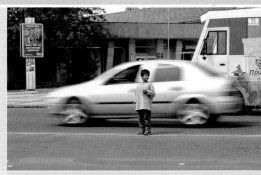

Near miss (left and above)
Find a stationary object that is adjacent to an area that is moving in order to emphasize the sense of movement and speed (left) or of vulnerability and danger (above).

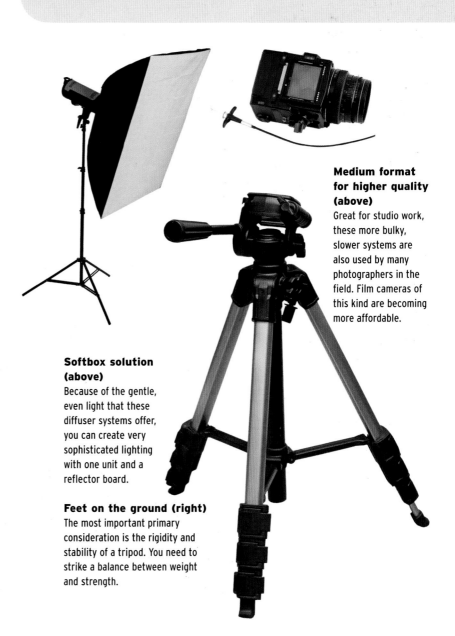

Medium format for higher quality (above)
Great for studio work, these more bulky, slower systems are also used by many photographers in the field. Film cameras of this kind are becoming more affordable.

Softbox solution (above)
Because of the gentle, even light that these diffuser systems offer, you can create very sophisticated lighting with one unit and a reflector board.

Feet on the ground (right)
The most important primary consideration is the rigidity and stability of a tripod. You need to strike a balance between weight and strength.

Format

The standard formats available today, including the majority of digital systems, are based on the long-standing range of films and camera developments over the complete history of photography.

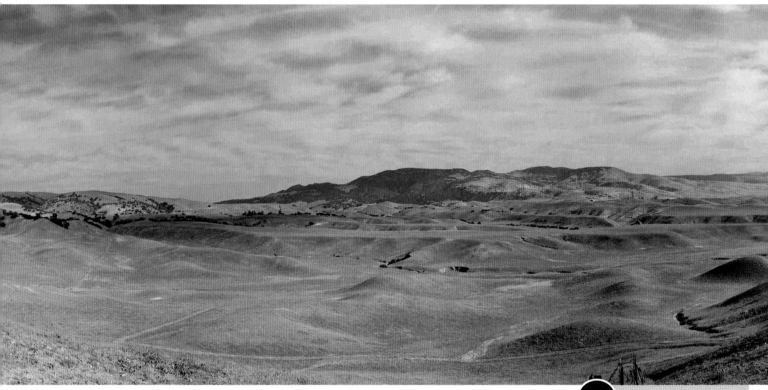

Choice of format today is partly subjective, occasionally driven by the nature of the job in hand, and commonly linked to the pursuit of the highest possible print quality.

In the early days of *Life* magazine in the United States, the standard issue equipment for staff photographers was a 35mm Leica and a 6 x 6 Rolleiflex. The general idea was that if the photographer came across a situation that had the potential to make a front cover, they should shift from the Leica to the Rolleiflex in order to give the magazine a much better quality print for reproduction.

The most widely used format throughout the twentieth century, possibly with the exception of the holidaymaker's Kodak Instamatic, is 35mm. This format, with minor adjustments, is the main format that continues to exist in the majority of digital systems on the market.

Medium formats

The next band of formats are generically known as "medium" format, which in itself covers a multitude of different sizes ranging from 6 x 4.5cm, 6 x 6cm, 6 x 7cm, 6 x 9cm, to 6 x 17cm.

For some, the shape of the frame itself is often the deciding factor choosing one format over

Shooting a panorama (above and top right)
Make sure you use a tripod when shooting a sequence of shots to make up panoramic landscape as it will be easier to line up and piece together your shots with your computer software afterward.

another, with many portrait photographers in particular finding the square format ideal for detailed head shots. Until recently, the majority of medium-format cameras were substantially larger and more cumbersome than their 35mm counterparts, lending themselves to studio work where the matter of carrying heavy systems around is less of an issue.

Within the last 20 years, there has been a marked increase in medium-format rangefinder cameras that many contemporary photojournalists have used to great effect. Again, quality is the main advantage, which is traded off against a slower way of working and frequent necessity to change film due to the small number of frames per roll.

To a certain extent, the massive changes in digital technology, as well as the decline

54 **Project:**
Create a panoramic photograph

Using PhotoStitch or a comparable piece of standard software, try making a panoramic photograph from multiple images taken specifically for the purpose, using on-line tutorials as your reference. Software manufacturers often offer free downloads of software programs for a trial period, along with how-to instructions.

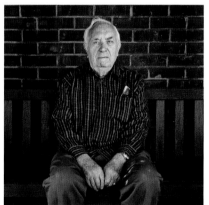

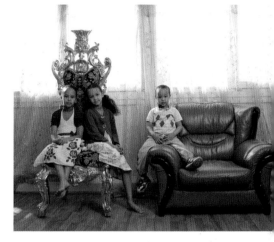

Traditional 35mm format (below)
In our digital age, a digital SLR with a sensor size that's equivalent to 35mm film is known as "full frame"; which means it has no "crop factor," such as a 1.6x/1.5x crop factor like entry/enthusiast-level D-SLRs by Canon/Nikon.

Creative 5 x 7in format (below)
Shooting in a 5 x 7in format will enable you to get more artistic and to use the extra room to give your subjects space, such as positioning these three children to one side for a more pleasing composition.

Hip to be square (left)
Shooting with square-format film (or making square crops of your images digitally with photo-editing software) can produce very creative results.

in photo labs who can deal with traditional film processing, has resulted in the majority of photography taking place within the digital arena. That said, there remains a dedicated group of new and old photographers who are reluctant to let go of a film-based world, which they believe was only abandoned under duress from the manufacturing industry.

Panoramic format

The panoramic 6 x 17cm format became interesting to many photographers during the 1980s when a couple of camera manufacturers brought out "affordable" systems that were portable and built to a very high specification. The resultant prints were beautiful and epic, resembling the great Hollywood wide-screen format of days gone by. This format was brilliant for landscape photography, but very difficult to use within the design of most magazines.

Large formats

The last format genre is large format. Slow, unwieldy, and weighty, these cameras use either 4 x 5in sheet film or 8 x 10in film. The quality is incredible and although portable systems exist, the majority of large-format systems exist for studio use.

55 **Project:** Practice shooting in square format

Switch the settings on your camera so that the screen on the reverse of the body is on during shooting. Mask off the screen on the back of your camera so that all that you see is the biggest possible square. (You will need to tilt the camera on its side for this to work, as if shooting vertically in normal conditions.) Practice shooting a range of situations with the square format, exploring the different way you start to compose and frame your subject. Make sure you perform the same exact crop to the frames you process/edit later in Photoshop.

Mask off your LCD
Add a line of tape to one side of your camera's LCD so you can only see a square format photo.

Tilt your camera
Learn to tilt your camera at different angles to creatively fit your subjects into the square frame.

Wider composition
You'll always have the original ratio photo if you prefer this to the square crop.

Lenses

Before going out and spending a lot of money on a range of lenses that you will only use once a year, it is important to establish which lens you are likely to use more than any other.

56 **Project:** The "desert island" lens game

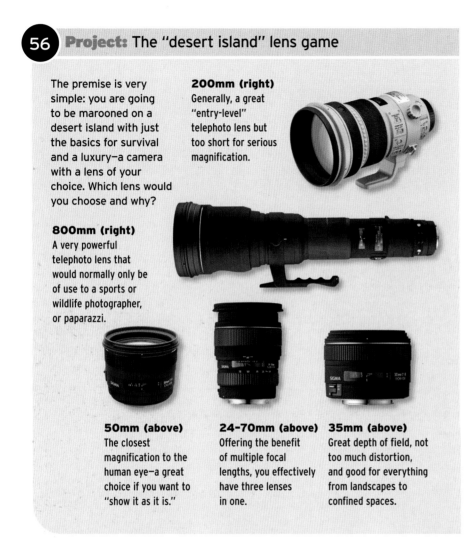

The premise is very simple: you are going to be marooned on a desert island with just the basics for survival and a luxury—a camera with a lens of your choice. Which lens would you choose and why?

800mm (right)
A very powerful telephoto lens that would normally only be of use to a sports or wildlife photographer, or paparazzi.

200mm (right)
Generally, a great "entry-level" telephoto lens but too short for serious magnification.

50mm (above)
The closest magnification to the human eye—a great choice if you want to "show it as it is."

24-70mm (above)
Offering the benefit of multiple focal lengths, you effectively have three lenses in one.

35mm (above)
Great depth of field, not too much distortion, and good for everything from landscapes to confined spaces.

If you canvas a group of photographers on their favorite lens, a high percentage will mention one lens in particular—the lens of preference that they automatically fit to their camera without thinking.

If you are interested in working up close to the action and like to be in tune with the human interaction before you, it's important to work with a lens that functions in a similar way to your eyes. The lens that comes closest to replicating the optical characteristics of the human eye is the 50mm, but many prefer the width and depth of field afforded by the wider 35mm focal length.

The best advice would be to buy the best lenses you can afford. Depending on the kind of photography you are interested in, a good starting point for fixed lenses would be 35mm, 50mm, 24mm, and 135mm, before starting to consider telephoto lenses or super-wide-angle lenses.

To zoom or not to zoom?

Some of the modern zoom lenses are excellent and fast, meaning that they allow you to shoot at very wide aperture settings, up to f2.8 (see page 51). The more extreme the shift from wide angle to telephoto, the less optical quality you are likely to have. Disadvantages of the zoom lens are quite subjective, but one of the main

Super wide-angle lens (below)
Big skies are a classic part of the landscape tradition and achieved most successfully with wide-angle lenses and decisive placement of the horizon.

24mm

Wide-angle lens (above)
The sense of scale between human and architecture is emphasized by the width of the picture and strong sense of perspective.

70mm

Telephoto qualities (above)
The minor telephoto characteristics of this lens allowed creative use of the shallow depth of field.

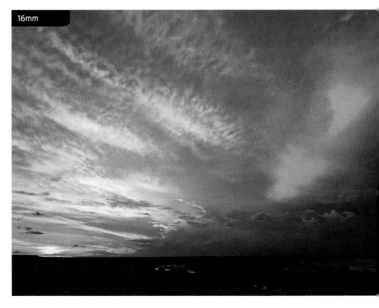

16mm

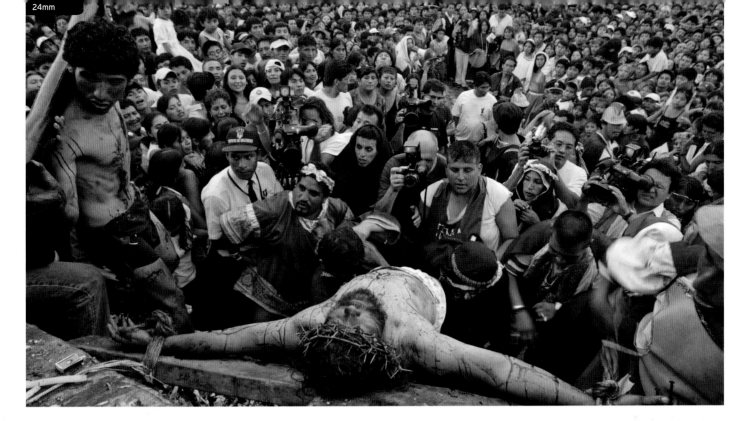
24mm

problems is that the best-quality zoom lenses are often very bulky and obtrusive. Furthermore, they sometimes give the impression of making life easier, because you can zoom into a situation so easily. Robert Capa's famous quote, "If your pictures aren't good enough, you're not close enough" is one of the greatest deterrents of using a zoom.

Being close enough is not a statement about lens choice, it is all about engagement with your subject—being in the thick of things, so you can really understand and witness what is happening. It is important to remember at all times when using a zoom lens that having the capacity to bring a situation closer at the blink of an eye is completely different from a genuine physical proximity.

Wide-angle drama (above)
This powerful picture from a Catholic ceremony in Peru is made all the more powerful by the intelligent use of a wide-angle lens. Great depth of field allows the "Christ" figure to loom large and sharp in the frame while its exaggerated perspective adds to the sense of a very large gathering of people.

The beauty of long lenses

The compression of distance that occurs with long lenses brings the distant background closer, thereby allowing the foreground to become an anchor point to the composition.

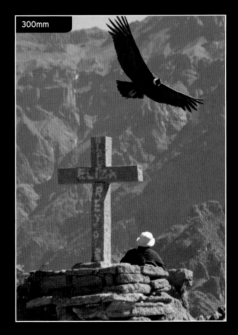
300mm

Long lens
Using long lenses can create a surreal composition. In the picture above, shot in Peru, the condor appears far closer to the man than it was in reality.

57 **Project:** Learn about lenses

Start "framing" the world as you go around. Try to estimate by sight what field of view a particular lens would give, then check your estimate through the lens. This will develop your ability to know what focal length is needed before raising the camera to the eye, which can be very useful in selecting lenses, and also when you want to work quickly and discreetly.

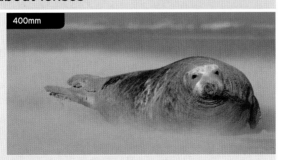
400mm

Telephoto lens
There are often practical safety issues behind the choice of lens, for example, when photographing dangerous subjects.

Shooting in color

The choice of shooting in color or black and white is now, in the majority of instances, just a matter of changing a couple of settings on your camera. However, the ease of making such a decision should not detract from the important thought process that precedes it.

There are many reasons why a photographer may choose color over black and white. These could be aesthetic, commercial, journalistic, or sometimes instinctive. The important thing to always remember is that whatever the choice, it should be definite and not a matter of chance. Each mode brings a distinctive feel and interpretation to the subject and both handle tonal range, light sources, and skin tones in completely different ways. As to which most faithfully reflects reality, the debate rages on!

Color as an artistic medium

The great color photographers embrace color as an integral part of their aesthetic approach, using it as a primary element of their artistic expression. The acceptance of color photography by the art establishment is comparatively new within the broader history of photography, with many people acknowledging William Eggleston's seminal exhibition at New York's MOMA, in 1976, as the beginning of serious color photography.

Color wheel

Color wheels are not just for painters, they are important in photography too. You can use the relationship between colors to create a sense of dynamism and drama, or harmony and peace. Buy a color wheel from a graphic arts store and carry it in your camera bag. Use it to create harmony or contrast between the subject and the background.

Remember the two main rules of the color wheel:
- Colors on the opposite sides of the wheel build a sense of tension and drama (complementary colors).
- Neighboring colors create a sense of harmony and tranquility (analogous colors).

Color temperature

Color has a temperature that can be measured, and different light sources have different color temperatures. The scale used is called Kelvin or K. The lower the measurement the warmer the light. Daylight in bright sunshine and flash are quite blue at around 5,200° to 5,500°K. Evening light is warmer, around 3,800° to 4,500°K, and artificial light is warmer still, at around 3,200° to 3,600°K.

10,000°
9,000°
8,000°
7,000°
6,000°
5,000°
4,000°
3,000°
2,000°
1,000°

Kelvin scale (above)
Color temperature measurement is about establishing a sound white balance (see page 61).

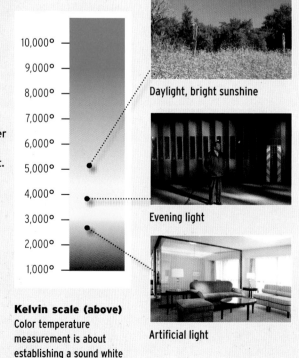

Daylight, bright sunshine

Evening light

Artificial light

58 Project
Explore color temperature

At dusk or dawn, find an outdoor location where you can see a number of different light sources. Try and take a photograph with as many different light sources as possible. Including natural light, you should show at least four different color temperatures.

A city comes alive
This picture features the white light of the moon, the blue light of early morning, green fluorescent tube light, and yellow tungsten light.

59 Project: Daylight and color

The time of day affects color greatly. The light at different times of day has different color temperatures. On a clear sunny day early in the morning just after dawn and late in the afternoon before sunset, the light is warm and saturated, ranging from almost red through orange and yellow, with long and deep shadows, but lots of detail in the highlights. Just after sunset and just before dawn, the light is a pinkish color and soft. At midday the light is harsh. This light is the worst to shoot in, as it gives little atmosphere or quality to the light and therefore to the color. Unfortunately for photographers, many news events such as demonstrations tend to happen around midday.

These characteristics of light are exaggerated in the Tropics and near the Equator, and are less obvious in countries further north and south. On an overcast day, the light is cooler and almost blue later in the day and early in the morning, a typical feature of light in northern Europe. A problem on overcast days when shooting in color is the lack of any detail in the skies, which can look white and washed out. In black and white, some tone can be added in printing, but this looks unconvincing in color.

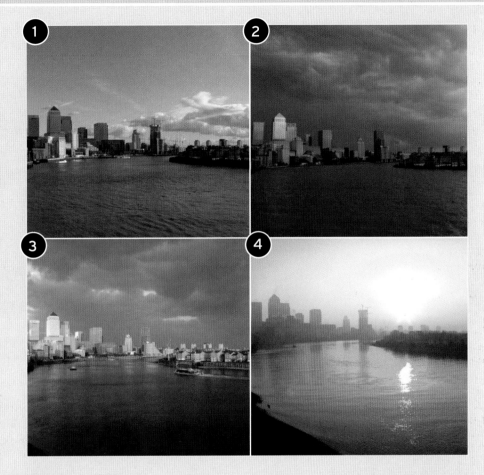

From dusk 'til dawn

In photos 1–4 the shifts in daylight conditions are self-evident because the photographs deliberately make a point of capturing the color tints that the light conditions create. The important thing to remember here is that these differences are far less obvious to the naked eye if, say, you were taking pictures on the street with tall buildings shielding you from the spectacular differences we see above.

60 Project: Learning from advertising

Cut out some advertisements from magazines. Analyze the colors with the use of the color wheel above. What is the relationship between the color of the product and the color of the background? What kind of message is being communicated by the choice of colors?

After completing this analysis, try taking photographs that intentionally use the same color scheme as the advertisements you analyzed.

Vibrant color scheme

Every advertisement has a target demographic, and its color scheme is designed to appeal to that audience. Think about the links between color and product in the examples you choose.

61 Project: Use a polarizing filter

With digital cameras, the need for filters is virtually redundant (see opposite). One of the few lens-mounted filters that remain relevant to the digital photographer is the polarizing filter which, in the right conditions, increases color saturation. It's a good, inexpensive piece of equipment to have in your bag.

Without polarizing filter (below)
The golden statue is set against an undramatic, slightly dull blue sky and is largely unremarkable.

With polarizing filter (above)
The effect of the filter is to darken the hue of the blue sky, increase the contrast, and elevate the richness of the colors so that the picture is stronger.

62 Project: Take your camera night clubbing

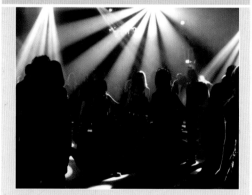

Disco inferno
The bright lights of a club allow you to work on reasonable shutter speeds and make interesting shapes with the silhouetted people and shafts of intense light.

In order to explore shooting in environments where there are very heavily colored light sources, go out to a club and have some fun exploring what works and what doesn't. With the constantly changing lighting, lasers, and strobes, you should be able to create a small portfolio of pictures with different dominant colors.

63 Project: Experiment with different color filters

You can use filters in color photography to correct color casts or to add color to a scene. The other option is to correct the colors in post-production, but this is not always satisfactory, since mixed light sources, i.e. flash and tungsten or fluorescent, will be of different color temperatures and hard to balance.

Filters reduce the amount of light coming through, so unless you are using through the lens metering, you need to compensate for this.

Without filter (above)
When you're shooting on assignment, you often have no flexibility to wait for the light conditions to be more dramatic. Filters can be useful ways of creating a more interesting picture in a dull situation.

Our perception of color

The color of an object is determined by the color of the light that illuminates it as well as the color of the object itself. Both film and digital cameras record light as it actually is, unlike the human brain, which is constantly correcting and compensating for the fluctuations in light that occur throughout the day, depending on environment, time of day, angle of sun, and the predominant light source.

For example, if you look through the windows of an office block in the evening, from outdoors, there will often be a noticeable green cast inside the building. This is caused by the light that is emitted from the fluorescent tubes, which has an inherent green hue to it. However, were you to walk into the office, the picture would be instantly different as your brain reprocesses the same information and corrects it to "normal," resulting with the impression that the interior is lit with white light. Film and digital sensors see things as they are and in this instance would record the green color cast.

White balance in photography

These problems are overcome by the use of filters, in the case of film cameras, and in-camera changes to the "white balance" with digital systems. Effectively, both technologies introduce a new color that compensates for the prevailing cast and renders it white (see also page 62).

64 Project: Customize the white balance

It is essential to know how to change the white balance settings on your digital camera so as to avoid the problems of erroneous color casts. With the Custom White Balance feature, you shoot a white surface (it's a good idea to carry a piece of white card in your bag) that will serve as the control for your new setting. There may be some minor variation in how this task is performed, depending on your camera, but the principle is the same for all. When in an environment with problematic color temperatures, the reading taken from the white card is processed by the camera and interpreted as pure white from that point onward. Remember to reset your white balance when you change location.

Calibrate your white balance
Use a piece of white card to calibrate your white balance in situations where there is artificial light or the need to create a highly accurate color rendition from a color-specific subject, such as a piece of artwork.

Blue filter (above)
The blue filter renders the scene almost monochromatic, and would be useful if you were aiming to give a range of different scenes or subjects (and therefore many disparate colors) a uniform feel or style.

Orange filter (above)
A surreal glow to the sky gives an Armageddon-like quality to the subject.

Warm-up filter (above)
Some photographers keep a warm-up filter (81A or 81B) on the lens to enhance the color. This is less necessary with negative films and digital cameras, since the color can be added in post-production.

65 Project: Look for a scene with a single hue

With your camera set to its normal color mode, spend a day looking for pictures with little or no apparent color in them or with just a flash of a single color.

After-sun treatment
The richness and warmth of the evening golden hour (see page 86) is replaced by a much colder, blue light. Working at this hour is difficult and inappropriate for any photography that requires realistic skin tones. However, when used intelligently, this approach can be very dramatic, as seen in this post-sunset beach scene.

66 Project: Playing with white balance presets

Set up a still life under incandescent (household) lighting, then play with the white balance presets and compare the results. You can "trick" the camera's sensor by deliberately using inappropriate white balance settings to add special color effects.

Add extra red/ yellow tones (left)
Under incandescent lights, try the Fluorescent preset to turn the image red.

Add extra blue/green tones (right)
Use the Incandescent preset under fluorescent lights to make the image blue.

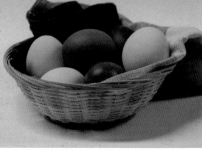

The white stuff
By selecting the correct White Balance (WB) setting on your camera you can ensure that the whites of your images are white. If the WB is too warm your images will appear red/yellow, and too cold, blue/green. Although to the human eye, white objects will look white regardless of the light source, with a digital camera, the WB needs to be set correctly.

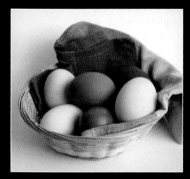

Test shot—neutral light
Shoot the subject in good daylight (neutral light). The white eggs show perfect white balance under daylight.

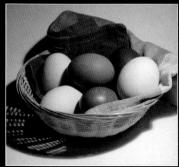

To create daylight effects
Use Custom White Balance setting to remove the yellow hues when shooting under incandescent light (here you can tell the white balance is correctly adjusted, because the eggs are the same color as the test shot).

Artificial light

Tungsten light, that is light from ordinary light bulbs, is yellow-orange in color and will give a strong, warm cast to negative film. Digital cameras set to Auto White Balance will remove this cast, but ironically they can produce images that don't look right, as we are used to seeing indoor images that are slightly warm, and digital images can look too clean.

Be careful if you have daylight coming in from windows, as this will be of a different color again to the artificial light. Daylight and tungsten mix well together, as the eye reads this combination as natural, but daylight and fluorescent do not mix. Either the daylight will be magenta (pink) or the fluorescent will be green. To get around this problem, you can turn off the lights and use available natural light, or avoid showing windows in the frame.

Shooting indoors (above)
When photographing set-ups or still-life objects indoors, be aware of your lighting source (or sources). Use available natural light for natural-looking results, but if you only have a tungsten or fluorescent lighting source, set the White Balance on your camera accordingly for the best results.

67 **Project:** Shooting film noir

The film noir ("black film") is the genre of Hollywood films from the 1940s and 1950s, famous for the use of a low-key black-and-white visual style. In a typical film-noir image, the subject is lit by a narrow beam of light and the background. Long, dark shadows create a menacing atmosphere, and this style of photography works equally well for portraits, urban landscapes, and still life.

The simplest way of setting up a film-noir shoot is by letting a narrow beam of light into a dark room. If you have an off-camera flash, you can make a simple and effective device that will narrow-focus the light from the flash down to a thin strip, giving you a way of experimenting with film-noir technique in any dark setting. You will need to increase your flash output by 1-1.5 stops to compensate for the blocked light (for more on black-and-white photography, see page 68).

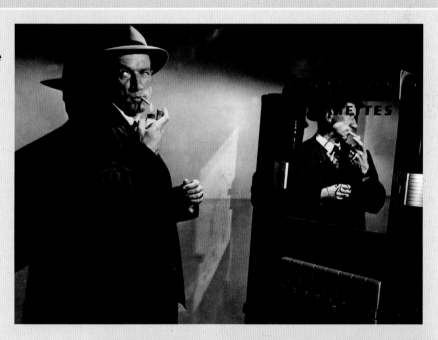

Simple flash adapter

You can make your own flash attachment for shooting in the film-noir style. Construct a box that fits snugly over the top of your flash out of cardboard and duct tape. Make a ½-in. (1-cm) deep slit at the front, which narrows the space for the flash to shine out of. Secure the box over the top of the flash with reusable poster putty, or for a more permanent fitting, with Velcro.

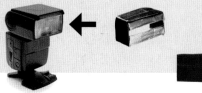

Check these out

The best way to learn about the film-noir style is to watch some great films:
- *The Third Man* (1949, Carol Reed)
- *Touch of Evil* (1958, Orson Welles)
- *Bunny Lake Is Missing* (1965, Otto Preminger)
- *The Killers* (1946, Robert Siodmak)

Gallery on-line

Look at the photographic work of George Hurrell on-line. Some of it is available here:
http://silverscreensirens. com/george_hurrell.htm

Flash photography

You could describe flash as sunshine in your pocket, and that's the key to understanding how to use it. Flash can give a hard, direct, and directional light or a soft, gentle overall illumination. You need to learn how to use it to create natural effects.

The power of the flash is shown by the guide number (GN). The higher the number the more powerful the flash. Note whether the GN is quoted in feet or meters and at what ISO/ASA. Most modern cameras and flashes work through the lens metering (TTL), and the power of the flash is easily adjustable. Older flashes that work on manual or automatic need to be set to give the required power output.

While some important photographers have used flash as a central part of their aesthetic approach, the general objective when using flash is to make its presence as undetectable as possible. Used with care, flash is invisible. In the hands of the unskilled, heavy flash can render a photograph unusable.

Direct flash

The most obvious way to use the flash is mounted on the camera, but this is also the worst way to use it. Direct flash gives hard edges and is ugly. It flattens the image, can cause red eye, and casts shadows directly behind the subject. It should be used only when there is no alternative, for example, in a situation where space is tight, when the subject is far away, when you are indoors, or it is night time.

Fill flash

Fill flash is when you use direct flash as a fill light to reduce the contrast in a backlit subject, such as someone standing with their back to

the sun. The technique for this is to set the flash between one and two-and-a-half stops below the ambient light, depending on how strong you want the fill-in to be. This means that if your overall reading for the scene is a shutter speed of 1/250th at f11, the flash output should be set at f5.6, f8, or f9 (see opposite).

In your face! (above)
Full flash is harsh and unforgiving but can be used, particularly in combination with extreme saturated colors, to create a powerful effect that can enhance the photograph.

68 Project: Use a bounce card for better flash control

Without bounce card (above)
More contrast, sharp shadows, and "hot spots" from reflective surfaces make direct flash too aggressive in many situations.

With bounce card (above)
A bounce card or bouncing your flash off the ceiling helps to diffuse the directional harshness and soften the intensity of the light.

Many flashes give out light that is rather cold, so it is a good idea to put a pale orange gel over the flash head to warm it up, especially if you mix the flash with ambient light indoors, as this tends to be warm too.

Try using a bounce card, a small reflective piece of plastic put on the flash head to reflect a little light forward as well as upward towards the ceiling. You can also use Omnibounce or Lumiquest, which diffuse and soften the flash light to simulate bounce flash when the room is too large or when you are outdoors. Experiment with different accessories to find one you like.

69 Project: Flash and portraiture

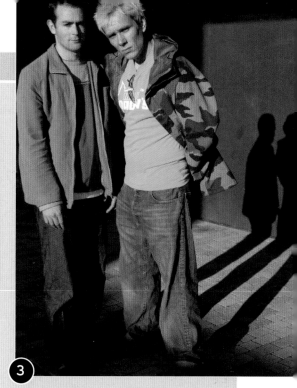

1 Sense of movement
Use a slower shutter speed than normal with your flash for an artistic result that captures the sense of movement of your subjects.

2 Detailed backgrounds
Underexpose by one-to-two stops to capture the color and detail of the background and sky, then use fill flash to light up your subjects.

If you can establish a range of different techniques with your basic flash unit, it can become an invaluable part of your day-to-day kit. Learn the many different ways you can use a simple flash unit to add light, freeze a moment, or create dramatic shadows in your work. It is worth investing in some simple accessories that allow you to diffuse directional light, remove the unit from the camera or trigger the flash remotely.

3 Remote flash
Use your flashgun on a cable and angle it toward your subjects from the side and above to create moody shadows behind them and on their faces (see page 63).

Flash as the main light

Where flash is more powerful than the available light, you can use it as the main light. You can turn day into night, or a dramatic image in the evening. The technique is to take the overall reading, say 1/60th at f11, and then use the flash at f11 but set the shutter speed to 1/250th. This will make the background two stops darker than the foreground lit by the flash. In the evening, balance the flash and the available light in the same ratio. For example, if the overall reading is 1/15th at f5.6, set the flash to f5.6 as well and balance the background with the foreground.

Synchronizing with shutter speed

The duration of the flash is very short and has to be accurately synchronized with the camera shutter or the image will only be partly exposed. Most modern cameras' sync speeds are 1/250th of a second and below, but some older cameras sync at 1/60th and below, and some medium- and large-format cameras have the shutter in the lens and sync at all speeds. This means that the shutter speed must be set to the camera's sync speed or less, or the image will have a dark line across it where the flash and shutter failed to synchronize. Most modern cameras will set the sync speed automatically when used on program, but have to be set by the photographer when used on manual. You can use longer shutter speeds with flash for creative effect, for example, 1/15th with f8 set on the flash. (See flash blur on page 66 for more details of this technique.)

70 Project: Practice outdoor fill flash

Your work will often be driven by events that take place when the sun is at its highest and most unforgiving. Practice adding a small amount of flash to your exposures to blow out some of the shadows caused by the overhead sunlight. It is important to test this technique extensively and get a feel for the right amount of flash to achieve good results.

Brighten outdoor portraits
You can utilize your flash for more than just low-light or night-time portraits. Use fill flash outside to brighten up your subjects and to reduce unsightly shadows on their faces caused by the sun.

Flash blur (above)
Use your flashgun creatively by shooting with a long exposure (try ¼–¹/₃₀ sec) to freeze and bring out the color in your main subjects while blurring any movement in the background.

background. For example, if the light reading is 1/15th at f5.6, set the flash to f5.6 and use it to light the front of the scene. The available light will fill in the rest of the background, giving depth to the image.

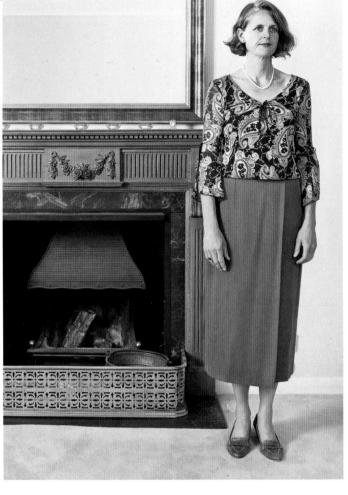

Flash blur
Longer exposure times will give an effect known as flash blur. With flash blur, the subject is frozen by the flash while the background is blurred and moving. Point light sources, such as spotlights, will leave trails of light that can look strange and interesting.

Balancing flash
A technique similar to fill flash is balancing the flash to the available light indoors. This means taking an overall light reading, using the flash to fill the foreground, and letting a long exposure fill the

Bounce flash
This technique involves bouncing flash off the ceiling or walls of a room. It gives a soft light that fills the space. It can be a little flat and low in contrast, but it is flattering. Most modern cameras with TTL work well this way. Older automatic flashes tend to need a little more exposure than normal, so you should open up the aperture half a stop. If you are shooting color, be aware that the flash will take on the color of the surface it is bounced off. Beware of green walls!

Using an umbrella or softbox
You can use a simple umbrella and light stand setup to give a softer, more flattering light very easily, replicating the quality of light you could get from a studio lighting setup.

Umbrella or softbox (above)
To create a softer, more flattering light when taking portraits, use an umbrella or softbox with your flashgun on a stand.

71 **Project:** Compare light situations

Practice balancing flash and available light around dusk, and in a bar or club with good artificial lights.

Get artistic
Use flash and slow shutter speeds to get artsy shots of people in clubs or bars. Also try the same technique with brightly lit vehicles at fairgrounds or carnivals.

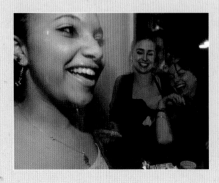

72 Project: Experiment with flash and daylight

It is best to wait until you get a ratio between the flash and the daylight that you like.

With fill flash (above)
Shot at f22 at ¹/₂₀₀ sec and ISO 400. Use a little fill flash in daylight to brighten up and freeze action shots while retaining the detail and tone in the background. By increasing the ISO to 400 you'll also be able to extend the effective range of your flash.

Without fill flash (right)
Shot at f5.6 at ¹/₄₀₀₀ sec and ISO 400. This time by not using any flash when shooting into bright sunlight the camera has struggled to expose the BMX rider, resulting in an underexposed subject and overexposed sky.

Warning!

Flash units can be dangerous. Do not try to repair a defective flash unit; the condensers can retain electricity and give you a nasty shock.

73 Project: Experiment with flash and angles

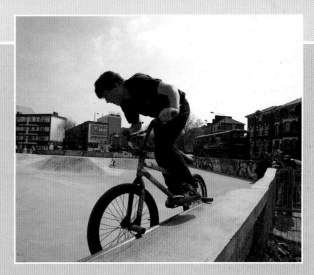

Separate the flash from your camera and use it on a cord from the side, holding the flash in one hand and the camera in the other. You can then direct the flash at the subject from the side at an angle of 45 to 90 degrees, and get a more interesting, directional light that will give more depth to the image.

Off-camera flash
By using your flashgun on a cable you can light your subjects from one side to create longer shadows and more depth and dimension to your photos.

Shooting in black and white

68

Black and white is an abstraction; we do not see the world simply in tones of gray. This abstraction can be used to advantage to focus on the content of an image or on purely aesthetic qualities.

74 Project: Learning to see in black and white

Black-and-white photography is not just taking color pictures without the color. Black-and-white images are constructed from tones and areas of dark and light, and work in a subtly different way from color images.

- To see how a scene will look in black and white, half close your eyes. This will make you concentrate on tonal differences rather than color.

- Look through a piece of colored glass or a yellow, red, or green filter to reduce the scene to its tonal values. This is how the film industry used to judge how a scene would look in black and white. The best tool is experience. Shooting lots of film in different light will build up your memory bank so that you begin to see in black and white.

Dark and light (right)
Shooting in black and white is a great way to emphasize dark and light sections within your shots, as this example photo of the view from inside a train station shows.

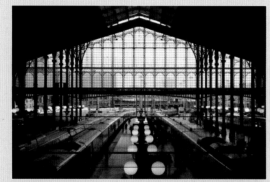

Tonal range (right)
By removing color from your shots, you can see the different range of gray tones. White subjects such as swans work well in mono images.

Concentrate on composition (right)
Without the need to consider any of the pitfalls associated with shooting in color, it becomes easier and very rewarding to work only with light, shape, and form in your compositions.

Black and white is still regarded by many as the classic mode for documentary photography. In recent decades, however, more photographers have been using color in long-term documentary work, arguing that if used correctly, color is more effective than black and white. The fact of the matter is that black and white continues to exert a powerful allure to photographers from all genres. In portraiture, landscape, and fashion photography, black and white continues to enjoy immense popularity.

Shooting using traditional analog technology is still an option that many apply in their practice. However, the reality is that film, processing, and traditional darkroom skills are less available than in the past and increasingly expensive.

Digital cameras and monochrome

Digital cameras can be used for black-and-white photography, but are at a disadvantage because their tonal range is less than that of film. There is a way of dealing with this problem, which is explained overleaf.

75 Project: Research great black-and-white photography

Learn what print quality is possible in black-and-white photography. As with all photography, the finished print remains an important part of the end product. With fewer opportunities to see "genuine" or analog photographic prints, it is important to understand the quality that exists within this field and which we should strive to replicate within the digital alternative. Go and look at the work of some great black-and-white photographers in museums and galleries whenever you have a chance. Study the tonal ranges available through film and photographic paper and strive for these qualities in your digital practice. The scale at right shows the range you should aim to capture.

Monochrome masterpieces (left)
If captured in color, this landscape would have appeared lackluster, but shooting the scene in black and white has turned the uninteresting blue skies and brickwork into a moody masterpiece.

76 **Project:** Shoot a series with tonal variation

Take a series of pictures that contain as many tones as possible from black to white. Be patient and try shoot the same situation at different exposures, bracketing one f-stop either way from the camera's recommended exposure. Similarly, try exposing for the shadows and see what happens.

Bracketing exposures (above)
Take three photos of the same scene: standard exposure, one-stop underexposed, and one-stop overexposed. Then compare the three black-and-white shots side by side to see which shows the tonal variation best.

Mixed lighting (right)
Shooting a subject that's a mixture of tones and in a mixture of lighting can prove challenging. Convert your images to black and white, and the difference in tones—from bright highlights to dark shadows—will work better together.

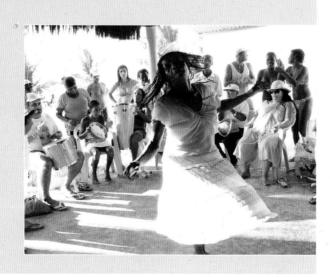

Filter effects
Using screw-on colored filters on your camera lens can instantly enhance your black-and-white images by boosting the overall contrast.

The effects of colored filters

Many photographers use colored filters over the lens to change the contrast and tonal range of the image. A yellow filter has the least effect; orange and red filters have progressively more. A red filter has a strong effect (see page 71). It can make a blue sky very dark and clouds stand out. This effect is too strong for most journalistic photography. Many photojournalists keep a yellow filter on the lens all the time when shooting outdoors to make skies easier to print. Other filters can be used to change the tonal qualities of the image, but again these are not generally used in photojournalism.

"Black and white are the colors of photography. To me they symbolize the alternatives of hope and despair to which mankind is forever subjected."

Robert Frank (Legendary American photographer)

When to go mono (right)
Some color photos can be too busy for the human eye to process. By stripping this intriguing scene of color, it is simplified, and also becomes captivating as the statues and assortment of people become intertwined.

77 **Project:** Explore Ansel Adams' zone system

Shoot in RAW mode

The majority of digital camera manufacturers offer a black-and-white setting on their cameras, many of which are based on JPEG files. It is far better to shoot in full color on your highest-quality RAW setting and make the conversion later in Photoshop. RAW files retain the greatest amount of image information so the tonal variation is improved, putting you in the best position to convert the files into good monochrome versions.

Ansel Adams, the famous American landscape photographer, devised the zone system, which divided tone into ten zones ranging from pure black to pure white. This system can help you decide where to set the exposure so as to keep all the significant information in an image within a seven-stop range, maximizing the detail in both the shadows and the highlights. If the scene has too much contrast, the exposure and processing can be varied. If the film is slightly overexposed and then underdeveloped, contrast will be reduced. If it is slightly underexposed and overdeveloped, contrast will be increased.

Practice getting to know the capabilities of your own camera in different lighting conditions, and do your own research into the zone system on the Internet. Take light readings from the brightest area and the darkest area of your subject, so that you understand the extreme differences of exposure that exists in any situation. Try to take a range of photographs that contain as many tones as possible.

Tonal range
The above architectural scene was shot specifically to capture as many tones on the "gray scale" as possible, from black at one extreme to pure white at the other end of the spectrum.

78 **Project:** Shoot a historical photograph

Set yourself the task of shooting a photograph that appears to come from a different time in history.

Timeless pictures
To make the photograph work, you will need to take as much care with the contemporary details you exclude from the frame as you do with the historic symbols you include.

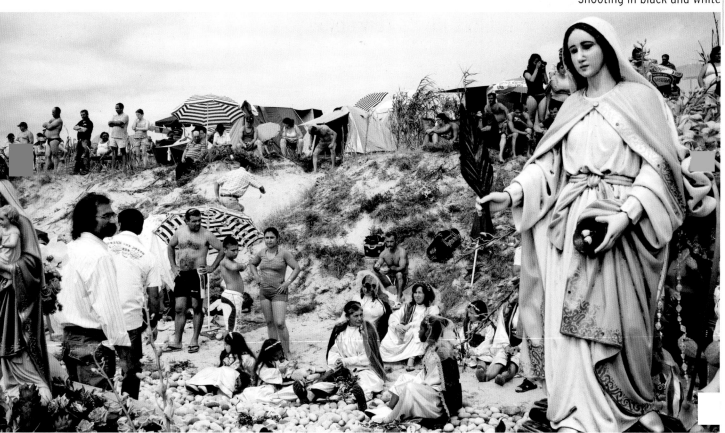

79 **Project:** Practice shooting in black and white with a red filter

Either "in camera," if using digital, or on the lens if
not, practice using a red filter. On a day with blue sky
and white clouds try and take some great "big sky"
landscape pictures and see what a powerful effect the
filter has on the sky and the resultant photograph.

Without red filter (right)
Fill the majority of your frame with bright blue
sky and fluffy white clouds. First take a black-and-
white photo without a red filter attached to your
SLR's lens.

With red filter (left)
Now take a photo of the same scene with a red
filter attached to your SLR's lens. You should
instantly see an improvement in the overall
contrast of the sky; the blue sky should be
darker, helping to make the white clouds stand
out, for increased impact.

Shooting at night

There will come a time when you are required to shoot some material at night. It could be that you are trying to make a beautiful moonlit landscape photograph or that you are maybe trying to shoot a familiar landmark most often photographed in daylight. Shooting at night requires some simple new skills and benefits enormously from special pieces of equipment.

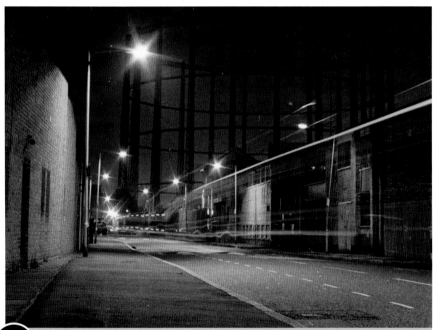

With the considerably greater exposure times that you will require (there is far less light!), it is crucial to keep the camera absolutely steady so as to avoid blurred photographs because of "camera shake." You will need a tripod to lock the camera in place and, because even pressing the button can generate a tiny bit of unwanted movement, a cable release is also preferable. Additional useful tools are a hand-held light meter, which will allow you to take a range of light readings in order to calculate the best exposure, without having to move the camera.

Set your camera to the "B" setting, which keeps the shutter open for as long as the button is pressed. For night photography, this setting is the only one that will allow you to make the length of exposure required. The cable release will allow you to lock the shutter open. On many cameras, the "B" setting remains a manual exercise that does not drain the battery power on your camera, because of the long amount of time the shutter is kept open.

As with all photography, practice is vital when learning to shoot at night.

80 Project: Shoot with long exposures

Experiment with long exposures in a situation where there are lots of moving lights. Set your camera up on a tripod with a cable release and the camera set to "B" (see above). Bring a stop watch and shoot the same situation at a variety of different exposure times.

Slow shutter speeds (left)
If your camera doesn't have a "B" setting, use your manual shooting mode and try shooting night scenes with a 10-, 20-, or 30-second exposure until you capture pleasing light trails.

81 Project: Capture ambient city light

Shoot a wide-angle landscape with city lights as the backdrop; it will provide much-needed light to brighten up your scenes as well adding a pretty glow to your night shots.

City lights
A slow shutter speed and a totally stable camera, combined with a well-selected vantage point, are essential for this kind of picture. If you don't have a cable release, use the self-timer function to release the shutter so that your finger does not create any shake.

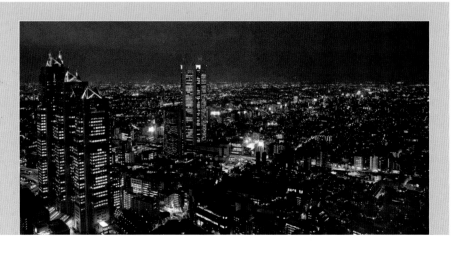

82 **Project:** Shoot landscapes by moonlight

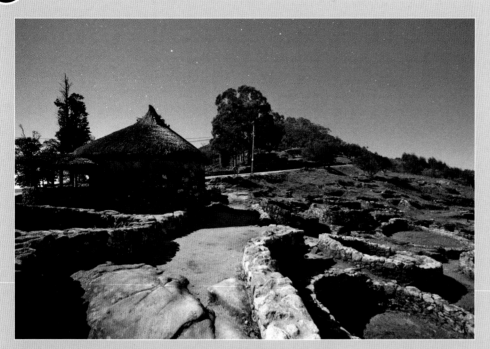

Sky at night (left)
To capture successful moonlight landscapes, you'll first need a clear sky with a full moon to light up the scene in your shots.

Lights out (below left)
Even with a 20- or 30-minute exposure, if there's no ambient light or moonlight you'll struggle to capture any detail, tone, or color in your shots.

Cool colors (below)
Just after sunset is a great time to capture breathtaking, cool colors. Try photographing coastal landscapes when the moonlight reflects in the sea.

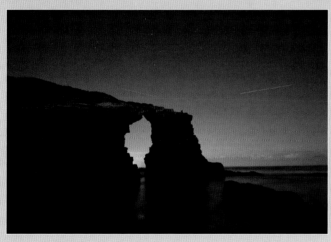

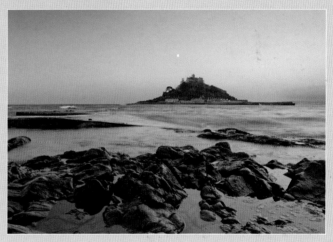

83 **Project:** Practice capturing fireworks

Ever wondered how photographers capture fireworks going off in the sky? The trick to this is to first work out what the correct exposure is for the area of the frame that will cover the situation at ground level. This might be buildings, people, or landscape features, which represent vital compositional elements to a successful frame. Employing the principles discussed opposite, when you see the fireworks going up, press the shutter so that it is open when they explode in the sky and keep it locked open for the exposure time that you have already calculated for the ground detail.

Explosions of light
Zoom out to allow for the firework explosions to fit into your frame, then get ready to press the shutter as soon as the fireworks are launched into the sky.

Printing your photographs

As in almost all areas of photography, printing has gone through huge changes because of the technological developments within the industry. Despite these changes, many photographers continue to use traditional methods for their photography and print-making.

Long live the family album (left)
Keep the tradition of making prints alive by using one of the many on-line print ordering companies such as www.photobox.com.

An understanding of traditional darkroom printing remains worthwhile, both as an exercise in consolidating the basic principles of photography as well as gauging the quality of print that is achievable and therefore should be matched using digital methods. Furthermore, the magic of experiencing the way in which a picture appears before you in a developing tray is still an exciting part of the craft. Photography remains a physical and tactile operation in which many of the standard processes, such as editing, sequencing, and final presentation are far more intuitive when working with prints than on screen.

Printing at home

The quality of print that is now available on reasonably priced home-printing systems is now exceptional, and it is important to learn how to get the very best from your equipment in order to be able to make quality prints. Although the possibilities for home printing

84 Project: Explore different papers and finishes

Make a selection of ten of your favorite photographs and make a selection of prints, using different papers with different finishes, in order to establish a preferred range of materials that suit your practice.

Photo finish
Paper comes in different textures, weights and surfaces. Some are off-white, others brilliant white, some high-gloss, others offer an almost powdery matte surface.

Four- or six-colors black (right)
You can get incredible tonal range and longevity in your monochrome prints if you replace the color inks with four or six different densities of black ink. Try the specialist inks from Lyson.

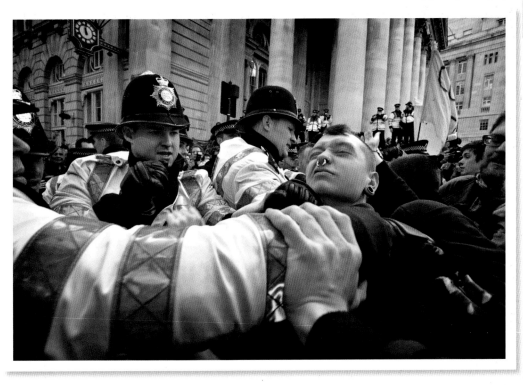

are considerable, there is a point beyond which the home system cannot reach. The professional photographer will regularly use professional printing facilities for their exhibition prints or for prints that they sell. You should research the best professional printers in your area and talk with them about what file type and size they require in order to obtain the best results.

Calibrate your screen

An image on screen will look different to the same image in print. In order to achieve prints that look the same as the images on screen, you will need to calibrate your monitor. The simplest calibration methods involve adjusting the contrast and brightness settings of your monitor, which might be adequate for a working environment that is creating images purely for screen use. Obtaining faithful prints from your files will require special software to help you calibrate your monitor and printer. Software and hardware is widely available for this task, with some of the best products coming from Adobe. It is also possible to pay a technician to make a home visit to do everything necessary to establish a sound and stable color management environment.

85 Project: Calibrate your monitor

Calibrate your monitor and home system so that you are able to create a print that faithfully represents what is seen on screen. Look at the various systems on the market by companies such as X-Rate, Pantone, and Datacolor.

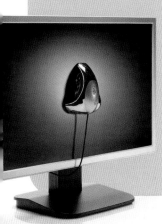

What you see is what you get
A properly calibrated monitor is essential for the main digital workflow of the photographer, namely, shoot, display, and print.

Paper

Paper choice makes a big difference to the final print. As well as the proprietary papers available from the printer companies, which are sometimes very good, there are hundreds of different papers on the market that offer different finishes, thicknesses, and archival stability.

Ink

As with paper, there are other alternatives to the proprietary ink brands. Theses often involve some minor changes to the feeder system in your printer, but can result in far better results with greater longevity, color rendition, and (significantly), economy. The best ink suppliers have ranges of inks that are specifically directed at the professional photographer and include ranges of different-toned black inks that will allow you to make black-and-white prints of the highest quality.

86 Project: The beauty of work prints

The joy of prints
Try printing an extended border on one edge so that there is enough space to spiral-bind each set before filing.

Get into the habit of making work prints from your projects. Work prints are small, quickly made prints that make the process of editing, establishing good juxtapositions, and creating effective sequences far easier (see page 114).

Shooting digitally

We are now living in a digital world where the vast majority of photography, printing, and communication takes place through digital technology. While the transition between old technology and new has taken some time and seen many of the traditional skills associated with photography disappear, the modern arena in which a photographer can ply their trade is exciting and dynamic, offering the potential to take total control over the look, presentation, and distribution of their work.

87 Project: Explore Photoshop's creative features

Digital photography has opened up endless creative possibilities with Adobe Photoshop's image adjustment features. The program allows you to select areas of images and then apply many differing effects, which can then be layered as desired. Have fun exploring the features in Image > Adjustments.

To experiment with these effects, take several pictures of themed objects, which could be leaves, shells, or handwritten letters. Ideally, the tonal or color variation within the images should be quite varied, which allows you to select areas more easily and helps the blending mode, which you will apply in Step 6.

Each picture file can be prepared separately for combination. For ease, always copy the background image layer and work with the copy layer, select different areas, and play around with effects.

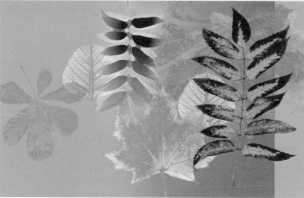

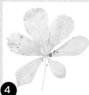

1-3: Steps 1-3 show leaf images where the color has been manipulated via Image > Adjustments > Color balance.

4-6: Steps 4-6 show how you can play with the opacity/ transparency (4); duplicate, rotate, and add fading backgrounds (5); and add solid background colors (6).

Main image: Create a file approximately 6x the canvas size of the individual files and copy each prepared file into it, color the background layer, and then experiment with each layer via Layer > Layer style > Blending options.

The ability to see the image straight away is one of the great advantages of digital cameras, as it allows the photographer to check the settings and composition. By giving immediate feedback, it allows the freedom to experiment without having to worry about the cost of film. Also, as clients can select pictures immediately after a shoot, they tend to order more and bigger prints. This and the lower proofing costs increase profits.

Coping with difficult light
Digital cameras allow you to work in difficult light, as the white balance can be adjusted to suit tungsten or fluorescent lights (see page 63). Color temperature adjustments in high-end digital cameras can give you far greater control over color than conventional correction filters.

Information as well as images
Digital cameras can record information such as the date, name of the photographer, exposure details, and the sequence of pictures taken. This information can be very useful when you are cataloging and indexing images, and writing captions or stories.

Although digital cameras can capture images as JPEG files, thus saving space on memory cards, this is not the ideal way to work. The JPEG process of compression involves a loss of quality even at the highest settings, and most digital cameras are already operating on the edge of usable quality. It is therefore preferable to shoot on RAW format whenever possible as this means that the digital image made by the camera is not compressed or altered. It is in effect a digital negative that can then be processed through a software program to provide the file required.

The RAW format has a wider latitude than a JPEG or TIFF, and has some of the characteristics of color negatives. However, the RAW image can appear to have less contrast than a JPEG. Do not be deceived by this. The RAW file contains all the information you need and can be given more contrast in Photoshop if necessary, whereas the JPEG may have already lost valuable data.

Practical problems

Digital cameras rely heavily on electronics and batteries to function. This can be a problem in remote areas, in extreme weather, and in places with little or no electricity supply.

• Delayed action Most compact digital cameras as well as low-end SLRs have a delay due to the camera's need to process data. This can cause a photographer to miss the peak of action unless you take the delay into account.

• Sensor chip Digital cameras capture an image using a sensor chip mounted in place of a film. On all but the most expensive cameras, this chip is smaller than a 35mm film frame, so in effect it magnifies the image the camera lens produces, usually by a factor of 1.3 to 1.6. This is the equivalent of using a tele-converter on the lens, so that a 20mm wide angle becomes the equivalent of a 32mm lens, for example.

• Relative film speed and noise Digital cameras have settings that are the equivalent of film speeds, 100 to 1,600 ASA/ISO.

However, as with film, at higher speeds there is a significant loss of quality. The grain of high-speed film is replaced by increased noise in digital cameras, which is especially noticeable in areas of shadow.

• Highlights and contrast ratios Digital cameras have a smaller exposure latitude than negative films, especially in the highlights, and behave in a similar way to slide film. They have about a five-to-six stop latitude compared with negative film's seven stops. So don't let highlights burn out, since you will lose the detail and it is difficult to get any tone into such areas in post-production (see page 79). Many cameras have a

Dive bomb (above)
Shot using a high-quality Nikon point and shoot, the moment of the diver entering the water is lost because of the unpredictable shutter delay after pressing the button.

visible warning on the screen when highlights are overexposed, but to increase the dynamic range of the image and reduce noise, it is best to slightly overexpose digital images, as long as the highlights do not blow out.

Project:
Tape up your screen

Some photographers take a picture and then immediately check what it looks like in the preview screen. Tape up the screen so that you cannot see what you have taken and practice shooting in this way for a day, only going through your work when you download the material to your computer.

Work for it!
Shooting with your screen taped up is a good exercise in self-discipline and forces you to work harder and longer on your picture making, in order to be sure you have something worthwhile.

89 **Project:**
Catalog and index your files

Photographers who shoot digitally tend to shoot a lot more than those working with film. Unless you have a good filing system you will lose track of your images. Go through your images, creating numbered folders and filing images from each shoot together so you can access them quickly and easily.

90 **Project:** Store your images on-line

Many photographers also keep a copy of their valuable images on the Internet. If you do, make sure it is a password-protected storage facility where only you and people you give the password to have access. You can send the URL to people as you would send postcards.

Give me shelter!
Both as a storage repository and a functional showcase for your work, platforms such as Photoshelter make it easy for approved downloads of your material without you needing to be at your computer.

Digital post-production

In the digital photographic environment, nearly all the skills that were once associated with professional photo labs now take place on screen. Retouching, color adjustment, and all the creative fine-tuning that goes into producing a high-quality result is now achieved through Adobe Photoshop.

Once the file has been processed, you should save the master file as a TIFF, because this is a lossless format. You should add a caption in the file info section. Captions are vital as they are the only way of ensuring that your image is used in the right context. This master file should be left as it is, so that you can return to the original if any corrections are needed in future. The color can then be corrected, tonal variations adjusted (dodging and burning), and sharpening filters added if necessary. The file can then be resized, saved as a JPEG, and given to the client on a CD or DVD, or transmitted electronically. It is a good idea to save the image in a variety of sizes for different uses, for example, maximum image size for book, magazine, and library use; medium resolution for

newspapers and work prints; and low resolution for web sites and on-screen browsing.

You should never make a JPEG from a JPEG because of the loss of quality. Always go back to the original file.

Correction and enhancement

Today, there is not a single published fashion or beauty image that hasn't been checked through a Photoshop program by either the photographer and their team, or a specialist retoucher hired by a fashion/beauty client or a magazine before production. From color correction to skin beautifying, any photographer benefits from learning the basic Adobe Photoshop moves. Whether using Photoshop or Photoshop's simpler sister program Lightroom, photographers from all genres need to get

91 Project: Storing files

Digital workflow produces a lot of large files, but it is important to retain the original files, because once a file is worked on, information is lost that can never be regained. It is also important to keep the original file in case of any future dispute, over image manipulation, for example. Photographers need to back up their files in several formats, ideally on an external hard drive (see page 52).

92 Project: Practice color correction

Correct color is crucial to the success of any photograph, especially where skin tones are concerned. Relying on the white balance settings on your digital camera isn't always enough to get the color right, and imbalance can be detrimental to the outcome of your photograph. There is a quick-fix tool in Photoshop called Auto Color, but due to lighting conditions and other factors, it is often more accurate to fix color manually. Practice using the Color Balance feature, in Image > Adjustments.

From cool blue to red hot
When a picture is too cool or blue, add equal amounts of yellow and red as a first step to add warmth. If the picture is too warm, try a combination of cyan and blue to cool it a bit.

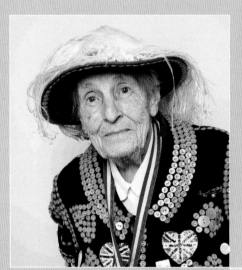

Try adding 20–30 yellow and 20–30 red to achieve a healthy, warm skin glow.

Before color correction control (left)
This photo is lacking in warmth, so open up the Color Balance window and add equal amounts of yellow and red.

After color correction control (below)
The subject looks healthier as her skin tones have improved.

Try small increments at a time to warm or cool your pictures.

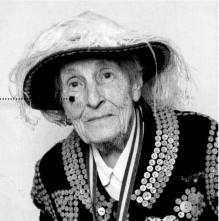

to grips with this technology. However, unlike fashion and advertising, where the boundaries between reality and fantasy are blurred, photographers working in other areas, such as news and photojournalism, must operate within strict ethical guidelines. In a number of well-publicized cases recently, photographers have manipulated their work extensively in Photoshop and paid a heavy price.

93 Project: Practice exposure and contrast control

Probably the first thing a photographer does after downloading the photographs is check if the exposure of the image has the right amount of brilliance. An underexposed image can make the photo appear dark and, even worse, lacking in vibrant contrast. An overexposed image will appear bleached out. There are three basic exposure/contrast controls: Brightness/Contrast, Levels, and Curves. Get acquainted with all three and you will find it easy to make precision adjustments to your photographs.

Brightness/Contrast
This is the simplest of the exposure/contrast controls and is easy to use.

Increase contrast by sliding this button to the right; decrease to the left.

Sliding this button to the right brightens; to the left darkens.

Before exposure and contrast control (left)
The photograph appears too dark and lacking in contrast.

After exposure and contrast control (right)
The image has improved dramatically.

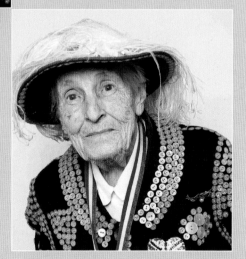

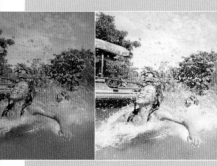

The practice of underexposure
Many professionals deliberately underexpose their pictures and correct the files later in Photoshop. Some professionals state that slight underexposure of no more than one f-stop retains all the essential details without running the risk of blowing out the highlights. It is worth practicing with this technique to see how it works for you.

Image correction tips

The Photoshop functions below can be found in the Image menu, under Adjustment.

Brightness/Contrast
The Brightness/ Contrast correction is the easiest of the three exposure and contrast controls to use. In Adjustments, scroll down to Brightness/Contrast and simply use the sliders to compensate for darkness and lightness, as well as more or less contrast.

Levels
Go to Adjustments and click on Levels. In the Levels window you will find a graph with three sliding adjustments. The one on the far right is for highlights, the one in the middle controls the mid-tones, and the one on the left controls the shadows. Make the necessary adjustments before saving.

Curves
Go to Adjustments and click on Curves. In the Curves window, grab and drag the upper right part of the diagonal to the left and see a dark photo get lighter. Grab and drag the lower left part of the diagonal down to the right to increase contrast.

Color Balance
Go to Adjustments, and open the Color Balance window. Use the slider controls to make fine-tuned adjustments to the color levels until the balance is pleasing. For example, if your photograph appears yellow, slide toward the blue. If there is a green cast, then try red or magenta. If an image is shot in heavy, overcast weather and seems cold, warm it up using equal amounts of yellow and red.

Tonal Balance
You can be more specific with color correction by using the Tone Balance box underneath Color Balance. Here you can adjust the color balance of the shadows, mid-tones, and highlights.

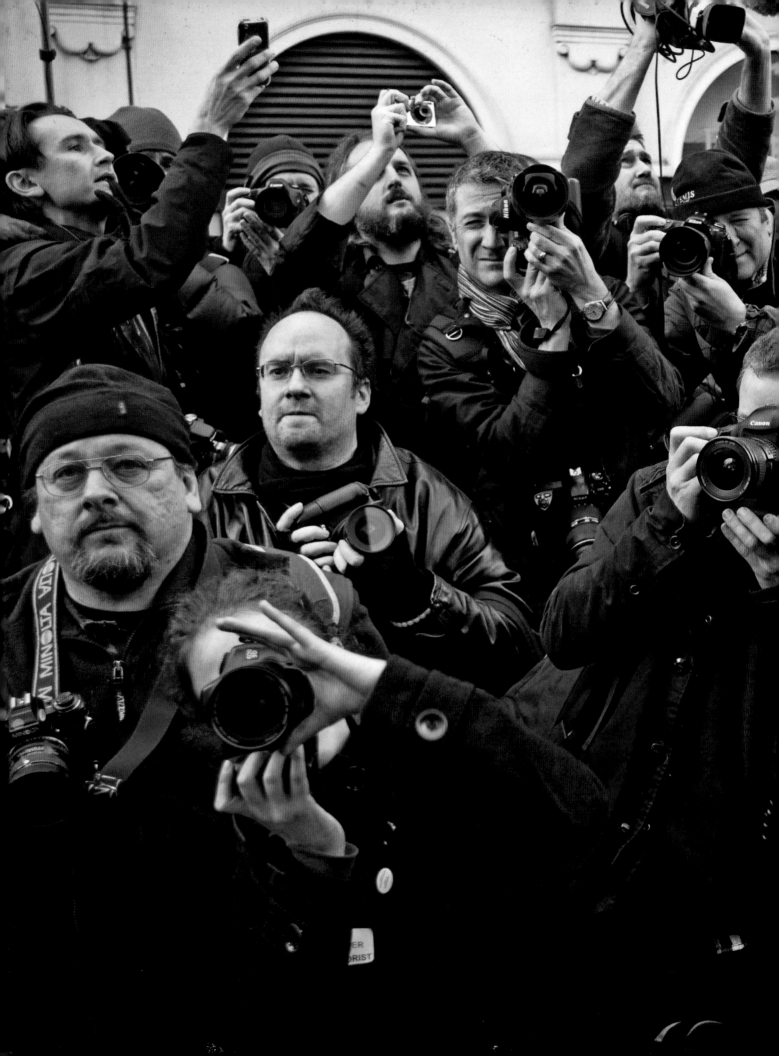

Shooting

It may seem, at this stage of the book, that in order to be a successful photographer, you need to learn a mind-boggling array of skills, own loads of equipment, and invest years in practicing your skills.

Many different areas have been covered, and a lot of these have been specific to one genre or another. Only photographers with significant experience will have had time to fully master each and every one of these. Photography is by nature a process of perpetual learning, evolution, and personal development. The most important thing is to be in a position to work in a style that allows you to express yourself in the way that you want.

While the ultimate goal is to be in full command of all of the technical elements of photography, at this stage you should aim to be confident with your chosen camera system, aware of how to properly expose your photographs, and how to utilize flash, lenses, and light to their best advantage. When your control over the technical aspects is instinctive, you are free to concentrate on getting the picture instead of worrying about the technique.

You are not alone!
Join one of the forums like www.lightstalkers.org to share tips, troubles, and information with fellow photographers.

Using lenses creatively

Different lenses can bring a radically different perspective to a scene, but they can also dominate it if used without care. The first thing to decide is what you are trying to say and the best way to say it. This will help you in deciding what lenses to use in any given situation.

A sports photographer will need a full range of lenses from long telephotos to extreme wide-angles. A news photographer will probably need almost as many lenses to cover every eventuality. But a photographer working on a long-term documentary project might use a very small range of lenses—mostly just the 35mm, with a 50mm and a 28mm when they need to shoot more tightly or when space is limited.

There is a pattern that is common among many photographers in that they start out with very few lenses—just a standard and a wide angle or a short zoom—then as they can afford more lenses they buy a full range, and use the extremes of focal lengths. As time goes on, they tend to return to the more normal lenses and end up shooting most of their photos in the range of 28-70mm.

The advantage of extreme lenses is that they distort the world in ways the human eye does not. An extreme wide angle can include a lot of information, or make the foreground appear huge in comparison with the background; a long

Stand up for the standard lens

Many people dismiss the 50mm standard lens as dull, but if used effectively it can be a very useful lens, as its point of view is very similar to the human eye, and so makes very natural-looking images with no distortion. It can relate foreground and background together, and is useful when you want to orchestrate an image as it allows you to stand back a little but still include the whole scene.

94 Project: Same subject, different lenses

Use a wide angle, a standard lens, and a telephoto to explore how the same scene changes according to what lens you use. Stand in one spot, somewhere like a main square of the city where you have some buildings nearby, in the middle distance and far away, preferably

with your camera on a tripod. Take a series of pictures, without moving the camera position. Start with the widest lens you own, then change through each lens until you are using the longest lens you own. Look how changing the lens changes the position.

Underground busker
1. Taken with a 28mm wide-angle lens.
2. Taken with a standard 50mm lens.
3. Taken with an 80mm lens.
4. Taken with a 120mm telephoto lens.

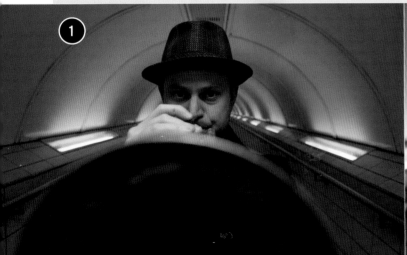

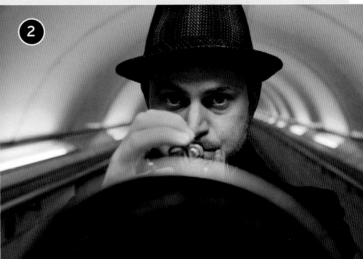

95 Project: Understanding depth of field

Depth of field is the area before and after the focal point of your frame that will also be sharp. Nearly all SLR cameras have a button on the front, close to the lens mount that allows you to preview depth of field. This is useful in learning how the aperture changes your depth of field. Experiment shooting the same subject with different aperture settings in order to see the significant differences.

Aperture settings
The widest aperture on your lens is the lowest number. Note how the area of focus in the left picture, taken with a wide aperture (f2.8), is narrower, ie. more shallow, than the picture on the right (f45).

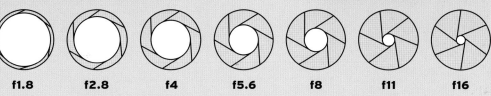

| f1.8 | f2.8 | f4 | f5.6 | f8 | f11 | f16 |

telephoto can compress an image and make distant objects appear to be close to each other. This can help to make the subject look more "interesting," but unfortunately too many photographers use these lenses indiscriminately, so that their pictures actually become repetitive and dull. When this happens, the equipment is winning over the story; form is defeating content.

Wide-angle lenses

Wide angles are useful when you want to show the whole of a scene, when space is limited, or when you want to relate different elements of a scene to each other. But be careful, as they can produce exaggerated effects. Wide-angle lenses over 24mm especially have a tendency to distort the image, most notably at the edge of the frame and can simply be too distracting, especially when used to shoot verticals. There are very few situations that are so cramped that you cannot move back a few meters, which is all you need to get on a 28mm what you would need a 20mm for if you were a little closer.

96 Project: Depth of field in portraiture

Explore taking some close-up portraits of faces using different aperture settings to show the difference in depth of field. Many of the greatest portraits over the years have used shallow depth of field for dramatic effect, concentrating on the eyes and allowing the rest of the picture to become out of focus. You should pay particular attention to shooting at the widest aperture setting permitted by your camera to illustrate this technique.

Shallow depth of field
Use a wide aperture (around f2.8) to create a shallow depth of field in your portraits.

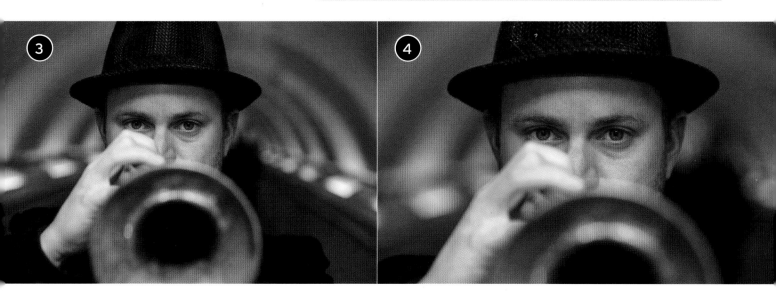

`200mm`

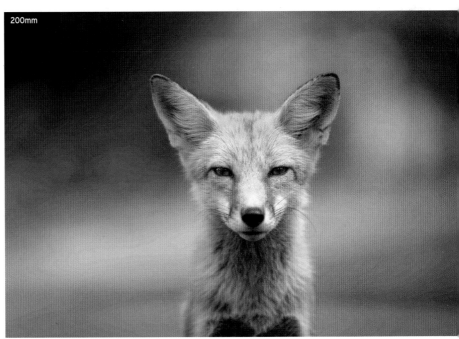

`70mm`

`50mm`

Telephoto lenses (above)
Professional sport photographers rely on telephoto lenses (e.g. with fixed focal lengths of 400mm or 600mm) as their magnification capabilities enable them to get close-up shots of competitors in action far away on the field, track, or ice. Bear in mind that they are very expensive and also very heavy, so you'll need a monopod or tripod.

Telephoto zoom lenses (top)
Big telephoto zoom lenses (e.g. with fixed focal lengths of 120–400mm) are ideal for wildlife photography as they exaggerate the shallow depth of field to really blur the backgrounds behind your subjects.

Short telephoto lens (above)
With magnification and a very shallow depth of field, the photographer has isolated this detail of a telephone dial.

Standard lens, wide open (above right)
By shooting close-up on the widest aperture of the lens, the depth of field on both sides of the focal point is exaggerated, forcing the eye to the part of the frame that is sharp.

Wide-angle lenses have more inherent depth of field than telephoto lenses, and this feature can be used to get a lot in focus. If you set your lens to what is called the "hyperfocal distance" (often marked on the lens), almost everything will be in focus from infinity to very close up if you use a small aperture. This is useful when shooting landscapes, but also when shooting quickly, as you don't really need to focus, since everything should be sharp anyway because of the great depth of field.

Telephoto lenses
Telephoto lenses give a narrower view than the normal lens. Their focal lengths are long and their angles of view narrow. These lenses do more than just let you photograph things that are far away—they can also be very effective and dramatic when used on subjects that are relatively near to fill the frame, eliminate unwanted foreground, and emphasize details. The lack of depth of field can be used to isolate the subject from the background, or the compression that a telephoto lens gives can be used to relate the foreground to something far away in the background that would not have been visible with a wide-angle lens.

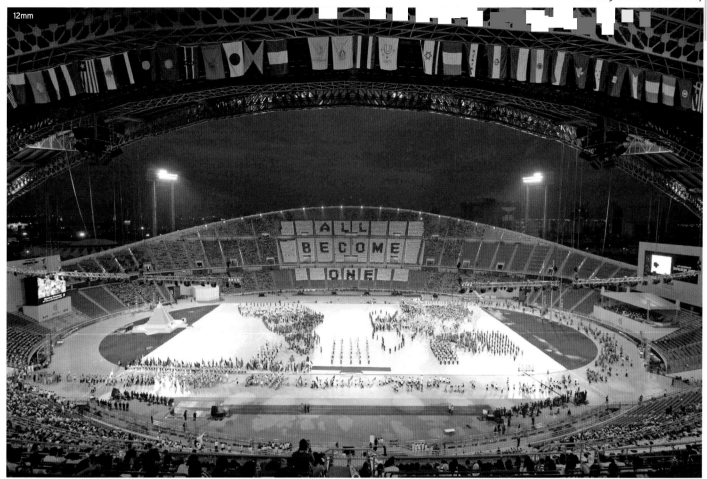

12mm

Wide-angle lenses (above)

To capture big scenes, especially when you haven't got much room to move, you'll need a wide-angle lens to fit all the action into your frame. When using narrow apertures (around f/16), wide-angle lenses also capture a greater depth of field, so they're good for keeping your scenes in focus from foreground to background.

Image magnification, however, is an important characteristic of very long telephoto lenses. The incredibly detailed close-up action shots of sporting moments are made possible by the exceptional magnifying ability and optical quality of highly expensive, very fast, telephoto lenses of anything up to focal lengths of 800mm.

Telephoto lenses require accurate focusing, since they have an inherent shallow depth of field. Because their angle of view is so narrow and their weight can be considerable, a tripod is recommended to ensure continuous, accurate subject placement. Their longer focal lengths also make hand-holding the camera less of an option, since shutter speeds must be fast to avoid blur from either camera or subject movement. If you use a long focal-length telephoto lens, you should also use a sturdy tripod to ensure sharp pictures.

Unless you are photographing sport or wildlife, you may want to think twice before spending on a single lens what you might have spent on your entire camera system.

97 Project: Practice with your 35mm lens

With a 35mm lens, concentrate on shooting in crowded confined situations like subways, shopping centers, or elevators, to learn and explore the advantages of the substantially greater depth of field and to see how you can still compose pictures in situations with lots of physical interference.

Greater depth of field (left)

Learn to enjoy using a 35mm lens on your SLR for capturing a greater depth of field, such as this shot where the oranges in the foreground and people in the background are both in focus.

Crowds of commuters (right)

A 35mm lens lends itself to confined situations when you want to capture as much of the scene as possible, such as crowds of shoppers or commuters in busy public places.

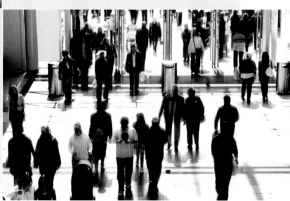

Using light creatively

Understanding the characteristics of light is the very essence of photography for without light we cannot take photographs, and without being able to harness the light, our photographs are useless.

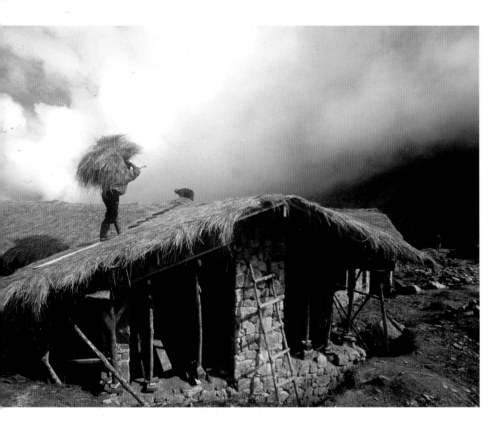

Natural light, created by direct or reflected sunlight is the light source by which most photographs are taken. However, natural light behaves in many different ways, dependent on the time of day, and the height of the sun and its intensity. When direct, it is harsh and unforgiving. When reflected, it can adopt an infinite range of characteristics, dependent on the color, tone, and texture of the reflective surface.

Midday madness

When shooting when the sun is directly overhead, particularly in the summer or in countries close to the equator, there is a tendency for photographs to have high-contrast, "blown-out" highlights and lens flare, and colors that can look excessively saturated. With poor color rendition and an exposure differential between the bright

Mixed lighting (left)
It's hard for your camera to take a balanced exposure when your shot contains a mixture of lighting, such as bright sky and dark buildings in shadow. Get around this problem by bracketing your exposures (three shots: standard exposure, under- and overexposed) then combine them in Photoshop afterward.

98 **Project:** Shoot in the golden hour

1 Landscapes can come to life in the golden hour before sunset.

2 With the sun lower in the sky, it is ideal for capturing street scenes bathed in sunlight.

3 The golden hour before sunset can provide a flattering light perfect for portraits.

Take a range of photographs during the golden hour—one hour after sunrise and before sunset—exploring the soft warm quality of the light and how it enhances all kinds of photography. Shoot some landscapes, street scenes, and portraits.

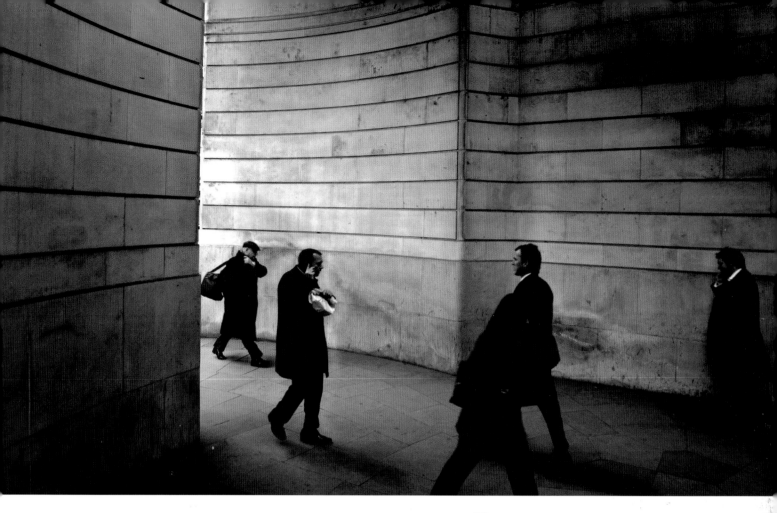

areas and the shadows that can be too much for the camera to cope with, many photographers use this time of day to do story research, look for locations, or take a siesta!

Landscapes and light

Landscapes are defined by light. It creates shadows which sculpt form and reveal texture, giving depth and dimension to a scene. But as with photographing people, direct sun is no friend to the landscape photographer. Blue cloudless skies—the sunseeker's dream—become bald, flat, lifeless vistas for a landscape photographer, whereas a sunny day with heavy incoming storm clouds, laden with rain, offers contrast and drama, intermittent shadow patterns on the ground, and all the tension of the unpredictable natural world that a great landscape picture requires.

The golden hour

Photographers often refer to the golden hour as the best time to work. This window of opportunity exists approximately one hour before sunset and in the first hour after sunrise. Adored by all types of photographers, from landscape, portrait, architectural, fashion, and photojournalists, the soft, warmer light created by a lower angle of the sun creates a magical quality, made all the more mystical because of the brevity of time in which to work.

High contrast (above)
Converting your shots to black and white can help turn bland "mixed-lighting nightmares" into moody "high-contrast dreams."

99 Project: Use shadows for dramatic effect

Make a series of photographs where the shadow pattern is a central part of the composition. Think of the drama of the cinema tradition of film noir when you shoot (see page 63).

Light and shadows
Use chunks of light, bold colors, and creatively placed shadows to lead the viewer into your photos.

Project: Explore the early morning light

Whether perched in your tent on the top of a mountain range or smack in the middle of a major city, set your alarm clock for "unearthly" in order to be out with your camera, taking pictures as the sun comes up. See how the cold, pre-dawn light slowly shifts into a radiant glow. Try to capture this moment and explore the other differences around you that early morning brings.

The early bird (above)
Get up with the lark and, as the sun comes up, you'll discover a beautiful soft, cool light to lift your shots.

Good morning (left)
Use early morning shafts of light (such as light that's crept between tall buildings) to light up your subjects in a scene. Also use the softer light to show reflections in water.

Waiting for the sun (above)
As the sun rises you'll find everyday scenes transformed. Low-level sun rays will highlight (and cast large shadows on) different areas compared to the midday sun. This will help to add shape and form to your shots.

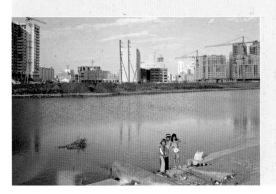

101 Project: Portraiture on an overcast day

With particular emphasis on the human face, and with no additional light such as flash, take a series of portraits in these overcast conditions. It would be worth experimenting with your exposure to see how skin tones are best captured in these conditions of flat light. After taking a meter reading from your subject, shoot in 1/2 stop increments up to 1 1/2 stops over and the same under the camera's recommended exposure.

Face book
The added benefit of shooting a series portraits on an overcast day is that there is no direct light to cause unwanted shadows on your subjects' faces. The diffused light can also help to produce more natural skin tones.

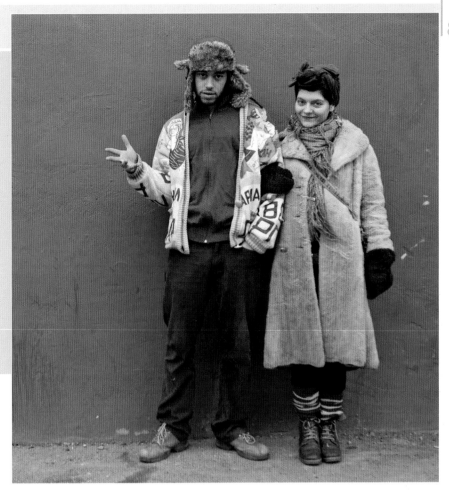

Overcast conditions
Overcast skies may initially seem flat and boring with little photographic potential. The battle between a learned logic from childhood, which decrees overcast as "bad" and sunny as "great," is a mechanism constructed around our passion for sunshine, sea, and sand and one that, in many instances, completely contradicts the principles of photography. To the portrait photographer, an overcast sky is like a giant softbox that diffuses the intensity of the sun, rendering subtle tone and detail to faces and skin.

Standing in shadows
The logical opposite to light—shadow—is equally important to good compositions. In black and white photography in particular, the use of shadows to create complementary shapes within a composition can create a sense of tension, mystery, and drama. For black-and-white portrait photographers, the shadowed areas on a face can be as revealing as the areas of light.

　If the sun has got the better of you, look for a way to turn a problem into something with creative potential. On occasions like this, use of silhouette can be a good way of creating a graphic image from an otherwise difficult scenario.

Silhouettes and shadows (right)
Using shadows and silhouettes is a great way of learning to use light creatively. Shoot into the sun and utilize the high contrast of bright background or foregrounds and dark subjects to your advantage.

102 Project: Practice using silhouette and shadow

Deliberately put yourself in a situation where the sunlight is intense and direct and employ your skills to find a solution to the difficult conditions. Use silhouette and shadow in your composition to help create a strong, graphic image.

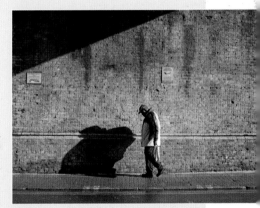

Added dimension (above)
Without the bright sunlight and shadow this shot would appear lifeless. Look for interesting shadows appearing in seemingly every day subjects to add an extra dimension to your shots.

103 Project: Same place, different time

Light and time of day can change a scene from dull and ordinary to atmospheric and interesting. Pick a street corner in the city, or a landscape in the countryside. Go back at different times of day, from dawn until after dark. Set up your tripod and take a series of pictures showing how the situation changes according to whether it is sunny, cloudy, early morning, evening, and even by streetlight. From this you will see how important light is to a situation.

From dawn 'til dusk
See how important the light has become when photographing Sydney Harbour Bridge at four different times of day:
1. Daytime 2. Sunset
3. Dusk 4. Night.

Timing is everything (above)
Knowing when sunlight will hit or highlight your subjects can transform your photos. By being at St. Peter's Basilica in Rome at the right time, the shafts of light are captured entering the insides of the dome.

Rising early

The early bird catches the worm. There are few limitations to the lengths that photographers will go to in their quest to shoot in wonderful light. New Mexico, famed for its breathtaking light, exerts an almost magnetic pull to those who want to experience the light that proved so attractive to Ansel Adams in his legendary landscape work. If traveling to New Mexico is out of your reach, putting yourself in the right place to witness daybreak and all that glorious gentle morning light can be a marvelous alternative.

Experiment with artificial light

We've already talked about how to correct the light of certain color temperatures when the environment you are working in is, for example, basked in an unpleasant green cast from fluorescent tubes. There will be many occasions, though, when artificial light sources will offer you great possibilities to use the light and its inherent characteristics to your advantage. When a balanced "white" is not a concern, the myriad of colors from the spectrum of light sources in daily life—from the humble candle to the bright lights of Vegas—can help you to create dramatic and beautiful photographs.

104 Project: Experiment shooting with strong artificial lights

Artificial strip lighting
Train and subway stations provide ideal locations with artificial strip lighting for you to try to capture creative and colorful photos.

Street lights
Artificial street lights, the ambient light from cities and traffic, and fluorescent lighting from bus stops and billboards can all create interesting colors for your shots.

Nightclub lasers
In the dark setting of a nightclub, try to capture the different colored lasers and see what different effects the color casts give your shots.

Find a range of situations with strong artificial light and use this to create pictures that make positive use of the different colors that the light creates. Don't worry about skin tones or color casts—they are not going to be natural but they will be faithful to the situation you were in. Try to find and use as many different colors as possible.

105 Project: Be creative with available lighting

Take a look around you and see what kind of lighting is already available as a possible device to use in your composition. Imagine you have been assigned by a magazine to meet someone on location and take their portrait. The client doesn't want flash used, so you are going to have to be clever and make use of whatever opportunities you can find. Make deliberate use of a light source in your environment to create a spotlight on your subject. This could be some kind of street light, a shop window full of television screens, or even the candles in a church. It's up to you to find the best solution and make it work.

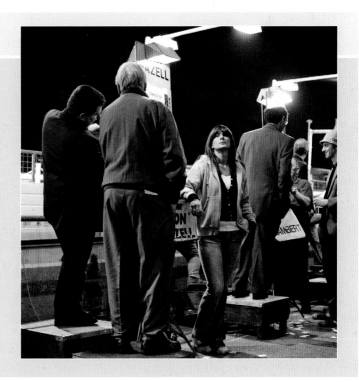

Are you experimental?
If you're unable to use flash for an assignment, don't be afraid to experiment with composition when looking for ways to use natural or available artificial light.

92 | Composition

The composition of your images is the most important factor in creating a successful photograph and determining a personal style. A good composition establishes a sense of harmony between light, lines, balance, framing, timing, and the full range of photographic techniques.

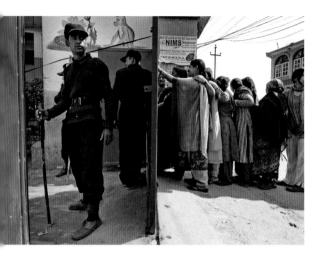

Creative compositions (above)
Learn to think about how you can compose your shots creatively, using lines, color, and tone to create a sense of balance in your images.

Compositional theory–trying to work out what it is that makes a good picture–is by no means a modern concept. For thousands of years people have pondered over the elements that combine to make a satisfying composition.

Compositional theories

Of all the theories and mathematical formulae that have been expounded, perhaps the most recognized and applied is the rule of thirds, which was conceived by the ancient Greek Pythagoras. Basically, this equation divides the frame into thirds both horizontally and vertically, which also gives six points of intersection between them. If you place elements of your composition along these lines and points, the image will appear well composed.

Pythagoras' rule of thirds has evolved and progressed, acquiring new names along the way, as later generations of thinkers and mathematicians tried to discover a scientific explanation for why one particular scene might elicit a favorable response among its audience, over another. The rule of thirds, golden mean, and golden spiral all embody the same basic principle, which is about balance, effective use of the frame, and drawing the viewer to the key points of the composition. These theories can be extremely useful in all kinds of photography, but, as with so many rules of this kind, should remain at the back of your mind while you work, rather at the forefront.

A somewhat simpler recommendation, again with its roots in the golden theories, is to avoid placing your subject right in the center of your frame. In general it is preferable to compose a photograph with the subject off-center, either to the left or right, in order to create a more dynamic composition.

Interpreting balance

When trying to balance your frame, both shape, tone, color, and metaphor are components that can be used. For example, balance can also mean a small dark object in the corner of

Compositional checklist

Aside from the compositional theories, you should consider the following when composing your image:
- Edges of the frame (when looking through the viewfinder, it is very easy to forget the rectangular or square format you are using)
- Movement around the frame
- Eye flow (the way a photographer employs devices to lead the viewer's eye)
- Rhythm (the placement of repeating patterns in your frame)
- Balance
- Off center
- Scale
- Chaos (avoiding clutter and competing elements that result in confused and uncomfortable views)
- Orchestration
- Color or black and white?
- Simplicity
- Fill the frame or empty space?
- Texture
- Contrast

106 Project: Test the compositional theories

Golden spiral
This is a great compositional technique to draw viewers into the key point of your image.

Golden mean
Place your subjects in one corner and establish space around them to create a well-composed image.

Rule of thirds (diagonal)
When composing your photos, think about the relationship between elements in the frame.

Rule of thirds (horizontal)
Place your subjects on the lines and intersecting points for a well-balanced result.

Balanced composition (left)
Try to create a balanced composition, such as darker tones filling two thirds balanced by lighter tones filling the remaining third.

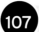 **Project:** Adding depth

Demonstrate how an object in the foreground of a landscape photograph adds depth and a greater sense of scale to your image. Experiment with objects in the foreground and also "paths" which start in the foreground and lead you into the main area of interest.

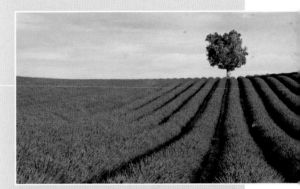

Leading lines
Using natural or man-made lines in your composition is a great method for leading the viewer into your photos.

the frame against a large light area in the rest of the frame. Equally, deliberately making the composition out of balance can create energy and drama, making the image exciting. Many images have a figure on a point of balance in the frame, but about to move out of it, creating a "what happens next" effect.

Other considerations

Portrait or landscape?
One of the first decisions you have to make is whether you are shooting a vertical or horizontal picture—these formats are also known as portrait and landscape respectively.

Foreground and background
Think about the relationship of foreground and background: do you want the foreground sharp and the background out of focus, or the other way around, or do you want everything to be sharp, in a landscape, for example? It is often a good idea to include something in the foreground of a landscape to hold the viewer's attention, a rock or a tree for example, or to use a branch or building to frame the scene. A person, animal, or vehicle in the frame can give a sense of scale.

Positioning the subject
Some images, especially portraits, place the subject in the center of the frame, allowing

108 **Project:** Test the compositional theories

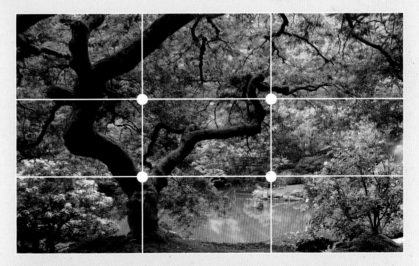

Using either a frosted paper overlay on your prints or Photoshop on screen, take a selection of your best pictures and see how they match up to the compositional theories mentioned on these pages. You'll be surprised how instinctively you will already have applied some of the classic principles of composition. Do the same thing with some famous pictures by other photographers.

the person to dominate the composition. Simple compositions such as these can be very effective, focusing all the viewer's attention on the character of the subject. The eyes are very important–normally in a portrait the eyes should be sharp, and in most "documentary" images, eye contact is avoided to maintain the illusion that the subject is unaware of the photographer, but again these rules are there to be broken. Other images place the subject off center, making the image dynamic. Filling the frame can give the image a drama and dynamism, making it appear full of life and action, or full of chaos and confusion.

Think about framing

Be very aware of the frame itself, when we look with our eyes we don't have a frame, so we have to learn how the frame works (see pages 20-21). One simple technique is to use your hands to make a rectangle though which to view the scene (see page 12). The way elements inside the frame interact with the frame itself is very important–some images use the frame much like a picture frame, surrounding the subject and holding it in space, others dynamically intersect the frame and the frame cuts through elements of the image, cropping into them, again creating energy and drama.

Look for the light

Really look for the light in the situation and make it work for you, move around the subject to get the best light, and look for shafts of light cutting across scenes. This technique, known as "chiaroscuro" (Italian for "light-dark"), describes the contrast between light and dark areas of a scene, and lends a sense of volume and depth to objects–the human form in particular–emphasizing their three-dimensional nature. Look at painters such as Rembrandt and Caravaggio to see examples of this technique.

Finding the pattern

Look for rhythm and lines in images. Repetition

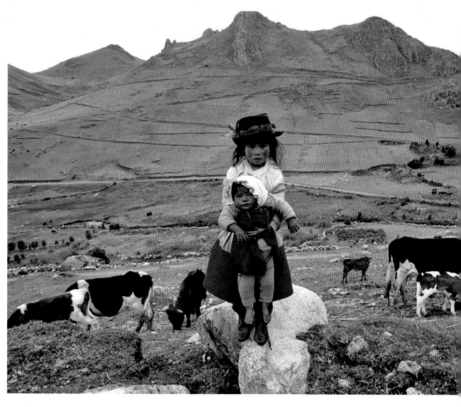

of similar elements can create interesting patterns–if you then break the pattern with another element, for example, a figure, the eye will be immediately drawn to it. Lines, for example, a road or wall, can lead the viewer's eye around the picture, taking them on a journey to the subject. This movement around the frame is very important in making images that will hold the viewer's attention for a longer time. Pay attention to people's arms, hands, and eye lines, since they can all be used to guide the viewer around the image.

Frames within your frame

Look for devices that will divide your frame into sections, allowing a multiple of "cameo"

Dominating the composition (above)
By placing your main subject in the center of the frame they will dominate the shot. Also think about how much of the scene you want to remain in focus–keeping the main subject in focus with a blurred background will change the composition, since the relationship between your subject and its surroundings will have changed.

109 Project: Reproduce the chiaroscuro effect

After looking at both photographic and fine-art examples of the chiaroscuro technique, take some pictures that emulate this approach. Concentrate on architecture–perhaps the indoor cloisters of an old monastery or church–and try to gather as many tones as possible, showing the relationship between light and dark. Apply the same principles with pictures including people or a single person.

Light and limbs (right)
When photographing people, use light on their legs, arms, and hands in your compositions to lead people around the image and eventually toward the head and facial features.

Light and dark (right)
Position elements in light and in shadow in your frame to show the relationship between the lighter tones and darker tones.

111 Project: Explore perspective

Take pictures where you make use of structural, architectural, or other features to lead the viewer into your frame. This might be an avenue of trees or some other element that is wide at the front of your frame and leads the viewer in.

Get some perspective
Artistic perspective has been used for centuries in beautiful paintings. Try and replicate the effect in your photos. Use elements that start wide in the frame and narrow off into the distance to lead the viewer toward the main focal point.

110 Project: Find the best vantage point

Look for a more interesting vantage point to add dynamism to your photographs. Try shooting from ground level or from up above. Pay attention to the horizontal lines in your frame, making sure that the final image does not look confusing or lop-sided.

Get up high (above)
When photographing big scenes or landscapes, try to get up high, and consider tilting your camera on an angle to add energy to your compositions.

Get down low (left)
In tight spaces, get down low to the ground and consider using diagonal lines to create harmony between the elements in your frame.

scenes to exist within the broader rectangle. These can be as simple as a single dividing line across the frame or a grid of mini-windows in which different, seemingly unrelated events are taking place.

Avoid distracting elements

Be very aware of the background; look out for elements such as lampposts and trees "growing" out of people's heads, and avoid strong colors or complicated details that will distract from the main subject. Use differential focus to throw distracting elements out of focus to make them less noticeable, or indeed to make them sharper to make the relationship between the foreground and background stronger. Also, don't forget that the background can be the sharp part of the picture and the foreground out of focus. The point of focus of the picture is very important.

Consider the contrast

Think about contrast between light and dark—light areas will appear to come forward out of the frame, and dark areas will appear to recede. Red areas in a picture will also stand out strongly. Contrast can also be interpreted on a more intellectual level: rich and poor, large and small, tasteful and tasteless, and war and peace. Compare two types of picture from a hypothetical scenario where a bomb has landed on a house in a street. One picture shows only the devastation of the former home, the other shows three terraced houses, with the middle house destroyed. Both pictures of the same situation could be very effective in illustrating the human tragedy, and loss of home and possessions. The difference between the two is that the first picture simply shows the destruction of one building whereas the second

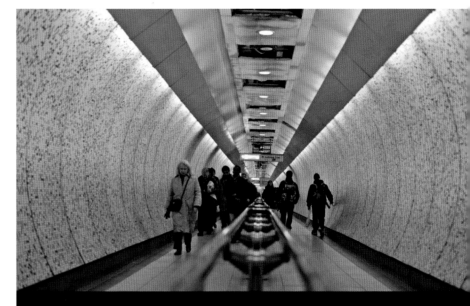

Learn the rules, then break them

There are many so called "rules" of composition, which can help a lot in making strong, interesting images, but don't forget that rules are made to be broken. For example, the rule of thirds doesn't accommodate the idea of symmetry and yet symmetry can make a composition very strong. A figure, lost in the middle of a frame might not conform to the "off center" rule and yet the fact that the figure looks forlorn in an empty space can actually create a powerful impact.

As always, remember firstly what you are trying to say—what is your message? Then think of how to say it—how to use the formal techniques available to you to get across the content of the picture.

Don't be tempted to sacrifice content for style. It's possible to get so carried away with the power of a composition that you completely forget the meaning you want to communicate. Always remember what you are trying to say, and then think about how to say it in the most effective and clear manner.

112 Project: Conveying contrast

Taking the notion of balance to a different tangential level, compose your picture to show contrasting elements in order to emphasize your point. You might be out looking to make some pictures about homelessness, and decide that instead of concentrating solely on working with some people on the street, you will look for symbols of affluence and wealth in the same picture to emphasize the difference in fortune.

Symbolism (left)
Before you think about your composition, think about what it is you're trying to communicate, and then use objects and elements that best convey your concept.

Textures (above)
Learn to look for contrasting textures and shapes to utilize in your compositions. Black-and-white images can work well in this way—by removing all color, you're left with tones, texture, and shape.

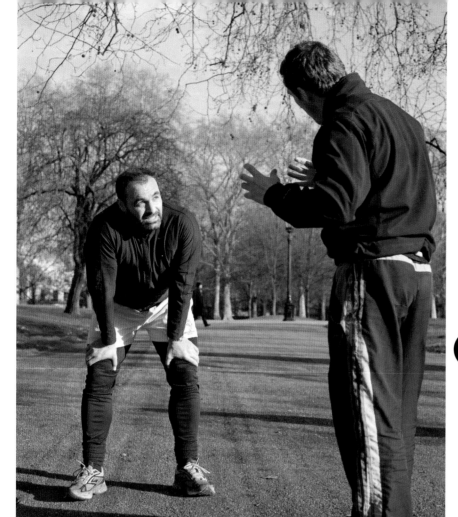

What's in the background? (left)
As well as composing your shots so your subjects are nicely balanced in the frame, don't forget the importance of your backgrounds and how they can add context and depth to your images.

makes the point that the bomb could have fallen anywhere—it could have been you.

Positive and negative space
Do you want to fill the frame with content, cramming it with detail, or do you just want to use one or two elements to make a minimalist image. We can think of the subject of the picture as "positive space" and the background as "negative space"—both are very important in composition.

114 **Project:**
Frame within a frame

Using elements within the working environment, try to create dividing lines that create a break or series of breaks in your own frame, in which different things seem to be happening. Keep it simple at first, looking for a single vertical line that creates a photograph of two halves that works in its entirety but also offers two slightly different situations. Think about energy and calm, and positive and negative space.

You've been framed
Try looking for lampposts, fences, trees, or anything that could divide your photos into two, three, or four shots in one frame. Have fun and attempt to show off your own style of photography with this project.

113 **Project:** Harmony and balance

Starting very simply, compose a series of photographs in which you have carefully considered the balance between elements within the picture. Think about tone, color, space, and weight when trying to achieve this state of visual equilibrium.

Harmonious compositions (below and below left)
Choose an event or location and try to capture balanced compositions where all the elements complement or contrast with each other.

Capturing the moment

The photographs that history chooses to recall often capture a "moment," a split second in time where all the elements converge to make a picture of lasting importance.

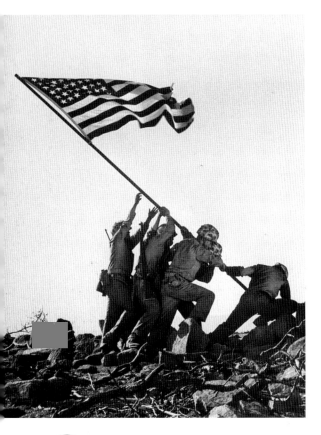

Capturing the moment is important in photography and when you succeed, ordinary life becomes elevated to something profound and uplifting. Very often these pictures look effortless, but in truth are normally the result of endless patience, good anticipation, an ability to read human dynamics, quick reflexes, and a fair degree of luck.

Look out for the moment

There are moments to look for—indeed some which you miss at your peril—in all kinds of photography from weddings or war, to fashion, fine art, and filling the family album. On a basic level, these and all other genres share common elements of timing and place. A set of wedding photos without the mandatory picture of the bride kissing the groom or the cutting of the cake, would be grounds for professional complaint. If Joe Rosenthal, the famous American *Life* magazine photographer, had waited until the U.S. Marines had finished hoisting the Stars and Stripes on the beach at Iwo Jima in World War II, his classic image of a heroic moment simply wouldn't exist.

All photographers know instinctively when they have missed a moment. That sense of failure is made even more acute if we were already aware of an impending moment but read the signs wrong, got distracted, forgot to change the camera setting or, in days of old, ran out of film at the critical time. As part of your working methodology, you should constantly make assessments of the unfolding events in front of you and learn to anticipate the emotional and symbolic peaks and troughs of a particular event in order to be ready for the key point.

Seize the moment (left)
Being in the right place at the right time to capture the moment is all about planning ahead, as shown through this 1949 movie reconstruction of the iconic World War II image of U.S. Marines hoisting the American flag on top of Mount Suribachi at Iwo Jima.

115 **Project:** Practice looking for the moment in everyday life

On the street
Learn to hang around the streets with your camera, being on the look-out so you're ready to photograph interesting little moments from everyday life.

Socializing
Whether in bars, cafes, or parks, there are many opportunities to photograph people's expressions when chatting and socializing together.

Take extra interest in the world around you and really study the rhythms and cycles of the many things you witness—they all have their moments. When you watch someone scratching off the numbers on a lottery ticket, try to anticipate when you would take the picture to capture the key emotions. For example, look at a beggar by an ATM and watch the tension between the people drawing money and the beggar, as he asks for "Any spare change, mister?" Consider carefully where, in this or other mini human dramas, the best picture lurks that will convey all the dynamism and emotion of the moment.

Playing sport
Photographing team sports is a great way of capturing moments of pure passion and emotion.

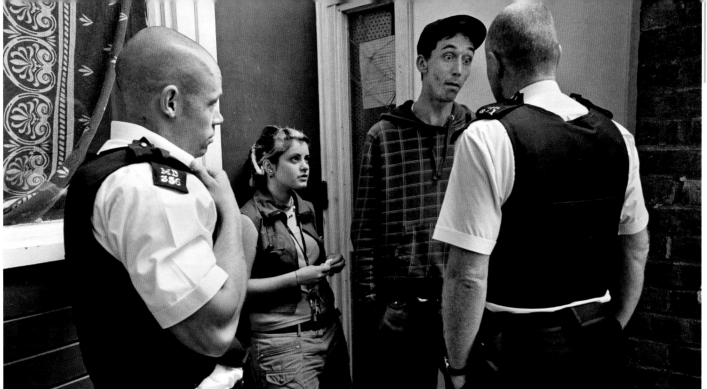

116 **Project:**
Turn the other way

Go to a public event where there is a performance of some kind. Choose something you are interested in that you feel has the potential for dramatic moments. It could be a sporting event like a football match or horse race or something more cultural like an opera or music festival. Instead of looking at the many moments that will exist in the performance itself, make a study of the audience response to convey the highlights or moments of despondency of the proceedings. See the victory, not through the straining sinews of man and horse as they cross the finish line but in the faces and actions of delighted gamblers as they experience their horse coming in first.

Crowd pleaser
A great way of capturing the joy and delight of the moment at a performance or public events is to focus on the crowds and their reactions.

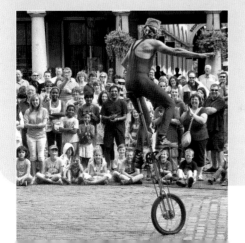

Remember the technicalities
Timing and anticipation alone are only part of capturing the moment. Knowing when the likely moment will happen is only one part of a process that also requires you to position yourself in the best vantage point, make all the necessary assessments of the light conditions, and physical pace of the event, before making the relevant adjustments to your camera settings and waiting.

In many areas of photography, you will be competing with others to get the best picture from a situation. So, as well as all of the above considerations, there's the added pressure of looking for a new angle that would allow you to shoot a picture that no one else thought of.

Prime location (above)
Being able to anticipate a potential photo opportunity is the key to becoming a successful photographer. It doesn't matter if you're photographing people, landscapes, or wildlife—knowing where you need to be and when will greatly benefit you in all situations.

117 **Project:** Search for the peak opportunity

Moments occur in almost every situation you look at. That is to say, whatever you are photographing, there is a good time, poor time, and an ideal time to release the shutter. In the home, hundreds of seemingly mundane activities take place on a daily basis, all of which have this peak opportunity. Seek out some very simple situations in your home and try to capture the best moment within that process. It could be the point where someone cutting onions suddenly can't control the urge to cry and raises their arm to their face to rub their eyes with the back of the wrist. It might be the moment when a familiar voice is recognized after answering the phone, and the face of the person on the phone lights up.

Home sweet home
Even in your own home there will be numerous chances to capture any significant and intimate moments.

100 | Interactions and relationships

How people interact with each other is one of the key themes of observational photography. Almost every photo essay has some element that deals with how individuals relate to those around them. Mastering the skills of taking intimate, involved images of people will give your pictures emotional and psychological depth.

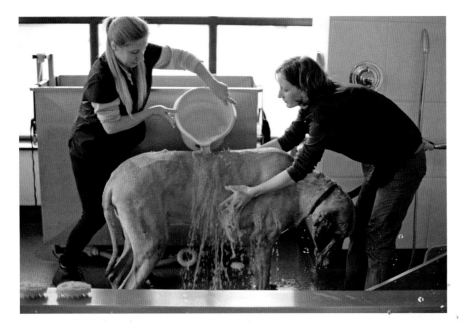

Many of the most famous images in the history of photography are what we can call "relationship" images. Many photographs in photo essays and single pictures show how two or more people relate to each other, either physically, emotionally, psychologically, or professionally.

Relationship pictures can also show how people relate to their environment and the world around them. Think creatively how relationship pictures can carry a message as well as showing an emotion. For example, consider an image of a poverty-stricken person walking in front of a billboard advertising a luxury car.

Visual communication (left)
Use your photography to show how people communicate and interact with each other. Look for different relationships between people, when they're working and at home.

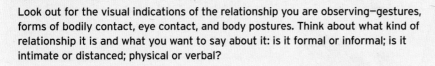

118 **Project:** Explore relationships between two people

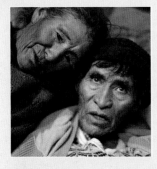

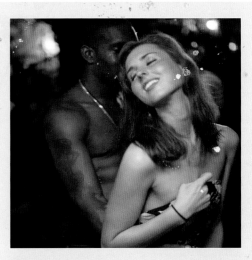

Intimate times
Look for intimate occasions or situations, and zoom in with a telephoto lens for a tighter composition to reflect their closeness.

Men at work
Photograph working relationships between customers and staff in shops. Compose your shots with a wide-angle lens to fit in the surroundings that give the relationship context.

Look out for the visual indications of the relationship you are observing—gestures, forms of bodily contact, eye contact, and body postures. Think about what kind of relationship it is and what you want to say about it: is it formal or informal; is it intimate or distanced; physical or verbal?

It takes two
Nightclubs, and in particular, dance floors, can be fantastic places to capture couples getting up close and physical. Look for body shapes and facial expressions that reflect their relationship.

Eye-to-eye contact (left)
Watch people interacting with each other
and focus on their faces, paying particular
attention to their eyes and eye line—are
they looking at each other or not? Also look
for hand gestures and arm movements that
suggest their relationship.

Focus on faces

Generally, the focus of relationship pictures is
on the emotions visible in the faces and eyes
of the subjects. It is important to really watch
the faces of the people you are photographing,
and to make your exposure when the emotion
you want to express is clearly visible. Eye lines
are also very important—the direction in which
people are looking and what they are looking at
is significant. Also think about hands and arms—
they too can be very expressive and indicate how
people feel about each other. We can use the
ideas of scale here too: one image of a tightly
cropped parent's arms holding their baby could
be contrasted with a politician giving a speech
to a vast crowd.

Selecting your situations

Make your pictures as direct and simple as
possible and start off with situations that
offer strong possibilities of real and visual
interactions. For example, avoid performer/
audience; try midwife/expectant mother, or
music teacher/pupil. Go for situations that
will give you enough time to explore them
photographically, rather than very brief snatched
moments on the street. The possibilities are
endless, since the subject matter is around
you all the time.

119 **Project:** Photograph a relationship with power imbalance

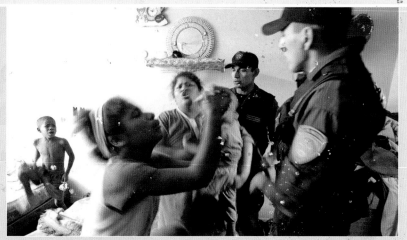

Look at a relationship between two people in which
there is some kind of power or authority differential
and try to show the many ways in which the hierarchy
is maintained in the way the people react to each
other. Look for the signs that betray the person in
power's sense of their importance and see how the
subordinate either accepts or resists these. This
needn't be negative, and you should consider as
many different dynamics as possible, ranging from a
grandparent with their grandchild to a head chef and
their kitchen staff.

Human behavior
For a photo-essay project
(and if possible), ask to
follow and photograph
a police or immigration
squad in action. The
unbalanced relationships
between authority
figures and the victims or
guilty parties can make
for powerful photographs.

120 **Project:** Observe negative interactions

Look for picture opportunities that
express the negative side of human
relationships. These are as much a
part of the human condition as the
moments of elation and happiness.
Eye contact is important in suggesting
a connection between two people,
but equally interesting to observe is
negative body language and lack of eye
contact between two people who are
uncomfortable with each other.

Capturing emotions

So much of what this book covers looks at human behavior and our collective, emotional response systems to one another and life in general. Being skilled at observing human emotion, and understanding when, why, and how an expressed emotion occurs is central to a greater understanding of humankind and, from a photographer's perspective, fundamental to creating work that makes a true connection with an audience.

The primary emotions commonly break down into eight categories: anger, contempt, disgust, fear, happiness, joy, sadness, and surprise.

These in turn have a range of secondary emotions: acceptance, affection, aggression, ambivalence, apathy, anxiety, boredom, compassion, confusion, depression, doubt, ecstasy, empathy, envy, embarrassment, euphoria, forgiveness, frustration, gratitude, grief, guilt, hatred, hope, horror, hostility, homesickness, hunger, hysteria, interest, loneliness, love, paranoia, pity, pleasure, pride, rage, regret, remorse, shame, suffering, and sympathy. This list is one of many interpretations, but is a good starting point when beginning to think about capturing human emotions.

Remember, not all emotions are expressed exclusively through facial expression. Certainly, the face and the eyes in particular are the gateway to many of our emotions, but body language is important too. A person with their head in their hands might say just as much about depression as a facial expression, so be creative in your thinking and presentation.

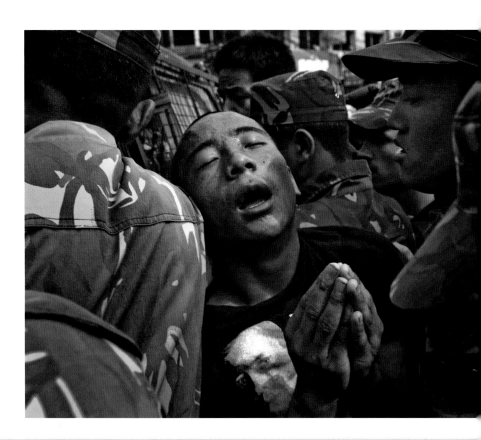

121 **Project:** Think about emotions

Study the list of emotions above carefully and try to imagine how each emotion is expressed visually. Think really hard about what you would look for, what the tell-tale signs might be, in what situations they might be expressed, and how best to capture them.

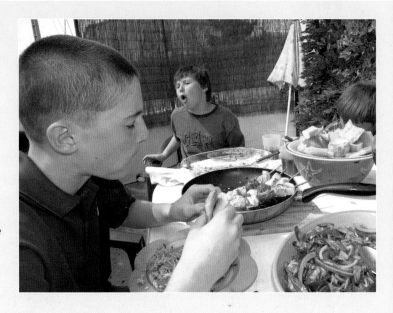

Mixture of emotions
The dinner table is a great place to get photos of children as they openly show a mixture of emotions, from happiness and joy to boredom and disgust.

122 **Project:** Capture a primary emotion

Take one primary emotion from the list opposite and try to capture this emotion photographically. Beware the pitfalls of setting this up with friends, and try to capture something real.

Magic moment (right)
Try to capture a moment of genuine emotion so your shot doesn't look set up.

State of concentration (below)
Photograph a chef deep in concentration as they are preparing a meal or desert.

Emotional response (left)
By focusing on people's faces you'll be able to capture whatever emotions they are experiencing. Try to get their hands in the shot, since they can add to the effect.

Love and emotion (above)
Train or bus stations and airports are ideal locations to get spontaneous photos of people displaying their love and affection as they either say goodbye or greet people.

123 **Project:** Express your own emotions as photographer

Feeling emotional (left)
As well as capturing people in various emotional states, also use your photography to try and communicate the emotion that you were feeling when the shot was taken.

Self-expression (below)
For this exercise try taking a series of photos as a way of expressing your own emotions. Look for interesting scenes or subjects that convey your chosen emotion, such as the outrage shown here.

We have looked at other people's emotions as characteristics to observe and capture, but what about the emotion of the photographer? Photography is as much a process of recording as it is of the self-expression of the practitioner or artist. Set yourself the challenge of expressing your own emotions through a picture or series of pictures. See this as a liberating experiment and don't be too hard on yourself if it feels corny or lacking in depth. Think about the use of color, light and dark, symbols, and signs that help you convey your feelings.

104 | People at work

People at work have been part of the history of photography from the very beginning. In Communist Europe, photography helped elevate the worker into a romantic, propagandist symbol of a political ideology. Fifty years later, Sebastião Salgado gave the world insight into the toil and effort of manual labor that underpins the global economy.

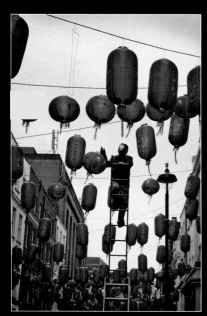

Pulled back and in tight
Three very different pictures of people at work. These employ a range of different compositional techniques. See if you can identify them.

Workplace photography tips

• Concentrating on close-up detail is particularly relevant when you are photographing an activity where intricate, precise work is required. Concentrate on the specific area where the action is taking place, but also remember that the concentration required to complete the work can be reflected in the face of the worker, resulting in a more interesting image.

• Intelligent use of the architecture, lighting conditions, and general surroundings can help salvage a strong image from a difficult or seemingly mundane situation.

• You may sometimes find that the person you need to photograph does not wish to be identified, or that you cannot get close enough to your subject, as was the case when the photographer wanted to capture the man on a ladder in London's Chinatown as he hung lanterns for the Chinese New Year (see above). However, the photographer was able to create strong pictures by using the environment to his advantage.

Every day, photographers around the world are photographing CEOs at work, documenting crafts and skills in the workplace, and covering new technology, scientific discoveries, industrial disputes, and catastrophes.

For most people, work is how we spend the majority of our life. If you add sleep to the equation, which in many respects is a necessary act in order to recharge our batteries for, yes, work, then over two thirds of our life is spent either working or sleeping. During the time that remains, we try to have some fun!

124 Project: Photograph a white-collar worker

Photograph an individual at work in an office. Remember how important it is to observe body language, especially in those situations where the work itself may not be very visually exciting. Look for moments of peak concentration, frustration, irritation, and satisfaction. Ensure your photographs clearly show who the person is and what they are doing. The image must be as self-explanatory and visually expressive as possible.

Tension (left and below)
Two graphic pictures of a city's financial district, suggesting a closed private world.

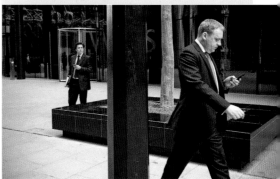

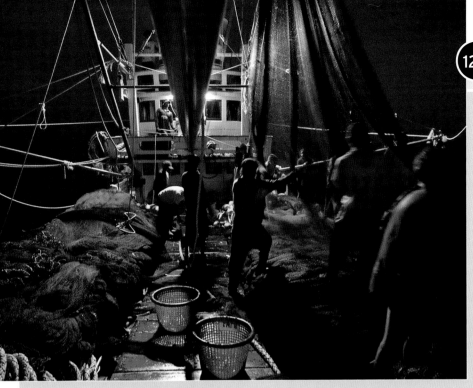

125 **Project:** Photograph a blue-collar worker

Photograph an individual person at work. Make a series of images that show clearly the job or activity that they are doing, and something about the nature of that job. Is it very dirty and sweaty, is it boring and repetitive, or is it dangerous and difficult? Ask yourself: what is the relationship of the person to their job, do they enjoy it or hate it? Think as well about the scale of the work—does the job involve working on something very small and detailed, or on something huge that dominates the human form?

All hands on deck! (above)
The blurred workers on the right are balanced by the empty, waiting baskets on deck. Good use of symmetry and beautiful exposure make this a complete composition.

Peruvian baker (right)
A simple activity is lent grace and poise by the diagonal line of the pallet of freshly baked bread and the stoop of the young worker.

Work and photography

Work is also a place where you see human interaction and emotion. In the broadest terms, the workplace, with all its drama and activity, is a place where you may well want to pursue your own photographic projects, or if you work as an editorial photographer, where you will inevitably be sent to take pictures.

Choose something that is naturally visual in the first place. Think hard about how you can make it dramatic, interesting, or unusual. Most jobs have a peak moment of action, either in the motion of the arm of someone using a hammer or an ax, or in the duration of the whole working day when one job is more dramatic than another—for example, metal being poured from a steel mill furnace is more dramatic than the worker sitting at a control panel. Try to find different kinds of work—indoors and outdoors, detailed work and large-scale work—and if you are feeling brave, try to make a good picture in an office environment (which at first might seem uninteresting), since many assignments you will get will be in offices.

126 **Project:** Photograph an outdoor worker

Photograph someone who works outdoors, maybe in farming or horticulture—perhaps a farmhand or tree surgeon? Try to capture the person's work, while paying particular attention to the relationship between people and the environment. If relevant, show the traditional skills, craftsmanship, and materials. If you get a sense of a man or woman at one with the world, make a statement about this in your work.

In all cases, the pictures are to be unposed—do not direct or set up the situation in front of you. Get used to moving around and exploring the subject you are documenting, looking for the best viewpoint, the best angle, and the best moments. Work through the situation you are involved in—once you feel the picture is starting to work, be prepared to shoot a number of frames. Expect to spend at least a couple of hours on each shoot with your subject. Make the pictures as interesting as possible and above all, choose a subject that interests you and provokes an emotional response—good or bad—in you.

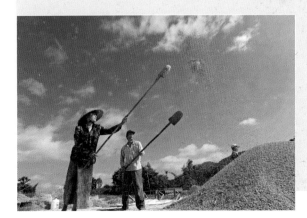

Frozen in time
Apart from the missing feet, this is a good and technically intelligent photograph of a simple farming activity on the rice fields of Indonesia, focusing on the peak moment of action.

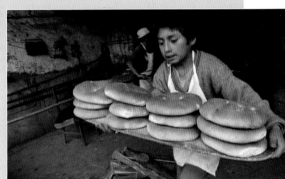

Concepts and ideas

We are living in a time where the concept and ideas are at a premium in many of the creative industries, and photography is certainly no exception. This does not mean that photographic excellence no longer matters, rather that photographic skill alone is not enough to make a mark in a shifting marketplace.

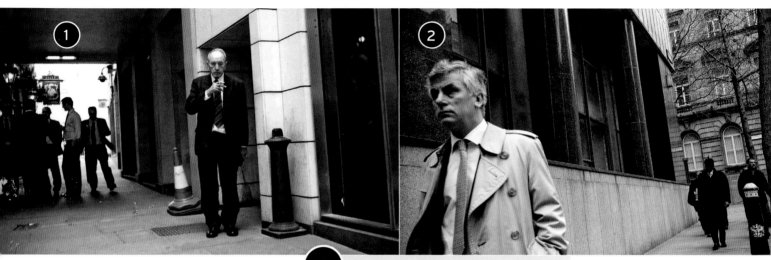

For those among you who aspire to work as photojournalists, witnessing and commenting on world events, sport news, current affairs, and major events, or who hope to conceive, shoot, and sell magazine features to an international market, you need to be constantly thinking about and researching story ideas. Good professionals are developing anything up to 50 ideas and story proposals at any one time. To succeed, both the subject and the concept behind the story have to be original and fresh.

Generating the concept

Take, for example, a global recession as a main subject that you feel is worth trying to make a statement about. How would you choose to deal with the subject in a way that captured an audience's imagination? The impact of a recession is far reaching. On a human level there are individual stories of hardship and suffering—repossessions of homes, unemployment, loss of pensions, and emotional and family breakdowns. You might choose to concentrate on a single touching story to make a broader point. The corporate world also suffers during a recession, resulting in shareholder unease, uncomfortable annual meetings, runs on the stock market, and sometimes the closure of one multinational company, leading to a house of cards-type collapse of subsidiary companies. Perhaps this area could inspire you—the commentator—to come up with an idea that captures the public imagination and drives home the core message of global recession.

127 Project: Generate a concept for a series

Come up with your own concept for a series of pictures that convey the idea of a global recession. Be creative and try to come up with an unusual idea that will make sense to a wide range of people.

The important point here is that identifying the story, no matter how important it might be, is simply not enough in these days of mass communication and the growing range of platforms that we draw on for our understanding of world affairs. Of course, finding an important subject is vital, but the real challenge to photographers, writers, artists, broadcasters, and communicators of all types is how to tell the story, how to be effective, original, and how to capture an audience. In short: the concept.

There are a number of ways in which you can generate a good concept. In the first place an idea must be visual—something that you can make a good picture from. Secondly, the content must be interesting. A useful starting point is to look for something unusual or distinctive. Is something the newest, biggest, smallest, the fastest, or the slowest? Ask yourself what the unique selling point is within your idea and assess why the idea should be of interest to a commissioning editor.

Different approaches (above)
The series arranges samples of work by two different photographers who wanted to comment in their own way on the economic crisis. Each idea is strong and effective in its own right and both take a particular stylistic approach. However, it is also

Is it worth it?

You need to weigh in the difficulty of getting the picture against how often it is likely to be published. There is not much point spending time, energy, and money on a picture that gets published only once, unless it is very special. For freelancers, this consideration is essential. Their time must be spent as effectively as possible looking for remarkable subjects to photograph and selling those photographs.

128 Project: Know what's going on

To produce informative images, you need to be well informed about the world, the issues of the time, current affairs, news, and the cultural climate. The Internet offers more possibilities for remaining at the forefront than we have ever before enjoyed. Whether interested in photojournalism, fine art, fashion, or documentary photography, you should be reading and researching world events continuously.

The Berlin Wall
Signage, graffiti, banners, and discarded front pages often tell the story of a moment: keep your eyes open.

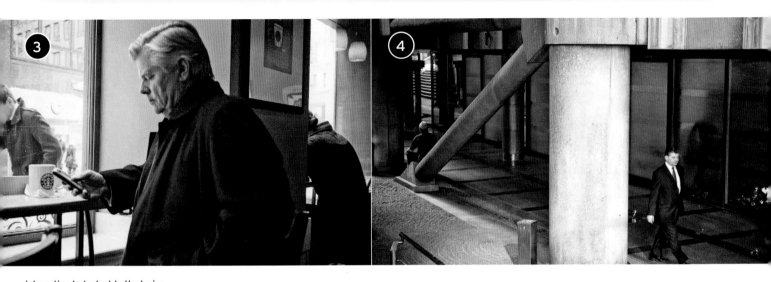

interesting to look at both stories when woven together as one.
1. 2. & 3. Look at scenes of stress and tension in the financial district.
4. Study of the empty spaces where businesses used to be.

129 Project: Start an ideas book

Ideas come at the strangest of times: in the middle of the night, on your way to work, even at funerals. They come and then they disappear before you know it. Your little black book is a way of holding onto those thoughts, developing them, sharing them, and referring back to them until you reach the point when you decide to commit to the research process.

The winning idea

Patterns have fundamentally changed in the world magazine market. It is a buyers' market where editors see hundreds of stories each day and only choose the ones they feel suit their readership best and reflect most dramatically on the profile and standing of the journal. More often than not, the modern feature photographer is on their own. If you select clever ideas that translate to a multinational audience, a single story will sell across the world and make you a good living. You will probably have to fund the initial expenses yourself, but if your instincts were correct, one sale will generally lead to many.

The list of interesting picture ideas is limited only by the photographer's own imagination.

There are, however, two elementary questions you should always ask yourself: is the subject visually appealing? Will the idea translate into income?

The better you know the market and the more you think about and look out for ideas, the better you will be at finding the right kind of picture ideas. Many freelancers live by supplying this kind of picture to newspapers and magazines. Staff photographers too need to develop their own ideas. They may not have as much freedom to choose their own subjects, but they have ample opportunity to use their own ideas when they are sent on assignment.

A changing industry

The Internet has evolved into a central part of our lives and the time when nearly all

130 Project: Find out what the market wants

It is important to develop a sense of what the market is interested in. Look at different newspapers and magazines and analyze the style and content of images they publish. The wire services Agence France-Presse, Associated Press, and Reuters send out stand-alone images all the time. If you can get access to the wires, just look at the kind of images they send out to gain some inspiration on what kind of subjects will work.

Keep news agencies in your favorites
Keep abreast of what is happening in the world by monitoring a selection of news agencies on the Internet.

108

131 Project:
Be a
collaborator

Find a partner from a
different field to work
with on a project, and
take the opportunity to
learn how others might
interpret the same idea.
The important element
of this exercise is to
tune into a different
way of thinking and
to work creatively to
conceive, execute,
and deliver a small
project. For example,
you might work with a
clothes designer and/or
typographer on a range
of shirts that carry a
political message, or you
might work with your
partner on a project
that chooses to present
the work in a public
space rather than a
conventional outlet.

**Revamp of building
exterior**
This sequence shows the
"before" and "after" for the
renovation of a dreary-looking
educational building.

1 A team of creatives, including a photographer, are
commissioned to improve the look of this building.

The collaborators present various options, mocking up their
ideas on computer. **2**

3 The idea is chosen. Large photographic prints are made and
erected on boards on the site.

After installation, photographs are taken for publicity. **4**

State the obvious
Ideas don't have to be
huge in scale and scope.
They can be for just
one picture as well as
a lifetime's work. Don't
ignore picture ideas that
seem obvious or familiar
to you. They might be
unusual to a foreign
audience, or you may be
able to come up with a
new angle on a well-known
topic. Many people take
things for granted, and
when they see things from
a new perspective they
can be astonished.

households will have broadband access has
become an objective for governments across the
world. A by-product of this revolution has been a
sharp shift away from print media as a primary
source of communication. Newspapers try to
retain our interest in current affairs that we have
generally absorbed via the television or on-line
at least 24 hours earlier. The loyalty which many
millions of readers showed to their preferred
newspaper has been terminally shaken, with
many choosing multiple on-line sources for their
information and entertainment.

Collaboration
Photography is just one of many forms of
communication that contribute to our general
interface with world events. Like the written
word, photography has the power on occasion to
communicate effectively and, unlike the written
word, to transcend language barriers. However,
the smart money is on developing new media
in which different disciplines will work together
to create more exciting outlets that are better-
suited to a new, young, Internet-aware audience.

In the years ahead of you, possibly at college,
you should seize opportunities to work with
others on projects in which photography is
not necessarily the dominant component.
Effective communication demands flexibility
and a willingness to adapt to changing
platforms in order to reach an audience. For the
photographer, there are possibilities to work with

writers, audio journalists, three-dimensional
installation designers, and, of course, the
Internet, which provides a platform for all.

Many photographers have seen the growth
of the Internet as an opportunity to start
experimenting with new, complementary skills,
such as sound, video, and audio visual. Some,
like the multiple award-winning photographer
Tim Hetherington, carry a range of tools in their
camera bag that would bear little resemblance
to the contents of a photojournalist's bag from
20 years ago. For Hetherington and others
like him, the important thing is reaching an
audience, and he therefore tries to cover his
subject in a number of ways, including video,
sound, and stills, leaving him with a resource of
material that can be edited and packaged to suit
the different markets.

Check this out
Take a look at some of the interesting work
being produced in the multimedia field.
www.timhetherington.com/
www.mediastorm.com
mumi.pbenj.net/ (Philip Benjamin project
using blog technology, see page 116)
www.nytimes.com/pages/multimedia/

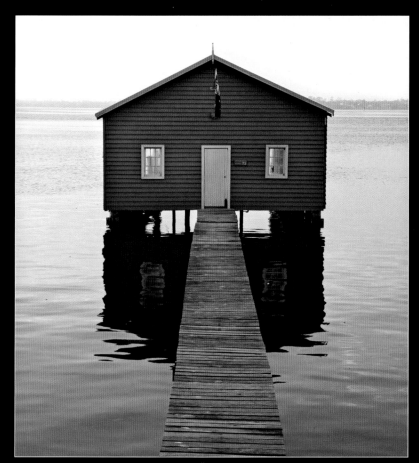

Concept as your work's foundation

Research two unusual or distinctive ideas, and use them as the basis for a series of pictures. Write a short proposal in note form for each, explaining why you think they are interesting.

Windows of the world (left and above)
There are scores of subjects to choose from. Here, the photographer's focus is on windows, and he tells his story using a symmetric and an asymmetric study.

132 Project: Create a multimedia piece

Put together a multimedia piece using sound, text, and stills. There are many free or demo applications available on-line as well as standard programs on Apple computers that will suit the job. Possible software to use, starting at the highest level, would be Final Cut Pro, Flash, iMovie, or Slide Show. Take a look at some examples of multimedia pieces on-line before you start and remember to keep it very simple at first.

133 Project: Customize your Internet home page

Customize your Internet home page using iGoogle or a similar web browser so that you have constant updates on the kind of news stories that might interest you and help you to find ideas. You can install all sorts of applications that will keep you up to date on everything from the latest entertainment news and stories about the rich and famous, to breaking international news and news of scientific discoveries and breakthroughs.

Editing and presentation

Judgement day or party time? The mom
you finally sit down to look at your shoot
begin the often laborious process of iden
the strongest pictures is a moment that
excites some and terrifies others.

How you choose to edit your work now and in
the future is up to you, but never forget that the
editing process, as in films and literature, can be
the difference between success or failure, of a
Pulitzer Prize or a rejection slip, or the difference
between a happy client or a lawsuit!

Once an edit has been made, there are many
choices and options available regarding the
way the work is presented to others. Today's
photographers can take a far greater role in the
shape and look of their final product. Without
needing to draw on outside resources, it is now
relatively simple for photographers to work with
pictures and text in order to create "layouts," to
send presentations electronically to clients, print
limited editions of digital books, and produce
multimedia pieces. Photography is largely about
communication and if you want to communicate,
it has never been easier to take control of the
destiny of your work.

Editing your photographs
Printed contact sheets are just one of the ways of
viewing and editing your work (see pages 112–115).

Editing your work

Different photographers have various techniques for editing their work, but all methods essentially work on the principle of elimination and selection.

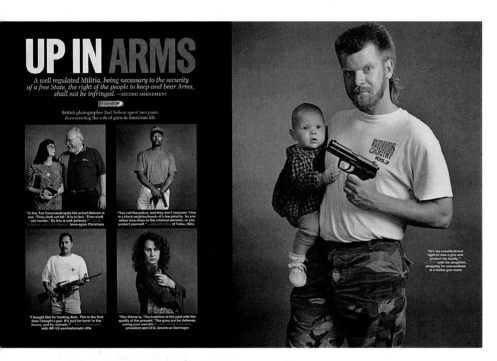

Some photographers start with an initial technical edit, removing the accidental shots, such as the inside of a camera bag, and frames where something has obviously failed to work, and some just dive right in. Whichever starting point you adopt, the main initial objective is to arrive at a general edit, which should contain a series of micro-sets, each dealing with a specific moment or theme within the broader project. These groupings immediately make the challenge of creating a definitive edit seem more manageable because the editor knows that within each group there is always a "best" frame, or at the very least, a far smaller quantity of "either-or" options to resolve later.

These early stages of editing are mainly about creating more order and a clearer range of tasks. If working with film, you will have a series of small piles of contact sheets, each dealing with the same theme. If working digitally, this process is more efficient with a good image browser, such as Photo Mechanic, which provides an excellent picture management system and links very effectively with Photoshop so that you can seamlessly select files on which you want to make adjustments.

View with a critical eye

Depending on the amount of material and the available time, the next step may require a number of visits because you now need to make tough decisions and lose all but the very best couple of frames from each of the previously created groups. Ideally editing is not a process to rush. When deadlines don't force your hand, it's better to make your judgments, live with them for a couple of days, and then confirm that you have made the right choice.

Although it is preferable to be decisive at this stage, there is a good argument to always pick vertical and horizontal versions of the same frame if they both work. Later, when your pictures have been broken down from the original story into "stock," you'll be glad that you gave future users the option to publish your photographs over a full page or on a cover by editing an vertical version.

Assess the technical merit

Examine every frame in great detail, scanning it for overall structure, composition, color, and for sharpness and correct exposure. This process is important because your initial hunch is valuable but also likely to bring with it an element of the dreaded emotional involvement, that prevents you from seeing a photograph's failings.

Bag 'em and tag 'em (above and left)
Although contact sheets are essentially part of the analog photographic world, it is possible to print contact sheets of your digital images in Photoshop. This process of editing contact sheets remains a fascinating and effective way of reaching your final edit. Use a soft wax Chinagraph pencil to mark selections and rejects.

134 Project: Reedit your work

Go back through some of your work and apply a more ruthless editing approach. Get rid of any erroneous pictures, duplicates, or weak links and reassess the newly edited work. Be honest and try to distance yourself from your emotional recollection of the time and place and just ask the simple question: "Is it a good picture?"

Check the detail
Using a loupe (small magnifying unit), it is possible to isolate the surrounding images and look deep into the photo in order to make your choice.

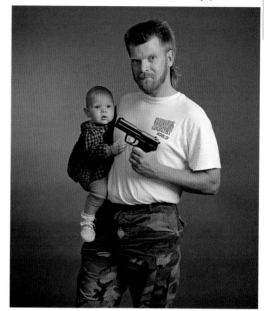

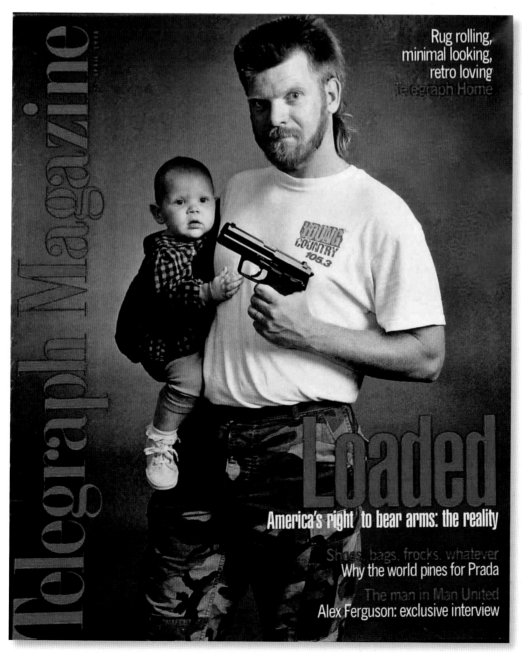

A successful edit

The contact sheet (above left), single frame (above), and magazine cover (left) illustrate the sequence of events that good editing is all about. One of the key contact sheets from photographer Zed Nelson's internationally acclaimed project, "Gun Nation" is shown. The contact sheet shows the subtle changes in posture, expression, and distance from the camera that took place during the shoot. The selected picture is marked with boxing and red shading, and the degree of cropping that would enhance the final picture is also marked.

The yellow sticker is an instruction to the printer, who will have the corresponding negatives in the darkroom. It identifies the exact frame the photographer wants printed, the size of print in inches (12in x 16in—large enough to blow up to front cover size) and instructs the printer to make a crop to the final print (above).

Finally, we see the outcome of the careful selection, cropping, and printing process in the form of a front cover use of the picture to accompany the feature inside the magazine.

Most situations have a rhythm to them. A series of images will build up toward the best image—the climax—then fall away as the photographer continues to explore the subject. It is necessary to recognize the "peak" of the action and choose the image that best expresses it.

A good trick for checking if a picture works is to turn it upside down. Turning a photo upside down makes it less easy for you to become distracted by the content while continuing to allow the formal compositional elements to shine through. If the picture works upside down, you have a good composition!

When you have identified a lead frame from a group, keep it to one side and compare it, one by one, with all the similar pictures to double check you are happy with your choice. Scrutinize the minute details, particularly when comparing two very similar photos. Often a tiny difference can make or break a picture, the position of a hand, or a slightly better expression can make a good image a great one. Watch out for background details that may not have been noticed at the time of making the picture.

After following this process with each group of pictures, you will have what many photographers refer to as the "A-edit"—the best pictures from every situation you photographed. Typically, the A-edit is two or three times larger than the final edit.

The final edit

The final edit is all about finding a picture, or series of pictures if you are shooting a photo essay, that best represent the message you want to communicate. The results of this process will represent the work that you show to clients and your peers. You will be judged

on your final edit, so it must be as strong and impressive as you can make it. There is no room for weak pictures, unnecessary repetition, or self-indulgence. At the final edit stage, many photographers still make work prints from their A-edit and work on the final selection, narrative, and sequencing by laying the prints out on a table to see what works best. Sometimes it helps to pin them to the wall for a few days next to each other, as a picture that looked good one day might not look so interesting the day after.

Always keep in mind the message you are communicating—one picture might be better formally but not express the content as well, so it may need to be replaced by another that more clearly illustrates the story. When editing for a

135 Project: Make work prints

Make a set of 7 x 5in or smaller work prints of your next A-edit (see page 75) and find out if working in this more physical, tactile way suits you. If you are not sure about a picture or can't decide between one or another, pin them up or stick them on the refrigerator door for a couple of days and see if a preference emerges. Consider the sequencing of the pictures—try to make sure that in a linear arrangement, each picture works with its neighboring frames.

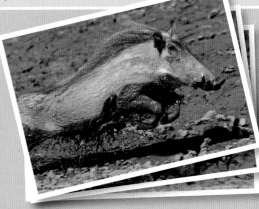

Study your prints
The idea behind work prints is to help you work on selection and sequencing. Carry them around and shuffle through them on the train until you have an edit you like.

Keep your rejects

Do not ever delete your rejected pictures. Unexpected events may take place in the future, giving you reason to take a fresh look at old material. Josef Koudelka, one of the greatest ever photographers, still occasionally packs a backpack full of his contact sheet books from old projects and heads for the hills with his tent, where, away from the world, he reedits his work to see if any pictures take on a new resonance or were somehow missed in the first editing process.

Old subjects have a habit of becoming relevant again—people die, anniversaries are reached, or circumstances change, leading to a new interest in work that you might have thought would never see the light of day again. When these things happen it is good to be able to quickly locate old work and get it out to the marketplace.

136 Project: Practice identifying the end shot in a series

Whatever kind of photography you are drawn to, the likelihood is that you will regularly have to present your work to others, and usually this will involve showing sets of pictures. In visual terms, no matter what area you work in, a set of pictures needs to work well and have a satisfying flow to it. There is a certain pleasure to be found in finding shots that wrap up a set well. Look through your work and practice identifying frames that would work well as an end picture for a series.

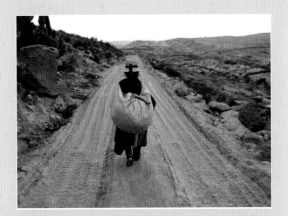

Down the yellow brick road
A classic concluding picture where the subject is walking off into the distance, enhanced in this case by the strong sense of perspective created by the road.

story, you must look for pictures that help you to build a sense of narrative for the audience. The viewer needs to know where the story is taking place, so you need to consider a picture that conveys this, one that works as a geographical or spatial anchor—known by many as the "establishing shot."

At all times you need to remember that your audience will only have the pictures and possibly some text to inform them. The viewer was not there; they need to be taken by the hand and led through the experience by you, using only your pictures. Good stories need a beginning, middle, and end; their characters need depth and personality and the subject of the story needs to come through clearly. The final edit is where these components are put together.

In summary, the purpose of editing is to identify the best material from a shoot. This fundamental principle applies to all photographic genres, whether personal work or assigned, documentary, advertising, or fashion. Sometimes the type of photography involved imposes additional conditions on the editing process. For example, a picture taken in a fashion shoot might be a great photograph, but if it fails to show off the item of clothing it is intended to celebrate, it is a failure.

137 Project: Source archive "establishing shots"

Go through some of your old material and look for photographs that you feel would work well as "establishing shots." Try to find pictures that make it clear where the picture was taken and what the theme of the broader project is.

Don't pull back too far
The wider perspective below is too extreme, resulting in a dilution of the impression of a large crowd; however, both are effective in terms of their sense of geography and place.

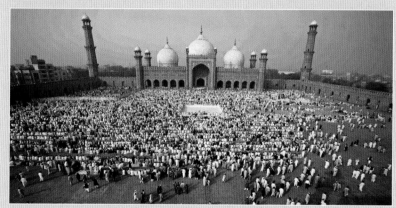

138 Project: Familiarize yourself with Photo Mechanic

This is the main window that you will be using in Photo Mechanic, where you will view all the image files in their folders.

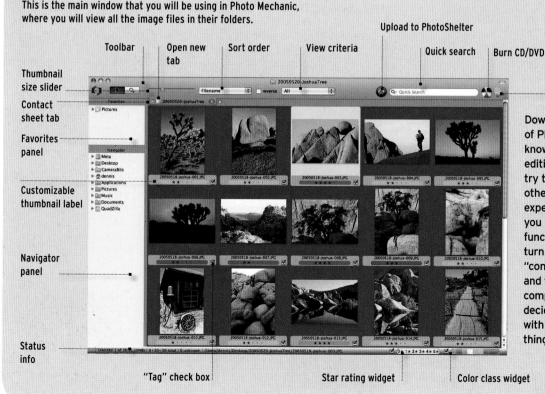

Upload to PhotoShelter

Toolbar · Open new tab · Sort order · View criteria · Quick search · Burn CD/DVD

Thumbnail size slider

Contact sheet tab

Favorites panel

Customizable thumbnail label

Navigator panel

Status info

Color management

"Tag" check box · Star rating widget · Color class widget

Download a free trial version of Photo Mechanic and get to know its key features. Practice editing and sequencing and try to get some feedback from others—preferably people with experience—on the choices you made. Using the rotation function on Photo Mechanic, turn all the pictures of a "contact sheet" upside down and try and identify the best compositions. (If you have decided that you like working with work prints do the same thing. The same rules apply.)

On-line blog presentation

Beyond the changes that the digital revolution has brought to the way we take pictures, the impact that digital technology and the Internet have had on how we show our work to others is equally important and far-reaching.

On-line exposure (left)
A blog can be the first tentative step toward exposing yourself to feedback on your work and thoughts from an audience outside your normal comfort zone.

Photography is about communication and reaching an audience. It is essential that you become familiar and comfortable in using the many different methods that exist on the Internet or through other new technologies. The array of devices at your disposal is large and constantly changing, and with ever-greater emphasis on the necessity to regularly update your information, it is important to commit to a sustainable range of on-line profiles that you have the time and patience to maintain. Remember that, although many of the social networking sites, such as Facebook and Flickr, are largely filled with amateur work, if you decide to be a part of that world, you should still take every care to edit your work carefully and present yourself professionally.

What is a blog?
The advent of the "blog" has had wide-reaching implications across the communications industry and media at large. A contraction of the term "weblog," the blog is a type of web site. Unlike normal web sites, a blog can easily be maintained by people without traditional web-design skills, and as a result, it has become an ideal platform for ongoing diaries and commentary, and stands at the forefront of participatory journalism. Typically, a blog will carry text, images, links to other web sites and blogs, and, should you wish, video clips. One of the key features of a blog is the facility for readers to leave comments and feedback in an interactive shared format.

Although many blogs have a limited audience, personal bloggers tend to take pride in their posts, taking care to update their entries regularly, making the best use of the somewhat limited design capabilities and, in general, trying to create a site that is engaging, informative, and entertaining. The blog should be a place where readers/viewers are compelled to return.

Blogs and photographers
For the photographer, the blog represents more than simply a way to communicate with friends and colleagues but also an opportunity

139 Project: Research existing blogs

Blogs have been particularly well embraced by the photographic community. They can facilitate communication with fellow photographers, help you with advice and tips, and offer a showcase for new work as well as fulfilling numerous educational roles. Below are a few different blogs that illustrate the range of applications they can have in the photographic world.

www.aphotoeditor.com/
curseoftheblackgold.blogspot.com/
www.edkashi.com/blog
photolovecat.blogspot.com/
stateoftheart.popphoto.com/

140 Project: Start your own blog

A blog doesn't need to cost any money; there are a number of free blog hosting companies where you can start your own blog. A good company to use for free blog hosting is Wordpress. Initially, keep your site inactive while you practice and become accustomed to the idea of writing a diary that others will read and establish a framework for how you want to present your ideas and work.

to discuss issues, share knowledge, and show new work. However, to simply use a blog as a showcase for new pictures would be to miss the point. A blog is not just a cheap way to get your own web site—they do not look like web sites and cannot really be adapted to that more promotional function. The blog is more "raw," and only comes into its own when it contains writing and opinion. If you are going to start a blog you must be prepared to commit to the process of airing your views and news and to do that, you need to use words.

The blog as new-journalism

Although few blogs break out of their small circle of readers, blogs that concentrate on the arts and discuss issues relating to, in this case, photography, have a habit of taking on a momentum of their own. In Hollywood, a number of bloggers started to post regular blogs about new films, celebrity behavior, and general showbiz gossip. Without the often politically motivated editorial restrictions placed on writers by magazines, a franker, more subversive style has emerged and with it have come readers in their millions, tired of the predictable, sanitized reporting and slow turnaround time of more traditional magazines.

141 Project: Send your blog link on for feedback

When you feel you have achieved a first "edition" that you are happy with, start sending people you trust your link for constructive feedback. Keep the site password protected until you have been through this process with enough people for you to feel sufficiently confident to remove the password protection. Once you have established a layout that you are happy with and content that you are prepared to share with others—and once you have made a number of updates—take off the password protection and start to let others know about it.

Use free blog providers

The two featured blogs are both the work of young photographers at the start of their careers and are both hosted by Wordpress. As you can see from the very different design and content, it is possible to have significant control and influence over the look of your blog and its functionality. A blog can show text, images, and video as well as being able to play sound files.

When starting your own blog, try to keep it simple and avoid saying too much. At their best, blogs are brief and to the point, regularly updated, and user friendly.

Editing and presentation

Applying to college

Degree and diploma courses that cover all photographic genres are available, as well as courses with a greater or lesser emphasis on theory-based learning rather than the practical tools of the trade.

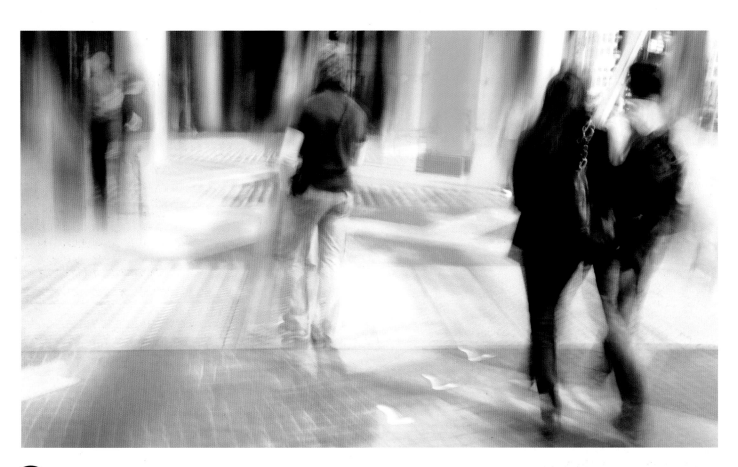

142 **Project:** Visit college open houses

Go to college open houses and find out what you can about the course or courses you are considering applying for. Make sure you talk to the current students, who can be brutally honest sometimes but will certainly offer you a valuable insight into the kind of experience you can expect. Ask current students about their interview experience, what questions were asked, and what kind of preparation they would advise. Interview questions are usually fairly standard and change very little from year to year.

College years (above)
Your time at college is an opportunity to immerse yourself in your subject, meet experienced professionals, share ideas with your fellow students, and develop your own voice as a photographer.

If you want to become the next great name in fashion, photojournalism, landscape, or fine-art photography, you must identify the leading colleges, research the credentials of the key lecturers, and take a look at the recent graduates they have produced in order to make the choice that is right for your own practice.

The decision to move toward such a fiercely competitive profession needs to be considered extremely carefully and should only be taken with the broadest possible understanding of the industry, the opportunities for success, and the level of personal dedication that will be required if you are to progress and prosper. For these and other reasons, identifying the right college for you is of the greatest importance.

Open houses

Most colleges run open houses for potential students when there is a chance to meet lecturers, see the facilities, talk to existing students, and ask questions. You should make every effort to get to these events. It is an opportunity to make an unofficial first impression that might help you later and the chance to build on your growing knowledge about the educational institution in question.

Finding the right course

First, you need to ask yourself what you are looking for. What kind of educational experience do you want? Are you interested in a more academic, theory-based course, which looks at the history of photography, aesthetic theory, and concept, or are you drawn to a more practice-based program with a greater emphasis on the development of photographic skills and their eventual application to the industry? What kind of photographer do you want to be? There are courses for nearly every discipline from fashion, fine art, and landscape photography to documentary, photojournalism, and architectural practice. Or there are colleges who offer a more general, rounded approach, specializing in no particular genre, but offering an overall grounding in the broader context of photography. Indeed, some courses promote a curriculum aimed more at learning about communication while placing photography on an equal footing with sound, video, and the written word.

The reason for raising all these questions here and now is so that you start to engage with the decision process yourself. It is important that you clearly work out what exactly you want from a course and what your expectations are before starting the application process. Establishing a clear idea of what you are looking for is not only important to you but also relevant to the process of applying to any college. The people who read through your application form will be looking for decisive thinking and a sense of purpose in their candidates.

With a clearer idea of what you are looking for, you now need to assess what is out there that might best suit your objectives. All educational establishments have comprehensive course information on their websites. Many will be happy to send you printed brochures containing course descriptions. You need to research the various possibilities. Take a look at the breakdown of the various curricula being offered, look at the course structure, the teachers, and, above all, the alumni. You should be able to see examples of work by former students fairly easily, either via the college web sites or by making a request to the photography department or college administration office. It is vital to see the kind of photographers the college is producing, and it is often quite easy for you to contact former students to ask for their opinion about the course, its strengths and weaknesses, positives and negatives, and ultimately, its relevance to you.

Don't be afraid to ask questions. Many potential students are nervous about asking questions or contacting course lecturers before making an application. This understandable, but misguided notion, probably reflects on the kind of teacher-pupil relationship students are familiar with from school. Remember, you are possibly on the verge of investing close to $50,000 in fees, accommodations, materials, and time, and for this and many other reasons, you need to be sure that the college you wish to join is the right one for you.

143 Project: Research college courses

Go on-line and identify all the courses that interest you. Download the relevant course information so that you can take your time in making an informed decision based on the information you have obtained.

Prize portfolio (below)
Take care over the choice of pictures, the way one picture works next to another, and the layout design. Try to create a modular concept that easily allows you to change pictures. This way you can tailor your presentation to suit the person you are showing your work to.

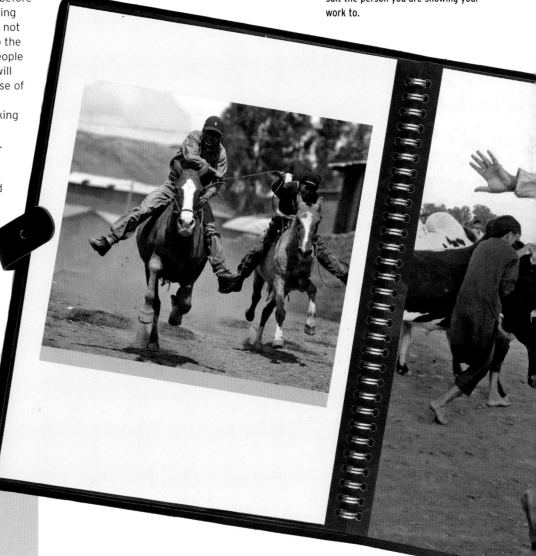

144 Project: Research college alumni

Ask for a list of alumni from the course, and see if you can find their work on-line. If they have a web site, you will easily be able to contact them to ask about the course and build on your intelligence gathering.

145 Project: Prepare for your interview

Write down a short list of things you want to say in bullet-point format and in order of importance. Discuss the list with other people with relevant experience. This will help you to refine the list and make it as useful as possible. This list will ideally stay in your pocket throughout the interview, but in the event that nerves get the better of you, no one will mind if you refer to your list, especially if you make light of it and just say something along the lines of: "Would you forgive me if I quickly check my list of important questions to make sure I haven't forgotten any points in all the excitement!"

146 Project: Pre-interview techniques

Relax and try to collect your thoughts quietly while you wait for your turn. Avoid nervous chit chat with fellow interviewees beforehand—it will only distract you from focusing on your own objectives. Just before you are called, take five slow deep breaths—in through your nose and out through your mouth. Sit with an upright, relaxed posture and be as good as you can be, nothing more, nothing less!

Procedures for applying to college vary from one country to another. What is common to most countries is a requirement for candidates to establish a prioritized list of courses they are interested in applying to. Even if this is not a mandatory process, it is advisable to establish your own list of preferences so that, in the event that you have a change of mind, you have a second option ready.

The personal statement

Common to most application forms is the need for a personal statement from the applicant. This is a chance to put all of your previously researched information about the college and the course to good use. Your should explain why you feel the course is right for you and, likewise, why you are good for them. This is a good starting point for your personal statement.

Remember, in all probability the college you are applying to will run an academic photography course, so if you are just leaving school, they will take your exam results into account. If these are not of a high standard, be certain to make a comment about this in your statement, giving any extenuating circumstances and reinforcing your faith in your ability to study at degree level. (You might use the statement to draw their attention to a letter from your school in support of your ability and suitability.)

Make sure you are clear about why you want to study photography. Think about your expectations of the course and your career goals. Have you completed any related work experience that has helped you make these decisions? Let them know where you find your inspiration and mention other artists who might influence your work.

The personal statement is an opportunity to let your interviewers know which exhibitions you have visited, what magazines you have read, and about any relevant TV programs you have watched, or any inspirational web sites you have visited.

To conclude, any college will want to find students who are inquisitive and thoughtful about their photography. Try to think about ways in which your own photography has been affected by outside influences, whatever these might be. Consider what you would be able to bring to the course.

If, at the application stage, you are asked to submit examples of your work, choose your photos carefully. Think about how your images might link together thematically. This will make it easier for you to write about them. The photos could be from different projects but thematically similar. When writing about your images, try to discuss your influences and why your work reflects this particular theme.

Remember that everything you write in your application and any visual material you send with it is likely to be referred to during your interview. You should therefore keep a copy of your application form so that you are familiar with what you said (it could have been a couple of months since you applied) and can be well prepared on the day.

The interview

Before the interview, absorb yourself in photography. For example, go to exhibitions, read books, magazines, reviews of exhibitions, and take time to look at images. Make notes about your reactions to all of the above and you will have the foundation of the preparation for your interview. If any of these have influenced a piece of your own work, then all the better.

You will not have a great deal of time to sell yourself to the interview panel—probably 15 minutes—so have a clear idea about what you want to say and don't allow anything to get in the way of asking the questions you might have or making the points you want to make.

Everyone gets nervous at interviews, so try to develop techniques for dealing with your nerves and remember, the interviewers do not want to trip you up or make you look stupid. You need to determine if they are right for you, and they need to do the same. Time wasted on telling people how nervous you are is time lost for demonstrating what a good candidate you are.

Be positive, try to smile occasionally, look people in the eye, and try to engage with everyone in the room at some point. You should demonstrate to the panel that you have done your research well. For example, if you are able to indicate that you went to the trouble of looking

Shoot experience (right)
Try to identify a group of strong pictures that can be presented in your folio on single sheets to show the range of pictures you were able to get from one situation.

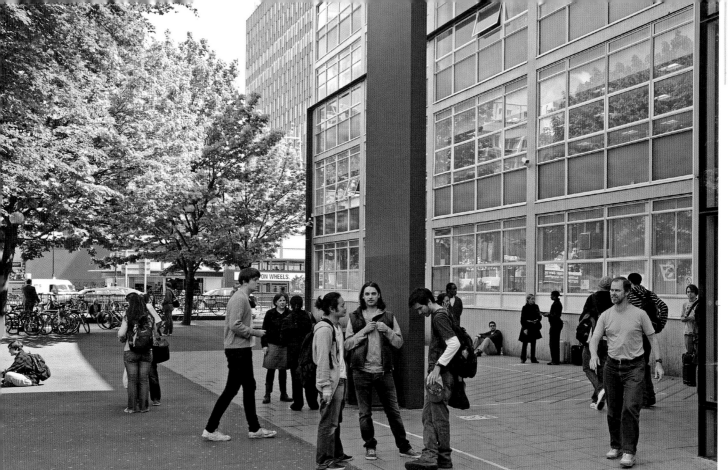

Key interview questions

There are some standard questions that you can generally anticipate in one form or another:

- Why do you want to take this course in particular?
- Who is your greatest influence?
- Where do you see yourself in five years' time?
- What qualities would you bring to the course and your fellow students?
- What are the biggest changes that you perceive to have taken place in the industry over the last five years?
- What are your weaknesses?

Collaborate at college (above)
Your time at college a great opportunity to collaborate with others in different fields who have different skills and to work together on ideas that show your combined talents in joint ventures (see page 108).

up an old student and discovered some very positive pointers about the course that were not in the college literature, this can only show you in a stronger light.

Before you attend the interview, practice speaking for five minutes about why you want to do the course, your passion and enthusiasm, and your ultimate goals. Make this mini-speech to other people beforehand—maybe ask one of your old school teachers to listen and give you feedback.

You will almost certainly be asked to show some of your own work. The way you take people through your portfolio and, of course, its content, should be carefully considered. The important part of a folio presentation is the content and verbal presentation itself. Beware of investing too much time and money in a flashy portfolio that overshadows its content. There is plenty of time for that later in your career.

 147 Project: Be positive at interview

There are occasions every year when colleges are faced with a shortage of places and a surplus of good applicants. What happens in this event is that they start to look back through the application form and interview notes for anything that will give them the excuse to accept or reject someone. Maybe exam results will be the deciding factor, maybe they will recall that "X" was slightly overconfident, to the point of arrogance, at the interview. Who knows? The important thing is to make sure that in this event, there would be extra positive points in your application form. One of the most impressive things to be able to demonstrate is that you have relevant work experience (see page 122). This might be working with a photographer, on a picture desk, at a photo agency, or in a gallery or bookstore. Providing there is a clear connection between the experience and photography, this might just be the difference between rejection and acceptance.

Career opportunities

The photographic industry is broad and it pays to have a realistic outlook on the career possibilities, since there is no automatic job at the end of the three years, and no open doors. There's work, but you need to go out and get it.

The basic tools of the trade for photographers of all genres to promote themselves have greatly increased with the advent of web sites, blogs, and other electronic media, but the core promotional device remains the same—the portfolio. Much of your self-promotion in the future will revolve around trying to set up appointments to show your folio to picture editors, art directors, designers, curators, and other funding or commissioning bodies. The folio should be at the sharp end of an integrated marketing strategy that includes e-mails, postcards, telephone calls, web sites, and advertising in the professional listings that exist across the industry (see opposite).

148 Project: Make a plan, and action it

Make a plan, write it down, and act (see 12-month plan, opposite). You will need a multifaceted strategy when starting out as a photographer, combining your clear photographic identity with a comprehensive marketing plan. Don't wait until everything is "ready" or you'll spend the rest of your life refining and meddling with your promotional tools, rather than putting them to the test. Alternate your efforts between categories in a methodical way, concentrating one week perhaps on trade magazines, the next on feature magazines, and the next on newspapers, so that you don't get bored or disheartened.

Picture editors are busy, often over-stretched, and inundated with requests to view folios. There is no point in taking offence when people refuse to see you or cancel appointments at the last minute—just be patient, bite your tongue, and wait for an opening.

Beware of the ego

In trying to strike a balance between confidence and cockiness, think also about the staff dynamic in companies and organizations that you are hoping will give you work or buy your ideas. For example, even though you may feel your work should be seen by the picture editor and the picture editor alone, it is often more fruitful for a young photographer to build a relationship with a picture desk by starting with one of the more junior members of staff. Your chances of getting a bit of time and advice from these people is considerably greater than would be the case with the senior figure.

Assisting your way in

Assisting photographers is a classic road into the industry, particularly in fashion, advertising, and portraiture. In some respects assisting a photographer can resemble working in a kitchen for a good chef. There can be explosions of tension and moments of high pressure, but the transference of knowledge from "master" to assistant is invaluable, and you'll pick up tricks and learn skills at a rate that is simply not possible in any other environment.

As an assistant, you can get first-hand experience of technical aspects of photography and post-production, as well as picking up tips about how to deal with the broader logistics, such as finding locations, hair and make-up, model agencies, props etc. Furthermore, when you work as an assistant, you are often allowed to borrow the studio when it isn't in use.

149 Project: Build up your work experience

Try to find practical work experience assisting a photographer or in a related field. It is important to maintain an active involvement in photography after college, since it is extremely easy to feel isolated and lacking in motivation when you lose the regular group culture of your classmates. It is also essential to receive feedback on your work in order not to feel like you are operating in a vacuum. Your former colleagues can provide you with this during a difficult time.

Consider your target area (below)
When you consider the many different areas of photography and the role that it places in our daily lives, the career possibilities are extensive. Photography allows a greater understanding of distant cultures (1), documents precious antiquities (2), sells products and lifestyles (3), keeps the tourism industry going (4), excites our taste-buds (5), and works as an art form (6).

150 Project: Lay your career foundations

Remember the first year is generally the hardest. Use it for laying down seeds for your future and be prepared to take some time before you get regular work. You need to plan for this both emotionally and financially as best you can. Try to make any non-photographic work you are able to get as useful to you as possible or flexible enough for you to be able to maintain your photographic practice in some way.

Work experience

There is not a great deal of work experience that involves taking photos. However there are opportunities in related industries that can help you gain a greater understanding of the business and find job opportunities that are exciting and worthwhile. The picture desks of newspapers, magazines, TV companies, and photo agencies all occasionally take on people for work experience.

Award schemes and grants

Be aware of the many funding opportunities and award schemes that are aimed at photographers. You should research these yourself and keep a live database of as many of these as possible so that you are aware of submission deadlines and ready to enter your own work, as and when appropriate. World Press Photo and POY (Picture of the Year) are just two major international award foundations out of many hundreds. In the case of the World Press Photo awards, as a random example, your submission of 12 images will get exactly the same treatment as anyone else's.

Making the leap

Undertaking a career in photography is not an option for the faint hearted. You constantly need to have one eye on your practice—in that you need to be engaged with the process of creating good, relevant work—and the other on marketing yourself. The balance between these two different and sometimes seemingly diametrically opposed roles is complex and needs to be successfully resolved. At the heart of everything is the quality and integrity of your work. By and large, all the marketing in the world will not be able to turn coal into gold and, conversely, the most brilliant gold nugget will remain undiscovered if nothing is done to bring it to the attention of others.

12-month plan

Months 1–2: Start compiling a database of contacts, subdivided into categories (see jobs list below). This should be an ongoing process.

Month 3: Consider buying mailing lists from independent suppliers (editorial, design, advertising, foundations etc).

Month 4: Establish a final edit of work for self-promotion.

Month 5: Write introductory text for your blog (see page 116): who am I, what do I do, how to contact me etc.

Month 6: Create a web presence via a blog using text and images.

Months 7–12: Employ your chosen marketing strategy (see below) to contact the relevant people in your database.

Career matrix	Studio	Fashion	Still life	Advertising	Wildlife	Landscape	News	Portraits	Documentary
Marketing strategy: Portfolio	✓	✓	✓	✓	✓	✓	✓	✓	✓
Web site	✓	✓	✓	✓	✓	✓	✓	✓	✓
Appointments	✓	✓	✓	✓	✓	✓	✓	✓	✓
Work experience	✓	✗	✗	✗	✗	✗	✗	✗	✓
Postcard mail shot	✓	✓	✓	✓	✓	✓	✓	✓	✓
Industry support: Awards	✓	✓	✓	✓	✓	✓	✓	✓	✓
Foundation funding	✓	✗	✓	✗	✓	✓	✗	✓	✓
Public funding	✗	✗	✓	✗	✗	✗	✗	✓	✗
Jobs: Assisting	✓	✓	✓	✓	✓	✓	✓	✓	✓
Print sales	✓	✗	✓	✗	✓	✓	✓	✓	✓
Stock library	✓	✓	✓	✓	✓	✓	✓	✓	✓
Newspapers/magazines	✓	✓	✓	✗	✓	✓	✓	✓	✓
Publishers	✓	✓	✓	✗	✓	✓	✓	✓	✓
Picture research	✓	✓	✓	✓	✓	✓	✓	✓	✓
Press agency	✗	✗	✗	✗	✓	✓	✓	✓	✓
Gallery	✗	✗	✗	✗	✓	✓	✗	✓	✓

4

5

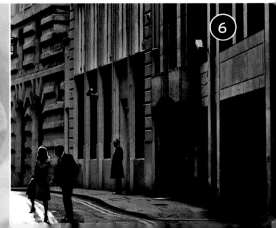

6

Resources

One of the best ways to learn is to study the works of other photographers. The contemporary photographers listed below are all internationally recognized, each with a distinctive style of his or her own.

Social documentary

William Eggleston (USA)
Inspired by family snaps, Eggleston set the bar for color documentary and art photography. Eggleston finds in everyday places, such as shopping centers and ordinary interiors, "the uncommonness of the commonplace," as photographer Raymond Moore described it.

W. Eugene Smith (USA)
Master of the photographic essay, he created essays that include some of the most dramatic and affecting single images of the 20th century. Fiercely energetic, he made countless photographs memorable for their formal brilliance and for their compassion.

Elliott Erwitt (b. France)
One of the greatest image makers of his generation, Elliott Erwitt describes himself as "a professional photographer by trade and an amateur photographer by vocation." A member of Magnum since 1954, his camera has taken him all over the globe and his pictures have been the subject of many books and exhibitions worldwide. Artist and documenter, with a unique visual humor, his work spans many traditions, subjects, and approaches to photography.

Walker Evans (USA)
American photographer best known for his work for the Farm Security Administration documenting the effects of the Great Depression. Much of Evans' work from the FSA period uses the large-format, 8 x 10-in camera. He said that his goal as a photographer was to make pictures that are "literate, authoritative, transcendent." Many of his works are in the permanent collections of museums, and have been the subject of retrospectives at such institutions as The Metropolitan Museum of Art in New York.

Robert Frank (b. Switzerland)
Legendary figure in American photography and film. His most notable work, the 1958 photographic book titled simply *The Americans*, was heavily influential in the post-war period, and earned Frank comparisons to a modern-day de Tocqueville for his fresh and skeptical outsider's view of American society.

Josef Koudelka (Czech Republic) Sprang to fame—as Photographer X—for his images of the Russian invasion of his native Czechoslovakia in 1968. Before and since then, Koudelka spent many years photographing gypsies, matching his lifestyle to theirs, traveling and living rough with them. His more recent panoramic views depict urban and rural landscapes devoid of people to reveal the impact of industrialization.

Philip Lorca diCorcia (USA)
Best known for his photographs of the street life in big cities of America, Europe, and Asia between 1996 and 1998. His technique of using hidden lights to photograph passers-by unawares give his images a unique quality of documentary and fantasy.

Don McCullin (UK)
Recognized as one of the greatest war photographers, covering war-torn regions of the world and documenting events normally hidden from view. His work proved so painful and memorable that in 1982 he was forbidden to cover the Falklands war by the British government of the time.

Boris Mikhailov (Russia)
For more than 40 years, Boris Mikhailov has used photography to document in unflinching detail the turmoil of life under the Soviets and after the breakup of the Soviet Union.

James Nachtwey (USA)
For the past three decades, Nachtwey has devoted himself to documenting wars, conflicts, and critical social issues, working across the globe. When certain stories he wanted to cover—such as Romanian orphanages and famine in Somalia—garnered no interest from magazines, he self-financed trips there. He is known for getting up close to his subjects, or as he says, "in the same intimate space that the subjects inhabit," and he passes that sense of closeness onto the viewer.

Martin Parr (UK)
Parr worked on numerous photographic projects, developing an international reputation for his innovative imagery, his oblique approach to social documentary, and his input to photographic culture.

Sebastião Salgado (Brazil)
Brazilian social documentary photographer and photojournalist. He is particularly noted for his social documentary photography of workers in less developed nations. Long-time gallery director Hal Gould considers Salgado to be the most important photographer of the early 21st century, and gave him his first show in the United States.

Alec Soth (USA)
Critically acclaimed photographer who spent five years working his way down the Mississippi River and documenting the places and people he saw with his 8 x 10in camera.

Landscape

Robert Adams (USA)
Best known for his series of photographs that investigate urban encroachment into the landscape of the American West.

Ed Burtynsky (Canada)
Powerful, large-format, richly detailed color photographs of sweeping landscapes scarred and altered by industry.

Jem Southam (UK)
Acclaimed for his series of color landscape photographs, beginning in the 1970s and continuing until the present, he patiently observes changes at a single location over many months or years.

Joel Sternfeld (USA)
Renowned for his large-format color photographs that extend the tradition of chronicling roadside America.

Massimo Vitali (Italy)
Acclaimed for his engaging large-scale color works depicting people at play, masses at leisure. Vitali photographs beach scenes, popular ski locations, and tourist destinations.

Fashion and celebrity

Annie Leibovitz (USA)
For a decade was chief photographer with *Rolling Stone*—there Leibovitz developed her trademark technique, which involved the use of bold primary colors and surprising poses.

Mario Testino (Italy)
One of fashion's most sought-after photographers, known for his highly polished and exquisitely styled photographs of the couture scene.

Portrait

Rineke Dijkstra (Netherlands)
Photographic series portraying schoolboys, teenage clubbers, adolescent bathers, and post-natal women. She often shows her subjects barely clothed to strip away the protective trappings of modern life.

Steve Pyke (UK)
Famous for his distinctive close-up portrait style in the 1980s. A common thread running through both Pyke's editorial and personal work is his abiding interest in what a face can reveal to the viewer.

Family and confessional

Richard Billingham (UK)
Disquieting snapshots of his chaotic family

and the poverty in which they lived brought Billingham to prominence in the mid-1980s.

Nan Goldin (USA)
Produced an influential series of photographs of the 1980s, documenting with brutal honesty her Bohemian friends: drug addicts, transvestites, clubbers, and battered lovers.

Sally Mann (USA)
Described by *Time* magazine as "America's greatest photographer" is acclaimed for her large enigmatic black-and-white photographs of her own children.

Nicholas Nixon (USA)
Famous for his ongoing portrait series of his wife and her three sisters, shooting them every year in different locations, Nixon also addresses many traditional themes of documentary photography—essentially pictures of people of all and any type.

Fine art

Sophie Calle (France)
French artist who works with photographs and performances, placing herself in situations almost as if she and the people she encounters were fictional. She has been called a detective and a voyeur, and her pieces involve serious investigations as well as natural curiosity.

Cindy Sherman (USA)
Dressed in a range of disguises and using herself as the subject of her photographs, these images are definitely not self-portraits. Rather, Sherman uses herself as a vehicle for commentary on a variety of issues.

Gregory Crewdson (USA)
Draws on film techniques, building elaborate sets and rigging up lights to take pictures of great detail that tell stories.

Andreas Gursky (Germany)
Large-scale, color photographs distinctive for their incisive and critical look at the effect of capitalism and globalization on modern life.

Thomas Ruff (Germany)
Acclaimed for his revival of the portrait during the early 1980s, and then for blowing the prints up to a monumental scale.

Jeff Wall (Canada)
Known for large-format photographs with subject matter that ranges from mundane corners of the urban landscape to elaborate tableaux that take on the scale and complexity of nineteenth-century history paintings.

Recommended colleges

The School of the Art Institute of Chicago
37 South Wabash Avenue
Chicago
Illinois 60603
T: +1 312 629-6100
www.saic.edu

New York University, Tisch School of the Arts
721 Broadway
New York
New York 10003
T: +1 212 998 1930
www.tisch.nyu.edu

Yale University School of Art
1156 Chapel Street
New Haven
Connecticut 06511
T: +1 203 432 2600
www.art.yale.edu

University of New Mexico
6401 Richards Ave
Santa Fe
New Mexico 87508-4887
T: +1 505 428 1234
www.unm.edu

The University of Arizona
Tucson
Arizona 85721
T: +1 520 621 2211
www.arizona.ed

Pratt Institute–New York
200 Willoughby Avenue
Brooklyn
New York 11205
T: +1 718 636 3600
www.pratt.edu

Parsons The New School for Design–New York
66 Fifth Avenue
New York
New York 10011
T: +1 212 229 8900
www.parsons.edu

Rochester Institute of Technology
One Lomb Memorial Drive
Rochester
New York 14623-5603
T: +1 585 475 2411
www.rit.edu

School of Visual Arts–New York
209 East 23rd Street
New York 10010
T: +1 212 592 2000
www.sva.edu

Hallmark Institute of Photography
Turners Falls
Massachusetts 01376
T: +1 413 863 2478
www.hallmark.edu

Maryland Institute College of Art
1300 Mount Royal Avenue
Baltimore
Maryland 21217
T: +1 410 669 9200
www.mica.edu

Pasadena Art Center
1700 Lida Street
Pasadena
California 91103
T: +1 626 396 2200
www.artcenter.edu

Cooper Union–New York
Cooper Square
New York
New York 10003-7120
T: +1 212 353 4100
www.cooper.edu

San Francisco Art Institute
800 Chestnut Street
San Francisco
California 94133-2299
T: +1 415 771 7020
www.sfai.edu

State University of New York, Purchase–New York
735 Anderson Hill Road
Purchase
New York 10577
T: +1 914 251 6000
www.purchase.edu

Eddie Adams Workshops
North Jersey Media Group Foundation,
P.O. Box 75
Hackensack
New Jersey 07602-9192
www.eddieadamsworkshop.com

Young Photographers United
www.ypu.org

Index

Acknowledgments

Author acknowledgments

A special thanks to my students from the MA Photojournalism & Documentary Photography 2009, London College of Communication. The vast majority of the photographs in this book were provided by this exceptional group of talented photographers, allowing me to show wonderful photographs of all types from across the world.

Ana Caroline Reid; Kirstine Fryd; Ian Buswell; Julianna Nagy; Julian Lass; Antonio Escalante; Freya Najade; Valentina Schivardi; Duncan Robertson; Brett Van Ort; Charlie Hatch-Barnwell; Harry Dutton; Siegfried Modola; Kalen Lee; Marta Moreiras; Arnau Oriol Sanchez; Lao Max Wellstead; Silvie Koanda; Marco Pavan; Poulomi Basu; Neil Aldridge; Briony Campbell; Francesco Stelitano; Rebecca Harley; Michal Honkys; Marcia Chandra; Sisi Xiong; Julian Lass; Nelli Ahmetova

Plus the following photographers:
John Biggs; p.110-113 Zed Nelson; p.41tl Alastair Thain; p.99t Adam Patterson; Sam Strickland; Jose Bacelar; Giovana Del Sarto; Pawlina Carlucci

Also thanks to the following for supplying images:
Photo Mechanic
Olympus Cameras
Canon Cameras
Billingham Camera Bags

Publisher acknowledgments

Quarto would like to thank the following for kindly supplying images for inclusion in this book:

p.7 Henri Cartier-Bresson/Magnum Photos
p.8 Text courtesy of Aperture Publishing
p.14tr, p.14br, p.15bl, p.36bl, p.36br, p.90t, p.91tc Ruth Patrick
p.19tl, p.33tl, p.93tl, p.123bc Phil Wilkins
p.20cl, p.20bl, p.90cl, p.90cr, p.90bl, p.90br Rob Baillie
p.27bc, p.27br, p.99bl, Hector Mackenzie
p.41b, p.68l, p.69cl, p.69c, p.69cr, p.70bl, p.89b, Sarah Bell
p.30-31 Caroline Leeming www.carolineleeming.com
Stylists: p.30t Lara Myall; p.30bl, p.30br Antonia Kraskowski;
p.31cl Carly Smith; p.31tr Salome Munuo; p.31b Louise Clarke;
p.77br James Nader www.jamesnader.com

Specially commissioned photography by David Crawford: p.55bl, p.55bc, p.55br, p.60tl, p.60tr, p.60br, p.61bl, p.61bc, p.61br, p.61tr, p.64bl, p.64br, p.67br, p.71bl, p.71br, p.83tl, p.83tr

Shutterstock

While every effort has been made to credit contributors, Quarto would like to apologize should there have been any omissions or errors—and would be pleased to make the appropriate correction for future editions of the book.